C000096595

WHERE ART BEGINS

HUME NISBET

CHAPTER I. WHERE ART BEGINS.

STANDING, as I do at present, in front of the partly opened gateway to that land of wonders—photographic discovery—I should like to begin my remarks, before looking through the narrow aperture, with a glance backwards, say twenty years, to what the science and art were then, and what they have since become, before we surmise what it—photography—may be twenty years hereafter.

I mean to take up photography only where it joins hands with my own work—painting—in the broad sense of the word, which, I may safely assert, is taking it nearly all round.

When I look back twenty years to the time at which I first began to mix with the professors of the sun-craft—'Brothers of the Light,' to use an occult term—and compare the work of those days with the results of this day, and think upon all it may yet be, it is with a feeling of profound astonishment, not unmixed with admiring envy, that I regard the young scientist beginning a career so filled with possibilities and future discoveries. It seems as if I, the painter, walked upon a highway tramped down by countless travellers, leading to an end definite and unavoidable, while he has before him only a little distance marked out, with a vast country to explore, as his mind and genius may best determine.

Many years ago my father took it into his head to begin a photographic business. He did not know much about it himself, although he had a good knowledge of chemistry; but he was an enthusiast in experiments and a credulous believer in the honesty of mankind. Therefore, through the advice of a friend, he built a glass-house, bought some cameras and chemicals (it was in the wet-plate days), laid in a stock of handsomely-designed mounts, &c., and advertised for an operator.

I dare say a great number of photographers have gone through a similar experience, thinking, as he did, that this was about the whole which was required to start a future flourishing business, and that the operator, like the cameras, would be equally easy to procure, provided the money was there to pay for them.

He bought cameras and hired operators. I think he got through about a dozen of the one, and about half a hundred of the other, before he woke up to the knowledge that something else was required before the business could be

built up on a firm basis or the public satisfied with the efforts made to please them.

In those days backgrounds and accessories were not greatly considered as the means towards an artistic end. One plain background and one a little complicated were all that the operator considered needful, with a carved chair or fluted pilaster; and thus the multitude were turned out with a set, fixed stare, full front, bolt upright. If male, a lenient photographer might permit one leg to cross the other by way of ease. The female portion generally sat with hands meekly crossed over the lap and a curtain falling gracefully on one side, like the heroic portraits of the times of Sir Benjamin West.

When I had painted the fancy background—a room with a bay-window partly open, revealing an Italian lake with a 'palace lifting to eternal summer' its (half concealed) 'marble walls'—and got a house painter to do the plain subject, we were ready to begin work, and to turn out your Dick and Harry by the rose-tinted dozen, all as visitors to that wire-work painted Italian lake. I had not then learned the value of suggestive mystery, nor did I do justice to the imagination of our public. I considered then that a fact could not be too plainly told—a mistake often committed by ardent youth.

We changed our operators rapidly. Some had been old positive men, who had no sympathy with the negative system, therefore, out of principle, spoilt all the negatives they took; some had a weakness for ardent spirits and strong tobacco while at work, and, in consequence, made mistakes with their solutions; others, again, developed such an extraordinary appetite for gold and silver, that the most profitable business in the world could never have supplied the baths they required to go on with. We tried a number of wandering workers, who, having pawned their own stock-in-trade, came with arms out at elbow, and stayed with us just long enough to do away with most of our stock as well as with the feebly growing trade; yet my father held out, tried another and another, and sunk a lot of money in that glass-house, before he eventually came to the conclusion that it would be much more satisfactory and less expensive to devote it entirely to plants and the growing of grape-vines.

While those experiments were going on, I was picking up some stray crumbs of knowledge. My artistic instincts and a fair education made me revolt against that instrument of torture, the head-rest, and I tried to pose the sitters

a little more naturally than by the rigid regimental rule. Of course, the time required for the sitter to remain steady in those wet-plate days necessitated a rest of some sort, so, considering all things, I suppose they took portraits then passably well; one point to be specially regarded with regret being, that the young photographer had more chance of learning the details of his trade thoroughly than he has now, with all the facilities for ease and comfort in the prepared dry-plate processes, for I contend that in all trades and professions a man to be thorough ought to learn the way to prepare his materials from the very foundation, as well as to be able to work with them after they are ready for his hand, as the old Masters did with their canvases and colours, and the old positive men with their collodion and other chemicals. We must look back with the same admiration on these men fighting so manfully with difficulties, now all smoothed away by our instantaneous plate manufacturers, as a modern tourist crossing the Atlantic (saloon fashion) may recall the same passage made by Christopher Columbus in his fishing-boat of a Spanish galley.

Of the many experimentalists migrating through that glass-house during their earthly pilgrimages and its photographic existence, I can recall two who stand out most prominently; one an Italian pantomimist and Jack-of-all-trades, who did the most damage in the shortest space of time, and the other a German atheistic disciple of Voltaire, scouter of Providence and blind believer in chance, who stayed the longest, and taught me, as the serpent of old did Mother Eve, the greatest amount of good and evil.

The pantomimist brought with him a wife and a large family, squatted upon the premises *en masse*, and cleared it out as completely as a cloud of locusts are said to demolish the track of country they settle upon; he was an ingratiating man, who could do almost anything from pitch-and-toss down to swallowing a camera, stand and all; and his fascinating family were equally handy in the art of stowing away. If the grocer's and butcher's bills had not, after their hasty departure, come in to be settled by my father, I should have been convinced that they devoured nitrate of silver for their dinner, aiding the digestion by a dessert of chloride of gold, so much of those two articles was consumed during that brief visit to the paternal roof of these interesting and noble refugees.

The little German could work, but objected strongly to my introducing any novelties in the way of pose or accessories. He had been brought up to regard a fluted pilaster as a necessity of life, likewise a cushioned, carved

easy chair with the marble palace, whether the sitter was a clerk or a clodhopper; there they stood, full front, fixed at attention, with an excruciating and ghastly grin distorting each face, flooded with light; the pilaster on the right, easy chair on the left, and the smiling lake with its startling detail all in the foreground, and brought out regardless of consistency or sentiment. I used to argue the point, and strive to surround a sitter with the accessories to which his daily occupations entitled him, but without avail; the operator would turn me off with a piece of Voltairean philosophy, or, what was harder to endure, a smack on the ear, the artist and the photographer standing then as distinctly apart as now they are so closely united.

But, with all his faults, he was a good chemist and a reader of books; had he been less of an investigator he might have been more of an artist, but so long as he could overcome the chemical changes in his baths and emulsions, conquer fogs and frillings, and produce a clear, undeniable likeness, he rested on his laurels, saved his money, and blasphemed creation. Twice a year he took a week's leave of absence, during which time I posed sitters to my entire satisfaction, and ruined plates innumerable. These holidays he invariably devoted to the racecourse; ridiculing a God, he worshipped Dame Fortune; put his entire half-year's savings, without fail, on the wrong horse, got kicked about by the welshers, and returned to his duty ornamented with a pair of blackened eyes and bruised frontispiece, a sadder but never a wiser man; his faith in his particular crotchets being as pathetic and unbounded as was his utter disbelief in a future state.

In those early days photographers did not trouble themselves much about light and shadow—*i.e.* the subtleties and refinements of light and shadow. To me, an artist, the sight of a good daguerreotype, with its silver lustre, soft light, and indefinite masses of shadow, is infinitely superior to the crude attempts at *carte*-printing in its early stages; the finest studio work of to-day harks back to those chance effects of imperfect knowledge, or time-workings, as the great painter strives to cultivate the freshness of early attempts, or the mellowing upon the canvases of the old painters. I have seen effects hit by chance from young pupils, who regarded them as failures through want of experience, which I would give a great deal to have been able to imitate; and so, the longer a man lives, thinks, and works, the more eagerly he watches immature attempts, and the more he can learn from seeming failures; for when a man is struggling with all his might to get at an object, he is wrestling with an angel, as Jacob did, and though he may be

lamed, as Jacob was lamed, yet the failure is so illuminated with a divine light that success may be read between the lines. He thinks he has failed, and that the ground is strewn only with the shattered pieces of his frail armour, whereas it is covered with the jewels which he has torn from his mighty antagonist; as he lies back panting and oblivious from exhaustion, he can see nothing of all this, but to the onlooker it seems a triumph, to the after-gleaners it means success.

You all know from experience how photography has grown, what giant strides it has made year after year, and how it is marching on. First a shadow on a metal plate; an impression upon glass, when all that art attempted was a little coloured powder to give it a life-like look; a staring print upon paper, where art sometimes stepped in and painted over. Then the modelling upon the negative, where art must reign supreme, where anatomy must be studied and mind dominate, and which, as far as I can see, has no ending in the way of possibilities. There is no need for a man to use paints and canvases to write artist, in the fullest sense of the term, after his name, if he is master of the art of manipulating a negative; here art begins, after the posing, and has a delicate and very great mission to fulfil.

When I think upon the vastness of this field where an artist may wander at will, and how little really has yet been done in comparison to what may be done, I could almost wish that this had been my lot in life rather than what it is. Ambition! why, a man may have the desires of a Napoleon, and yet find relief for them all in the great art of remodelling: but of that anon.

POSING

It is a very difficult matter to take a point in the career of a photograph—from the moment the sitter enters the studio until the *carte* is packed up—where art does not occupy the principal share. To begin when the sitter enters, and the artist looks upon him or her, as the case may be, as a subject upon which to expend all his skill, imagination, and brain force—in somewhat the same sense as a subject painter regards his model, so the photographic artist ought to regard his sitter; yet in somewhat of a reverse sense also; for whereas the painter suits his model to his subject, and therefore has the easier task, that of working out a preconceived idea, the photographic artist must be an impromptu man—he must improvise his subject to suit his sitter. To a true artist the strain upon the reflective and imaginative faculties must be tremendous, for he needs to vary and strike

subjects for every sitter who enters; and yet this is his imperative duty if he is an enthusiast in his art, which all great photographers must be.

It has amused me often to hear painters attempt to sneer at the photographer who called himself an artist: painters who are content with one or two subject ideas for twelve months, resting with an air of infinite superiority upon this painfully conceived and, in many cases, rather stale idea, and gazing down from the stucco pedestal of their own arrogance upon the photographic artist with his ten and often twenty ideas per day! Of course I understand that they, the single-idea men, do this through ignorance and want of due reflection, and that the more barren they are themselves, the more they are likely to sneer at the fertility of others; this I take to be one of the natural laws of nature.

A sitter enters—a lady, young, good-looking, and handsomely dressed, to meet another young, good-looking lady just going out. Fashion rules both fair subjects much in the same way as regards costume; a change of colour perhaps, but cut in much the same tyrannical style. The colour may make a slight difference in the two photographs, yet not sufficient to redeem the artist, who has only light and shadow to work with, if he cannot strike out something in the posing and accessories to individualise the different subjects or sitters. But the photographic artist, perhaps, has had six or seven young ladies, similarly dressed, one after another, during that forenoon, each sitter with her own ideas how she ought to be taken—ideas gleaned from someone else's pose, or something she has seen in a shop window or an album—ideas which the original instincts of the artist rebel against. The same may be said of the portrait painter, only that he has days, sometimes weeks, to study his subject, whereas the photographer is only allowed moments to collect his well-nigh scattered faculties. Again, the painter has variety of colour with which to cover over a repetition of design; but with black and white, a repetition will be at once discovered. This I mention as one only of many difficulties besetting the studio of a photographic artist from the moment the sitter enters, which renders his task all the more harassing, and which cannot trouble the layer-on of colours.

A true photographer seems to me to rank with, and resemble, the troubadours of the middle ages, poets who poured out their impromptu verses to the call of the audience. He ought to be a reader of faces—a close scrutiniser of the inner workings of the subject before him; catch with an eagle glance the peculiarities of gait, the tricks of motion; and be gifted with

the rare discrimination which can separate the natural habits from the society affectations. I think a photographer ought never to be in the studio when the sitter first enters. He or she ought to be left a little time alone, or rather, a special chamber ought to be set apart where the sitter may enter, with artistic objects to attract the attention placed about the room, while the artist, for a few moments, from an unseen point, may watch and study his subjects when they think themselves unobserved; afterwards let an employé enter and address the sitter while the photographer still watches from his point of observation, by which means he may judge and learn what is the difference between the sitter when alone and when in society. And so he may wait, after the instantaneous plate is in the camera, for the moment when the sitter unconsciously looks natural, to flash the light upon her or him; indeed, I have thought if the studios could be so constructed that the operator need never enter the room at all, but have the camera so adjusted from an outside room that the sitters might not know the moment they were taken, it would be best—for, to me, naturalism is always before even a first-class sighted likeness. However, if the photographer knows the peculiarities of his sitter, and these be comely peculiarities, he will pose so as to bring them sufficiently out for his purpose.

There are many rules laid down by Rubens, Titian, Reynolds, and other masters for the composition and arrangement of pictures; but of all the stiff, conventional laws laid down, I incline to the jerky, spirited, and contradictory sentences of the American painter, William Hunt, in his 'Talks about Art,' for I never yet knew a law in art which ought not to be ruled by circumstances and the good taste of the artist. The moment a man allows a law to govern him, independent of the great law of reason, he becomes a feeble imitator, and no longer dares launch out into the unknown regions of originality.

Of course, it is strictly necessary to learn all about rules before we dare infringe upon them, for our own convenience and the good of our object, the first and great consideration of the artist, whether of the brush or of the lens. We must learn the laws of lines and directions—we must know exactly how far we dare intrude the angles or blend the orders without being accused of barbarism; yet, to me, there is nothing so delightful as to fling a defiance in the face of time-worn laws, if my art knowledge and common sense acquits me of sin in the matter of taste—*i.e.* my own ideal of what taste ought to be, not Michael Angelo's, or Titian's, or Reynolds'. Knowing their habits by heart, I would not hesitate to turn my back upon them if they did not lie in

the lines of my own observations of the multitudinous and ever-crossing laws of nature.

Still, I would have the artist learn all those laws. As the doctor studies botany, so would I have the photographer learn thoroughly the laws of chemistry, physiognomy, and face anatomy, which alone can make him master of his great profession; for no man can defy a law who only knows the half of its capabilities and powers. The object in art justifies the means always; but we must not use illegitimate if legitimate means will answer the same end.

In arranging a sitter or model, both painters and photographers are apt to do just a little too much—adjusting this fold and planting that accessory so as to get them within the form they have determined. I like purity of style as well as anyone, yet it is very disgusting to hear all the twaddle talked about fine lines of direction, ellipses, pyramids, and serpentine lines. The painter or photographer who cannot thank God for a lucky chance or an accidental fold is at the best only a smart mechanic, and no artist.

My advice in posing would be:—Try to arrange as little as possible. Leave well as much alone as you can, for, depend upon it, all your adjusting will never better what chance and nature have arranged between them for your use, but will only tire out the subject and render the picture artificial. If not according to your preconceived ideas, accept the change as something better, and work your best upon it as a servant who has got a new task set by a great and unquestionable mistress.

LIGHTING

After posing comes the lighting up of your picture. This portion of the art of photography has become so very far advanced, and there are still so many difficulties in the way of perfect control, that I feel a little timid about suggesting any improvement, lest I should be met by the scientific reply that the thing is not possible; and yet I have such faith in the future of photography that I do not consider anything impossible to the operator who flings his whole soul into the discovery of nature's secrets. Light to be manipulated at will, lenses to grasp objects in and out of the present focus with equal intensity and proportion: as a painter places objects upon his canvas at what distance and under what shadow he pleases, so I think the photographer will yet do, and that before long, as he will, I am sure, yet be

able to reproduce by the camera and his chemicals all the colours in the object set up before him, as he sees it reflected upon his ground-glass focussing plate.

In painting, for instance, the great duty of the worker is to have one pure light as small as possible as a focussing point for the eye to go out to first, with a point of darkness to balance that light, as the light is more striking than the dark. A very small spot of white will serve as a balance to a larger proportion of black, so the wise painter is very chary of his pure white.

In landscape this rule is exactly the same, grey predominating in its various degrees over all. Of course I am aware that in landscape photography we have *as yet* no means of controlling the lens, that objects must just be reproduced as they stand, and that the utmost the artist can do is to choose a good stand-point with a favourable light, and make the best of it. Yet I foresee the time when the operator shall have instruments so constructed that he will be able to leave out what is objectionable by means of shades and blinds for the plate, so that he may do as the painter does—alter and transfer his foreground as he pleases.

Inside, the operator has the light more at his control, with his shutters, blinds, tissue-paper fans, and other contrivances to throw the shadow over what portion of the picture he wishes; and yet, with all the softening of harsh lines and gentle mergings of shadows, he has not nearly reached the inner circle of light and shade yet. There are lenses still to be manufactured which will penetrate to a deeper shadow than he has yet attained, deep although he may have gone in that direction; lenses which will wait and not over expose the highest lights until the deepest depth has been gained. With remodelling, it is now easy to make light; and what the photographer ought to aim at are the greys, or half-tones, and the blacks, leaving all dead lights and subtle gradations towards light for the remodeller.

Grey is a very precious as well as a plentiful quality in nature; beyond the point where light streams from, we seldom, in fact never, see white, and even the point of light is blended with gradations of prismatic flashes. There are also throughout nature great spaces; in spite of the multiplicity of detail, to me nature seems to delight in isolation. Take what you please, as an example,—a street scene crowded with people,—what is it to the looker out of a window? Simply dark masses (black always predominates in an English crowd), with here and there intersections of space; if you look for it, you will

find detail enough, but you must look for it. The general appearances are simple masses of shadow under you, drifting out to the grey, with gradations of grey isolation all round. Take landscape, the ocean in turmoil—grey stretches, gradating from deeper to lighter tones. A mountain and lake scene: the sea-gull coming inland from the stormy North Sea is the only speck of white we trace throughout it, with the vulture or crow looking jet-black as it intercepts the mellow light.

Space and half-tones seem to me the two great qualities to be sought after by the artist; in focussing, avoid sharp or high lights, but seek to pierce and collect as large and full masses of shadow as your tricks and appliances can give you. A clear and sunless day outside for landscape work, that sort of lustre which drifts soft shadows under trees, and causes the distance to float away indefinitely, where detail is brought out by under-tones, and high lights are left to the remodeller.

So with figures; as the subject sits or stands, pour all your light upon the obstruction, so as to give depth in the shadow, blend in accessories with the figure and background with reflected lights, just enough to redeem blackness, then soften over the high lights, so that in the negative there is not a single white, all grey, even to the cambric handkerchief carelessly left out of the pocket—although I trust no operator of to-day ever will permit his subject to exhibit such a speck of vulgarity. I would have all such objects as white flowers, lace, or handkerchief changed, or a dye kept on the premises to stain them brown before the negative was taken, so that nothing could be lighter than the hands or face, unless, like Rubens' work, the subject was to be seen dark against white, in which case the white ought to surround the object, never to cut it in two.

In portraits, as yet, the art of beauty seems to be the ruling idea of the operator; court favourites such as those of Sir Thomas Lawrence and Sir Joshua Reynolds are the examples set before the photographer. To flatter the subject is what both subject and worker seem to strive after; when they look to Rembrandt it is for a shadow picture, which, by the way, is no more Rembrandtesque than it is Rubenesque. Rembrandt did not make shadows like the shadow portraits, so called; look at his etchings and works and you will see what I mean. Rembrandt's lights were not shiny whites, but tender tones, as his shadows were not blots of dark, but gradations of depth.

There is a portrait of Thomas Carlyle by James McNeill Whistler, where the old sage is sitting against a grey background with a perfect simplicity of space, which is nearer to the work of Rembrandt than anything I have seen since that grand old Dutchman passed to glory.

RETOUCHING

Before concluding my remarks on the negative, I feel the necessity of devoting a few moments to the great art of retouching—the portion of photography at present too much entrusted to the charge of young ladies; but, if the photographer in any department of the science deserves the name of artist, it is here, when with his pencil he begins to create.

I thought when I began to write that I had little to say on photography, but now that I have got into the spirit of the subject, the possibilities, utilities, and various uses of photography start out before me from the chaos of unthought creation, all importuning me to take them up, one after the other, like a legion of undressed skeletons: photography as connected with etching, wood-engraving, lithography, zincography, typography, and a dozen other uses where photography is not only united in marriage to art, but must be regarded as the husband—*i.e.* the leading spirit, rather than the wife, in the indissoluble bond; but these for the present I must push back into their vague home, until I can at a future time take them up by themselves, which I trust to do, as they are far too important to tack on as a fag end to this chapter; yet before I close I must speak of the negative after it has been developed.

It is the misfortune of all large and prosperous businesses that, as in the making of a pin, the establishment has to be divided into departments—the poser, not the operator—and so the plate has to go through different hands. It is a pity, but I see no way to avoid the evil, except in special cases, where the artist can afford time to follow up his work personally from the first to the last stage. Were time and money no object, I would have each man or woman assistant in the photographic studio qualified to pose, focus, develop, retouch, print, and mount, with a complete knowledge of all the branches, and a thorough artistic knowledge besides. I would also have them all consider nothing too trivial for their talents in the progress of the photograph, but each to take alternately their turn at the different departments with their own plates; without this I cannot see how the art enthusiasm, which a really good photograph requires, can be kindled and kept up. I think modest photographers in country places, loving their

profession, and not troubled with too many commissions, have a better chance, if possessed of equal talents, of reaching perfection than their bustled and prosperous town brethren; in the same sense that I consider the painter, who has genius, to paint better pictures when he is selling for twenty pounds than when he is hunted after and getting two thousand pounds—but this is a matter of opinion.

I know also that it was long considered by some professional men to be false art to touch a plate after developing, as it is sometimes still regarded as wrong for an artist to use the compasses or straight-edge to save time with a drawing, but I consider these as silly prejudices, to laugh at. Personally, I would not hesitate for a moment to use either a pair of compasses, a straight-edge, or a photograph, if the so doing served me better than my eye, or my sketch, in the making of my picture; neither would I hesitate to call the man a fool who objected to me doing so on the ground that it was not legitimate art.

Retouching is exactly the same work on the negative as if the artist sat down before any other material. Upon it, if he has the genius, he can do almost anything, so that he has shadow enough as a basis. Here he becomes, as I have said, the creator, and of all the different operations of a negative, this is the portion where the artist stands out most prominently and proves what stuff he or she is made of. There is no end to the variety of work they may introduce as they work on—grains to look like engravings, hatchings, stippling, brush work. It is not enough to be able to remove spots and blemishes, or soften off harsh contrasts; girls mostly get up to this mark of excellence, and produce those smooth, meaningless, pleasant portraits of everyday life. The retoucher must learn to keep an expression of the negative, or make one if not there, and this is the lofty calling of a true retoucher. He must put a soul into his model, else he cannot call himself an artist any more than the painter can claim the title who only daubs potboilers. But if the retoucher can do this, and has art enough in himself to prefer soul to beauty or beautifying, then he has as much claim to call himself a painter or an artist (if he prefers that title) as any R.A. in the clique divine.

Expression, or soul, is what photographers are as yet deficient in, and that is the province of the retoucher. I want to see a photographer rise above the prejudice of the flattery-loving public, and lead them by intensity: give to the public faces ugly as Rembrandt's portraits, yet pregnant with character. I

want to see seams, and wrinkles, and warts, as the Great Creator left them—indexes to the wearer's character—and not doll faces, which simper and mean nothing. I want noses in all their varieties, with their own individuality intensified; cheek-bones standing out as they may be in the originals. I want men and women sent down to posterity as they are and not as they would like to be; for I never yet saw a face in its natural state that I could call ugly, although I have seen faces made hideous by rouge, and cosmetics, and false eyebrows, and also by the retouching which they were themselves so delighted about.

Vice and crime darken the souls which sit behind the eyes—make chins hard, and lips thin or coarse—destroy curves which are upon all lips when innocent; yet, to me, the most demoniac face that ever peered out upon a haunting world is better in its sombre gloom than that same face smoothed by a bad or mechanical retoucher. Beauty is expression, not chiselled features. A baby is not beautiful until it can notice its mother; then the meaningless bit of flesh is lighted up with a ray from heaven. That God-beam the photographer must catch; yet it is not a smooth surface, but a light breaking through torn-up cloud mists.

The other day I saw the photograph of a child, supposed to be a city waif. She was bare-footed and bare-armed, with a rent in her *pinafore*—a city waif with a pinafore! The photographer had studied his lines, and posed his model according to the rules he had learnt; everything was in its right place about that picture, but, like the mountains about Borrowdale, just a little too exactly as they ought to be. He had taken the trouble of dirtying the hands and face and legs, but I saw at a glance that, although it was all right according to art, it was not all right according to nature. She was not a real city waif, and to me, who had seen the real article, very far from it.

In Edinburgh, one winter morning, I saw a picture that needed no adjusting, only the camera, to render it immortal—a man out of work, saying good-bye to his wife and child before he went on the tramp. Where the Old Cross of Edinburgh used to stand (before the new malformation was put up), at its base in the High Street they stood—that group of two, with the speck of humanity in her arms; the man, in shirt sleeves, leaning against the railings, snow-laden, with his shoeless feet blue-black against the mud-coloured snow on the pavement. In his left hand he held a very small bundle, roughly bound in a red spotted rag of a handkerchief, while with the tattered sleeves of his dirty shirt he was attempting to wipe the eyes of the child, that poor

little pinched and smeared-faced baby, who was crying with hunger and cold. The mother who held it in her thin arms had turned her face from her husband to where I could see it as I passed by. She was oblivious to spectators in the silent abandonment of her own woe. A wisp of fair hair fell down from the old bashed hat upon her head, and hung against her clay-coloured cheek. Two tears, half congealed, lay just above the quivering lips. But there were no words of parting passing between those two.

In London one night, in the East-end, about the month of May, I saw another picture. It was down by the side of a hoarding covered over with gay-coloured placards, and over which a lamp shone. A man, a woman, and a little girl all huddled in a confused mass together. I could not see the faces, for they were hidden on their breasts, but I saw limp hands lying on the pavement, and the light night wind fluttered shreds of rags about. Presently I beheld amongst the passers a woman stop to look at them—one of those outcasts, all the more pathetic for the furs and silks that enveloped her. She stooped down to put a sixpence into the crouching figure's open hand, and for a moment bistre rags and cardinal silk flounce fluttered together; then she passed on to her sin, leaving them in their misery. The hand closed on the coin instinctively, but the brain was too apathetic to take in the significance of the gift all at once. A moment or two passed as I watched, then I saw the hand slowly lifted and the head listlessly raised; there was a dazed look into the palm, then a start into life, and, woman-like, a clutch at the arm of her husband. Then both heads were lifted to the light, and I caught an expression of wolfish joy on the faces, which I thought must have condoned for a deal of vice on the part of that unreclaimed Magdalen, as the pair staggered to their feet and dragged off the little one to where they could buy sixpence-worth of oblivion.

These were two pictures which required no arranging of lines or alteration of lighting up, although faulty according to art, perhaps. The humanity about them redeemed them; and it is pictures like these, to be found every hour, which the artist—be he painter or photographer—only requires to go out and secure, to make art immortal.

CHAPTER II. A STUDY IN LIGHT AND SHADOW.

MY subject—the Union of Painting and Photography—is not so short as you or I might wish it to be, yet I have tried to make it as terse as a subject so crammed with incident, and so exhaustless in matter, could be made. If you will try to endure it to the end, I trust you may not be disappointed.

Photographers, as far as I have seen them, are a jealous-minded race. They don't think enough of their art, or of themselves. They are too apt to think that painters despise them, while in reality the painters of to-day hang on to them as a drunken husband is apt to hang on to his good-templar wife during the festive New Year season, or, to be more poetic in simile, as a half-drowned sailor will clutch on, teeth and nails, to the hard rock, which may have broken up his rotten old boat, but now keeps him alive in the midst of the surf.

The painters of to-day have become realists, and photography is realism, or nothing.

A photographer, to be able to produce a good picture, must be a true painter in the highest sense of the word; therefore, a painter ought to know the right qualities about a good photograph, whether he knows the mixing of the chemicals, or length of exposure, or process of focussing, &c., or not; although, to be able to compete, the tricks of the trade have to be learned. Witness Sarony, Mora, and such men, with their fancy dodges and splendid effects, and Seavey with his unapproachable backgrounds.

Thus my title is almost superfluous, for painting and photography, requiring the same direction of talent, are already united; only it may be of a little service to hear a painter publicly avow the marriage which is so constantly being consummated on the quiet.

It is in your work, as in ours, the doom to be often annoyed with talented triflers who dip a finger into all the sciences, and are for ever ready to dispute the point with the originators—buyers of brains, who imagine that their cash gives them full liberty to find all sorts of faults, or suggest improvements upon the worker's designs; who will not buy unless their idiotic improvements are executed to the last letter, and who afterwards lay the whole blame of the spoiling of the pie upon the baker, when the guests condemn.

Having a direct object in view, I need not trouble you about chemicals or lenses, aurora lights, or secrets that you all now know much better than I could for years unborn, but come direct to what is of vital interest to us both in our wedded state-viz. the seeking how we may put as much as possible of the soul of nature, with her innate force of feeling and motion, into our pictures; the men, modern and ancient, who may best aid us by the examples and teachings they have left as a legacy to us; a quiet consideration of what they really have done for us; a right straight look at the men themselves, unbiassed by veneration or prejudice, with a consideration as to how much we have taken advantage of the legacies left to us.

The first aim of our investigation is therefore The Exact Imitation of Nature—*i.e.* the outward form and appearances of nature, the body, in fact, of that mystic Deity whom all men worship, no matter what is their dogma, whether they have a creed or whether they be creedless.

Secondly, The Feeling, Sentiment, or Sensations of Nature—how her appearance touches us, as we look upon her in the wealth and loveliness of her colouring; also how we may keep that sentiment alive in our light and shade.

Here the painter, with his colours, gets a better hand and a long start ahead of the photographer, engraver, and etcher; and it is here that, if those workers in light and shade can keep the sentiment as well as the painter in colours, they gain a double and richer triumph—the triumph of a racer who has been heavily and unfairly handicapped at the beginning of the race.

Thirdly, The Motions, Actions, Passages, Expressions, and Impressions of Nature. There both in photographer and painter the man himself is brought out, whether he is a trained mechanic or a born genius.

Lastly, The Perfect Image, the whole innate force, which is the spirit and soul of that matchless creation toward which we must all constantly turn (as the sun-flower turns or the daisy opens to the glance of day) for the life and light of our artistic beings.

Let us drop the weak word artist out of our consideration altogether. Personally I abhor it, as denoting nigger minstrel, sword-swallower, or that undefinable member of society who plays with foils and sable hairs inside a studio enriched with Turkey ruggery, old armour, and marble busts. Let us, who are workers, be plain painters and photographers, never heeding the

comforts of our surroundings, having only to do with objects as accessories to our work, thinking only upon the *utility* of every nick-nack we may have, aiming only at the result without considering the trouble or the inconvenience to the animal who is bringing it all about; every conception or experiment being an undiscovered country which we mean to find out and make our own—Stanleys or Thompsons with our Africas; Pizzaros conquering and annexing our Mexicos; plain, hardworking, earnest painters and photographers; brothers in one grand service—Art.

I think, at the present day, painters recognise this fraternal stand even more than photographers give them credit for doing; they know how much they are indebted to the camera for making matters lucid which were before obscure. Witness the galloping horses done by instantaneous process, the shape of waves in full action, the rushing of waterfalls, and the contortions of muscles in moments of great excitement. How many of the old masters knew what a horse at full speed was like! and what eye-openers to battle painters those photographs have been! None of the sea painters were able to draw a wave in all its subtleties and froth accessories as painters nowadays may do if they study the imprint of a flying second; we may also have clouds in their strata, as they actually are, with shadows perfect, in those artistic studies which, like the institution of Christmas cards, are coming more and more into vogue every year that we live.

And painters do use them constantly, whether they admit the fact or, induced by a false pride, pretend that they do not. I see in every exhibition glaring evidences of hay carts and field horses, yachts and ships of all degrees, blankly copied, with hardly any disguise, from the photographic studies suspended in the shop windows: clear photographic studies, faithfully drawn out, and in the painting knocked about a little, sometimes not so true as the original to nature, blurred and mystified into that obscurity which does for feeling with the crowd; the most original bit of painting being the man's signature who sells it, that being strictly his own, and not the copyright of either the photographer or the horse.

And why not? Clouds will not wait on our pencils and palettes being set; horses will not stand until we draw out a faithful enough study of their forms, nor ships pause until we get in all the rigging. The winds are against it, and the waves. The hours flying along and tearing down the sun-shadows before we have fixed one line of them on our paper or canvas join in the protest, jeering at our deliberation, and mocking us as slow-coaches, in these

steam-engine days, for trying to crawl on at six miles an hour, and dreaming that we can enter into competition with the mile-a-minute express.

The pride which keeps the artist silent, or makes him deny the charge of photo-borrowing, is an utterly false pride, and the sooner it is knocked out of sight the better for all parties. Why should we not correct our sketches—done for the sake of the colour and feeling, and not for the form—from faithful photographs? It does not hinder us from being original in the after-treatment, although it may save us much time in the elaboration of sketch-details. Why not save our precious time for something so much more worthy of it—the picture?

Hitherto I have wanted so much to be original that, from conscientious scruples, I would not use the photographic studies which some of my friends had sent me. I looked upon them longingly, and put them out of sight reluctantly, and so went down to sea-boards and meadows, catching rheumatics and toothache, and wasting hours upon hours, and many valuable sheets of Whatman's hand-made paper, trying to draw out all the riggings of ships, and the shapes of cows, losing the effect often in my endeavours to get the manipulation, and in reality not getting a hundredth part of what I might have got with half-an-hour's rapid dashing on of colour effects and a moment's focussing.

At present I know just a little about the art of photography, but I intend to make it my duty to learn a great deal more—enough to be able to sight a picture correctly; take and develop a dry plate, and afterwards fix a print; for I can perceive plainly that Time is coming on with rapid strides to the point when, along with his present utensils of colour-boxes and sketching block, the painter will require to carry his camera and stand, box of dry plates, and head covering.

And how proper it is that it should be so, a little experience will prove to every one. An old castle or abbey, or the view of a town, or even the markings upon the trees, would take us days to outline—the buildings of the town, the fret-work about the abbey and castle, or the knots and gnarling of the woodland—and even then they would be incomplete. To illustrate my meaning, look at even the most careful outline pencil drawings of Turner, one of the most delicate of outline draughtsmen *when he liked*, or the scrupulous and untiring delicacy of his admirer, Professor John Ruskin, with his pencil, and compare those efforts with the lines about even the most

commonplace photograph of a building or tree-trunk, and I need say no more on that point. The painter has lost the half, and distorted the rest; and although the drawing may appear more attractive at first sight, the photograph will be the better, for it embodies the first grand principle of a painter's training—faithful imitation of the object which he desires to represent.

Photographers are apt to labour under the mistaken notion that we do not recognise this plain fact of artistic necessity; but we do, and if we have not the manliness to own it, that is our cowardice and not our blindness.

Be content, therefore, when you go into exhibitions and see the misty result of your photographic studies in the realism of to-day hanging all round, that this is recognition enough of the obligations Palette owes to Camera.

To consider the first of our united art aims—viz., '*The Exact Imitation of Nature*,' as she appears to us and as she appears to others.

The eye is the organ to which we all appeal, and I do not know a more fickle umpire—except perhaps the ear.

Many people are colour-blind, yet not entirely so, and more is the pity, but just on one point, *like the sun-stroke of Sir Roger Tichborne*; and the worst is, they are not aware of the particular point, and feel quite put out if it is explained to them. They will think the man a fool who tries to prove them wrong, for if they are strong upon any point, it is upon that particular point. I have proved it dozens of times in cases of partial sun-stroke and colour-blindness. I mean, just a slight wipe-out of the mental slate, a blurring, or, as it were, a Dutch effect, in the case of sun-stroke; or a delicacy of perception a-wanting in the colour-blindness, a gauze veil dropped over, not nearly so apparent as the blue glasses, or the lack of distinction between red and green, for Daltonism like this ought to be palpable both to the sufferer and his suffering friends.

There is also a distortion of vision apart from nearness or longness of sight, which is a very troublesome agent to fight against for the producer of pictures: a little nerve gone aglee, through partial paralysis or an accident before birth, and everything is different to him from what it is to anyone else; or it may be that it is spasmodic and occasional in its effects, and then woe to the picture that comes under his lash (if a critic) at the moment when the twisted fit is on him.

Ten artists sit down to one landscape and make ten different pictures, and the camera drops in and makes the eleventh, like none of the ten, but wonderfully like the original, as those ten different pairs of eyes must testify, in spite of their varied distortions.

Ten different critics look at a picture and find out different faults, each praising as virtues the faults of the nine others.

Ten women will look upon one man, and ten chances to one they will all find different uglinesses about him, with the exception of the tenth, *whom he may have chosen*, and yet they will all unite in agreeing that she wasn't worthy of him; which clearly proves, I think, that this form-distortion of vision is only partial.

Realism is the passion of the day, both in writers and painters; and this passion photography is only too well qualified to gratify. To note down a scene, or describe an emotion, by the aid of its most minute outer symbolism, as faithfully and as free from complexity as possible, seems to be the greatest virtue and highest aim of the modern school.

The names which I would select as samples of this style of work will be those names which, by engravings and etchings, are best known to us, and so likely to be of most use in our search after excellent examples.

Amongst the old masters I would quote Albert Dürer, for stern realism, combining a symbolism and spirituality so refined that it is no wonder his qualities have been so long unseen by critics such as Pilkington, who says of him, 'He was a man of extreme ingenuity, without being a genius—in composition copious without taste; anxiously precise in parts, but unmindful of the whole, he has rather shown us what to avoid than what to follow.'

Rembrandt I would take next, as we all know about him and his powers, also because he seems to be the model chosen, but in few cases followed out correctly, by photographers who desire to produce striking effects.

David Teniers I would point out next, as a type of naturalism without much straining after force or effect, no elevating force or symbolic influence.

I take these three great names as samples, because their manners are distinctly separate, because their systems and tricks for reaching effect are easily penetrated, and because, while I am describing characteristic works by

them, and explaining as well as I can how they may be followed out with original force by photographers, you will be able, I dare say, to recall some specimens of their brush-work, and so follow me more easily.

All good original work is got from copying and following those who have gone before. I could quote scores of painters since the days of Dürer, Rembrandt, and Teniers, down to the present hour, who gain fame only through being Dürerites, Rembrandtists, or Tenierians, with a little of their own personalities thrown in, to make them masters. Dürer flung in and mixed up a part of himself (which he could not keep out) along with the training of Michael Wohlgemuth. Rembrandt hashed up Zwanenburg, Lastman, Pinas, with a host of others, along with the son of his own mother, to produce the mightiest giant of the art race, whom we all try to copy whenever we want to feel free from the feeding-bottle.

It is the fate of all great men to copy. Blake says, 'The difference between a bad artist and a good is that the bad artist *seems* to copy a great deal, and the good one *does* copy a great deal.'

Spending lots of time drawing after the antique and winning gold medals and certificates; fiddling over false niceties; trying *to finish*, when there is no such thing as finish in creation, far less in art; being so careful that they lose all freedom of action, freedom of thought, and produce *nothing*;—that is the rubbish they are turning out of the Government schools nowadays; students who labour five years at freehand outline, ten years at antique casts, and niggle the rest of their useful years amongst nude models in life schools, while the real active copyists are vaulting over their silly heads, and digging out niches to enshrine themselves in, down Time.

William Hunt, the Yankee, in his 'Talks about Art,' tells us about Dürer and copying in his own terse way thus: 'Albert Dürer, with an outline, knew how to make an outline look like a firm, full figure. He began with firmness, and finished with delicacy.... But he didn't get it in a day. Hercules may have strangled a serpent when he was a baby, but there was a time when he couldn't. "Dürer worked in his own way!" No! nor did anybody else at first. They all worked in the manner of someone else, in the way they were shown: Raphael after Perugino, Vandyke after Rubens. If Albert Dürer had lived in Venice he would have been a Venetian painter. As it was, he worked as the old German artists had worked.'

'The Lord and his Lady,' 'Melancholy,' and 'The Virgin and Child' are the engravings by Albert Dürer which represent his clear, concise style as well as any others of his works for our present purpose.

In the first picture, 'The Lord and his Lady,' we have a simple arrangement of straight perpendicular lines—the lady seen profile, with sloping unbroken lines of drapery; the lord almost full-face, looking upon her, a straight sword hung in front and slanting in unison with the folds of the lady's drapery; a plant at right side with split top, growing straight so far, yet inclining towards the direction of dress, sword, and figures; a tree-trunk at left wing with gnarling, repeating the folds of dress, with the figure of Death behind the tree holding up his hour-glass:—they are passing from Death's corner, yet by the hour-glass he knows that, as the shadows travel round, so surely will they both return.

The light and shade are simple as the arrangement, directly falling from above and to the left; the light divides the direct half of tree, dress, clock, and flower, and the other half is in broad shadow, a light foreground and light distance and a clear sky; all the shade relief rests about the central objects of interest. As a sample of unaffected masterly ease of management and restraint I do not know its equal; nor have I yet seen a photograph treated (although it might easily be so) in the same possessed way, except perhaps the first efforts of the amateur before he had learned how to manage his lighting up. If experienced men would only learn to come back to the effects of their days of ignorance, bringing their gained knowledge to rectify the defects *outside* the accidental effects; if old painters would only take lessons from the natural attempts of their little sons and daughters—how great we might all become, and how original!

'Melancholy.' This is a more complex composition, an arrangement of crowded shadow, worth studying for the effect of dying light, trailing from the folds of a woman's skirt. It is too much filled with symbolic objects to describe just now, and the great point of interest is the glitter upon the folds, the broken lines which make up these folds, and the universal gloom over the rest. It is not like the obscurity of Rembrandt, for every object is distinctly manipulated, yet from it Rembrandt may have got the first idea for the development of his style.

'The Virgin and the Child' I like for its extreme delicacy and lightness, and also for the power of reflections which it contains. The old house on the

other side of the river is a useless disturbance, and mainly useful in its historical architectural evidence, and also to prove that even the most astute self-critic may make mistakes and just work too much. How suggestive is that monkey at her side, chained prisoner like the struggling dove in the grasp of the mischievous Baby Christ—the dove, symbol of captured truth, and the infant with his humanity only as yet made manifest! I wish we could have a photograph with this subtlety of realism, this absence of shadow, this clear depth of transparency. It seems to me as if photographers could do it if they liked, and were not afraid of the public. That pale white subtlety, stealing gently upon us, not much to look upon at first sight, almost a blank, yet growing gaze by gaze, until we cannot let it out of our thoughts, like a white rose against a whitewashed wall, with the green leaves and the crimson stalk bleached vert-grey with the midday sun-blaze, and the shadow under it of the softest of purple greys.

I would like to linger over Albert Dürer and his influence, not only on art as regards painting, but on art as regards literature: Goethe working up his Faust; tales of mediæval chivalry; of demons and spirits, solemn, truth-loving souls beset by false decoys; knights sore tempted and yielding just for a moment, to fill out long years of repentance; honour ever rising up and choking love; love shadowed over by despair; death ever present and ever sweet as the surcease from labour and years.

But it would tire you, for we have it going on still, only much of the honour is forgotten and the tenderness of the love is brutalised; but we have the work, and the want, and the woe unutterable, with us ever, and for ever, and we who can will rush from it as the steam-engine rushes on iron lines, drowning the sounds of the wailing behind us in our own loud puffing, hiding the sight of the weeping behind us in the dense smoke of our own importance.

I turn from Dürer to Rembrandt, as from a nature refined and gentle to a nature rugged and strong, as from a woman to a man, whose firm hand I like to grasp even better than the tender clasp of the other.

Rembrandt, the master of painting—even more than Rubens—of etching and photography, who when better understood will benefit us all more than any one of the others, with one exception, which I shall name presently.

'The Painter's Mother,' a head with white cap, ruffle, and black dress, one of many which either he or his disciples painted often, strongly marked, a study in the modelling of wrinkles and reflections.

'Interior, with Woman plucking a Fowl.' The figure sits fronting us with face down-turned, a black cap casting deep shadows over the whole features, with the exception of a half-light playing upon the under-side of the cheek, and portion of the back of the neck seen from the white ruffled collar, open at the neck. Satin-textured body, with dull red sleeves, and amber lining on the upturned skirt; this is very dark green or black. She holds the fowl with one hand, plucking with the other, while between her feet rests the basket to catch the feathers. At the left corner lies a bunch of carrots, breaking up the copper Dutch pan behind; farther back is a basket supporting a board with flat fish upon it. Still deeper in shadow is a large boiler with earthenware jars and a chain hanging over; behind those again, a very dark background.

There is not much in this subject—a fowl half plucked and a harsh-featured woman plucking; the most commonplace incident, without moral, except the moral that life is very uncertain and mortality sure—in a hen-coop particularly. Without any pathos, save the pathetic tracing of those hard scorings of care on that matron's face; not much to make sentiment out of in an ordinary hand; what we may see any hour if we live where such acts are continued from day to day. Yet in the hands which have made it what it is, what may we, the lookers-on, not make out of it?

The secret of Rembrandt lies here exposed, if we can only read him aright. It is not the mass of shadow and isolated light which stamp the power and individuality of the man. These are only his tricks of trade, repeated when he saw how well they took with the public. It is the vigour and command of this master which strike us as we probe the breadth and extreme simplicity of his accessories. He is content with a bunch of carrots when they serve his purpose. The gigantic copper stew-pan would have been enough if he could have hidden a part of the exact circle; but he wanted the woman to stand out alone; the other objects were put in to support a blankness, as a little by-play, an incident by the way: the working woman is the aim of his setting up that large canvas. He got it all in an afternoon, the time she was plucking the fowl—that is, the master touches; the rest might be done by anyone.

To imitate Rembrandt properly, get hold of the first East-end basket-woman that you chance to meet—a herring or orange vendor will do; take her as she

sits, without arranging a single fold, adding to or removing one iota about her; take her in the street or in the close, or as she squats down inside the half-darkened doorway of her own little shop. She can neither have too little nor too much about her if she struck you distinctly while you passed as being picturesque. Never mind the lighting, and don't think to be original; as she stands, or sits, or squats, she is the woman for your camera; out with it, and secure her before she can wink or know what you are up to, and you have caught the whole secret of Rembrandt's power and realistic talent.

In hatching and touching your plate, which to me seems to represent the second working, think upon all the dodges of the etchers, Haydon, Hamerton, Herkomer, Whistler, &c. If you have a chemical to eat down certain parts of it broadly, leaving the prominent parts (be sparing of prominent parts) standing out dense, do not niggle with your pencil-point over-much, except it is to blur out an accessory which may be too distinct. I do not know much about printing photographs, yet I am inclined to think that it is here where the genius of the photographer may be brought out. If I were a photographer I'd never for a second leave a plate while it was printing. I'd try all sorts of dodges upon the sun with pieces of paper having little eccentric holes torn out where I wanted an artificial shadow to fall across my plate, by exposing the print altogether at times, so as to mellow any extreme lights, painting touches of white on it to bar out the sun altogether where I wanted a mysterious gleam, whether it was on my picture or not, and never rest until I had made it my own. I may be wrong, of course, in all this; but it is the idea which now strikes me; or all this may have been done already, or considered *infra dig.* or illegitimate; yet here, I think, as in the treating of a painted picture, the photographer can liberate himself entirely from the trammels of custom, and never be at a loss for fresh tracks.

In landscape photography I constantly observe good pictures rendered imperfect through the fatal power of the camera, which must print every object before it, and yet in the printing even more than in the sorting of the plate I think much, if not all, of this might be obviated by a careful study and following up of the tricks of Rembrandt; if it is the foreground which is too plainly marked, why not take another foreground plate, and, clearing off all not required, place it over the other plate, and so let the sun strike through both and blurr that corner? or make a dark shower cloud as in the engraving 'The Three Trees,' by covering boldly portions of the plate with paper and allow the rest to print darker; or by adroit covering and exposing, simplify the whole arrangement and create divisions where you want them; a ray of

light, or a part blackened, or any device that occurs to you, which is what we call inspiration?

The magic of Rembrandt rests in this—that he seldom creates, *but he takes advantage of circumstances and local incidents* to intensify the story he is telling you.

To illustrate my meaning by three short quotations from celebrated authors, whose tragedies are intensified and minutely expressed by the working up of the commonest accessories, as we see in every tragedy of daily life—a clock striking at the tensioned second; or a mouse peering out of its hole; or the crack of a distant whip; the rumbling of a cart; a laugh or a careless oath heard outside; something unimportant seen or heard that fixes it all into its compact run or place; the sledge bells of Mathias in the Polish Jew; or the ragged stick of Eugène Aram.

My intention in giving these quotations is to prove to you how writers know the value of common objects, and how few of them are wanted for the purpose, so that in choosing our accessories we may so choose that the link is carried on, yet nothing uselessly put in to distract the attention; the object being to draw the eyes and thoughts, *for a moment*, from the main act, so that we may return again better prepared for the tragedy.

Zola, that Rembrandt of modern French literature, in one of his novels, 'La Belle Lisa,' describes the return to Paris of an escaped political martyr called Florent.

Florent, having passed through fearful sufferings, is picked up exhausted by one of the Paris market women and taken to Paris in her cart. He is in a starving condition, but, being proud, will not tell the woman about his wants, and, leaving her, gets into company with a hard-up artist called Claude, who, although also hungry and *sou*-less, yet is carried away by the artistic glow of light and shade and wealth of colour about a coffee and soup stall which they pause to admire.

'I tell you,' says Claude, 'a man should paint what he sees, and as he sees it. Now, look there. Is this not a better picture than their—consumptive saints?'

'Women were selling coffee and soup. A small crowd of customers had gathered round a large kettle of cabbage soup which smoked on a tiny brazier. The woman, armed with a long ladle, first put into a yellow bowl

thin slices of bread, which she took from a basket covered with a napkin, and then filled up the bowl with soup. There were clean market-gardeners in blouses; dirty porters with their shoulders soiled by the burdens they had carried; poor devils in rags—in short, all sorts of people—eating their breakfast, and scalding themselves with the hot soup. The painter was delighted, and half shut his eyes to compose his picture. But the smell of the cabbage soup was terribly strong. Florent turned away his head—the sight made him dizzy.'

Here we have a Rembrandtesque study of hunger and endurance, with all the accessories put into quiet order.

The second sketch which I take is from an essay by Walt Whitman on the death of President Lincoln. We all know how he (Abraham Lincoln) was shot in the theatre, and in those few jerky commonplace sentences Walt Whitman, the American Michael Angelo of words, presents to us as grim and gruesome a picture as I know anywhere. It has more of the loose but massive work of our English realist, Millais, about it than the compacter work of Rembrandt. It has a day-light or surrounding gas-light effect about it also, and little shadow or mystery, but it is to me blood-curdling in its startling distinctness.

You have here a scene as filled out with detail in the light as Albert Dürer's 'Melancholy' in the shadow. Walt Whitman has not omitted a single object which impressed him at the time—in fact, he tells us the whole dire tragedy by the aid of animate or inanimate objects not at all connected, except by association, with the murder; and this I wish you to remember strictly—how, by the placing and building up of objects, chairs, tables, flags, as here, all leading out from the centre of sight, which is the tale, you may suggest a deed without showing the main actors of it at all. Witness here that the principal figure, Abraham Lincoln, is never seen.

The third illustration which I take is from that well-known poem by Bell on Mary Queen of Scots. I choose the closing act, her execution, as it embraces within the lines leading up to the climax the incidents of the verses going before, and because it is here that you see distinctly surrounding the principal character (our unfortunate Queen) trivial and more important items, all leading up to the loneliness of the victim and the fickleness of fortune.

In the centre of the hall is placed the block and the masked headsman, axe in hand. The scene is decidedly Rembrandtesque in its light and shade; to be treated as Rembrandt has treated his 'Descent from the Cross.' A strong light falls upon block, axe, and headsman; the rest is in shadow, the carved woodwork and tapestry hangings of the hall fading off towards the distant door; as the royal victim and her dog near, she comes from the shadow which covers her attendants and other witnesses into the full glare which falls upon that empty foreground; and, as it streams over her pale face and grey hair and becomes muffled in the thick folds of her velvet dress, the picture is complete.

The third picture of Rembrandt's is of little use to us, so it is needless going into detail with it. It has been misnamed 'A Jewish Bride,' as, from the general outline of the figure, loosely holding a bunch of flowers in the left hand and the symbolic vine-twisted staff in the right, we must conclude that the honeymoon has been for a considerable time passed, and that another joy awaits the expectant husband. It is a portrait of the painter's second wife, and a very lovely second wife she must have been, with her soft fair tresses, rich dark eyes, creamy complexion, and seductive chin—a much nicer Dutch frau than a Jewish bride.

But before leaving this master I would like to call your attention particularly to, and ask you to remember, 'An Old Woman.'

This is more in the distinct manner of Rembrandt than his 'Jewish Bride,' who might have any other name attached to it as well as that of Van Ryn.

Here the old tanned face is seen in profile; the square-cut nose and harsh mouth, subdued by toil, sullenised by hardship, with early hours when the frost-breath hardened that parchment skin: a pitiful face, without one ennobling trace upon it.

Just such an air of patient suffering as we have seen of a winter morning on the stooping, shawl-bound head of the aged hag raking amongst the cinders and offal of the street. It is thankless toil which does this sort of painting and carving—a spring-time of labour and lust, a summer-time of labour and curses, an autumn-time of labour and treachery, and a winter-time of labour, starvation, and neglect. Is it not all equally pitiful in its progression as we watch the stages?

The girl with her load making merchandise of her love; the woman with her load toiling on for the thankless male; the mother with her load selfishly laying as much of it as she can upon the delicate shoulders of her young offspring; and that toothless old hag stooping down amongst the shadows, square, gaunt, hopeless, resting from her load alone in her tenth hour, crouching amidst the shadows with the ashes of her wasted past crowning that hoary, honourless, neglected age.

This is passing realism and getting into the sublime, and this is what the gross, coarse, miserly old master has done, with his innate force and living soul, while his strong, bold brush, with its low, sad tones, has painted an obscure interior and an old woman sitting brooding in the cold and dark, clad in a dirty white-grey cloak, with a dirty grey skirt faded to grim black-grey with newer black, patched sleeves, a few jars on a darkened shelf overhead, all dark and hopeless except where the one ray starts out that gaunt profile and what is seen of the shrivelled neck.

Teniers.—I take David Teniers after Rembrandt as an instance and example of successful and easy grouping; I take him as the type of a school embracing a long list of painters ancient and modern—Wilkie, Faed, Orchardson, Cameron, Pettie, &c. &c.; and why I prefer him to our own Sir David Wilkie is not so much that Teniers was before Wilkie, because Teniers was by no means the first in that line of business. If you can recall the delicate and silvery half-tones and open composition of 'La Tourneuse,' and compare this with the hot colouring, slushy handling, and forced composition of 'The Penny Wedding' and 'Blind Man's Buff,' we must agree that here Teniers has the best of it. Yet I would by no means decry Sir David Wilkie, except where comparison is forced, as in this case; for I consider Sir David Wilkie, Tom Faed, and Orchardson to be the very best models a painter or a photographer can have for the composition of groups.

I am not at all prejudiced in favour of old masters or of old things, or big names, or advertised brains or dry bones; rather the reverse. I like young flesh and fresh blood, quick-beating pulses, and impetuous motions. I would rather have a living mistake than a dead perfection any day; yet, when I see the old ones far ahead of the young ones, it is both a duty and a joy to bend the knee and adore the vanished past.

Orchardson and Hugh Cameron have come up the truest to the silver and opals of Teniers, and for chaste deliberation and simplicity I can commend

no one before Orchardson: he always stops painting just at the point where people should stop eating and drinking—the point this side of repletion. Study his best-known examples—Christopher Sly, from 'Taming of the Shrew,' some articles of clothing and a pair of shoes in the left-hand corner, to continue the slanting line of feet of the servants waiting on Christopher; a walking-stick lying in the same line as the feet of the negro, and people behind the screen; a sheet of paper on the floor farther in takes exactly the same line of direction, and the eye is no more troubled with details; we can all laugh without let. In the 'Queen of Swords,' a more crowded composition, the ground lines are the same, with the queen forming the point of the angle and a clear foreground, with the exception of a fan that carries on the same lines. In that scene from 'Henry IV.,' Part I., Prince Henry, Poins, and Falstaff, we have one of the simplest, openest, and most refined specimens of humorous composition on record. A straight, horizontal line of tapestry, broken up at the exact limit by the burly hind-part view of Sir John, the buffoonery expressed in that capacious broad waist-belt, and the rounded folds of the doublet below it, is worthy of the mighty creator of that inflated sponge, Falstaff. A table and chair behind it keep the horizontal line, while relieving the emptiness of the floor between Falstaff and his companions. The wall starts out towards us at an angle, while, along with a chair, the Prince and Poins keep within the vanishing lines from the point of sight, which is exactly in the centre of the back view of Falstaff's waist, so that we must look (whether we like or not) first and last at him, even although, with Orchardson's usual love of refinement, he is modestly cast into half-shadow.

They say Thackeray could draw a gentleman and Dickens could not. I deny this sweeping assertion in the existence of Mr. Chester of 'Barnaby Rudge'; but one thing I do think, which is, that Orchardson is the painter who gives us the nearest approach to the easy insolence and *bonhomie* of a well-bred man of the world.

To return to Teniers (for a moment in passing), I cannot bring to mind one of his pictures which I have seen that could in any way be improved in the composition, added to, or taken from; every accessory tells its own portion of the general story, and this I would once more point out to the composer of a picture, along with a few simple laws which occur to me as I write. The principal object is the first object which rises up before the mind's eye, and fixes the composition when the story is heard or read, therefore the main object to be considered and first set up or drawn in—as the figure of the queen in Orchardson's 'Queen of Swords'; the philosopher nearest us in

'Bacchanalian Philosophers,' by Teniers; the two front figures in Rembrandt's 'Night Watch,' one dark, one light, the dark one put in by Rembrandt first; and the child with its cart even before the lighted-up woman and child who come before 'The Blind Fiddler,' by Wilkie. There is too much in this composition, particularly that group of foreground objects, which bear such evident traces of having been so carefully selected and placed in such a variety of artificial carelessness—watering-pan, cabbage, box and utensils, basin, stool, with little bat, and knife, placed so exactly as they ought to be, like the hills of Borrowdale—all being, after consideration, painty improvements, never dropped upon accidentally and not at all required. You will find nothing of this sort in Rembrandt's pictures, or in Rubens' (lavish though he is), or in Teniers', and seldom in Pettie's or Orchardson's. In Vandyke's you may, or in Wilkie's, because both Vandyke and Wilkie, being Court favourites, permitted their own individuality and good taste to be oftener biassed by the buzzing of the gartered insects about them; yielding to make this or that improvement to suit a foolish patron, until their own gifts became obscured, and their taste perverted to the level of a pair of Court breeches. Rembrandt and Rubens were strong enough men always to lead the fashion, and too strong ever to be led. But the times are changed with us now, so that I do not think there is any danger of Orchardson getting spoilt by good fortune; he is not in any way hurt by it yet, at all events.

After we get the first object set up, the others all fall into place to suit that central or main object, and this rule holds with the arranging of light and shadow, as well as form—one minute centre of light round which the half-lights range, and the deepest shadow where you can best afford it. The central form, the central light, is of paramount importance—all the rest are matters of convenience, chance, and discretion.

Think less about what you may put in to help your picture than upon what you may keep out, to give it importance and repose.

Every sitter has a fine point about him, or her: find it out—the best side of the face, a nice arm, or good hand; they will reveal it to you unconsciously before you have sighted them—and make that your first object, and all the rest subordinate and to help that out.

Don't seize two points in one model; decide which is the most useful, and take that; without regret, discarding all the others.

It may be that the only good bit is a hat, or a feather, or a pair of gloves, or a brooch. The point that first attracts your eye pleasantly is the point upon which to make your centre of vision, and around which you will arrange the rest. If it is an article of dress, of jewellery, then bring the light to bear upon it, and make all the rest in half-shades.

Study nature for ever, if you would have any photographs you take different from the last photograph. Never take a sitter at once; leave them alone to knock about your studio while you pretend to be sorting something else, but watch them unawares: you will see a natural touch before long, a peculiar habit which they are not aware of, but by which many of their friends know them. Fix on that as your character keynote, and work up features, position, and accessories, so as not to lose sight of this peculiarity; and with this borne always in mind and a good knowledge of face and neck anatomy, without which I cannot see how anyone can touch up a negative properly, I know of no reason wherefore a photographer should not give us as complete a character study as any painter, ancient or modern, from Millais back to Albert Dürer.

Yet before that state of perfection can be acquired, permit me, as one of the public and also as a frequent sufferer, to enter my protest against head-rests and long-sighting, to those who still practise these abominations. No natural expression or easy posture can ever be gained until instantaneous plates are used for everyone. Before they can well settle in their self-chosen places and posture, have them down and risk it—the chance of a spoilt picture is better than a conventional position.

Also this debasing system of smoothing away wrinkles, and blotches, and character traces. I never can see a real harsh, wrinkled face nowadays, except in some of the tintypes.

Of course I know the cry is raised that the public will have those wax productions; but as one of the public I have not yet had my own likeness taken quite right. For instance, in repose, I hang my head on one side, and I have always been made to hold it straight up, like a soldier at 'attention.' Again, my nose is neither of a Greek nor Roman caste, and yet I never do get that nose put in as I see it in a mirror, or as its humpy shadow is cast upon the wall; or, as a gentleman once closed up a wordy, if not very convincing number of reasons against my having the qualities to make a

poet, painter, or passable labourer, by exclaiming, 'Why, just look at your nose; did you ever know a clever man with a nose like that?'

This photographed nose of mine has afforded me and others some amusement; sometimes it has been so refined that I fell to reviling nature for being so far inferior to the artist who finished it off so well. Once it came home a splendid Roman, with the light upon it so intensified by pencil-work that it stood out in bold enough relief to have won a Waterloo, if big noses could have done that. I have one portrait, which I am keeping to leave to posterity: it is so Byronic and spiritual that future young ladies will no longer wonder why my wife married me. This refined likeness and my love-songs together ought to do the trick.

Yet I have some photographs very near perfection: one representing my two little daughters, done by Tunny. Professor John Ruskin writes: 'The face of the child on the spectator's right hand is the loveliest in expression I ever saw in a photograph.' Also some by my friend Mr. John Foster of Coldstream cattle-pieces, and landscapes breathing of balmy atmospheric effect. He gets up to work outside at three o'clock on summer mornings, the hour when nature is like a blushing virgin, all dewy loveliness and purity.

In France and England there is a school rising, who with the brush are trying to compete with the camera—*the Impressionists*, who, along with the camera, are yet fated to produce a great revolution in art. They aim at giving the impression, effect, or sensation of an instantaneous action or emotion or phase; not the phase exactly, but the swift impression which it leaves upon the mind of the spectator, with form, as it were—that is, with paints and brushes striving to embody the soul of nature, and when the two are joined the result will be *perfection*.

To finish by bringing up the name which I have hitherto kept back, the exception, about which some time ago I promised to tell you: the sweetest, tenderest, mightiest art soul that ever was chained inside a mortal body, and prompted the fingers to move as it wanted; the purest, saddest mind that ever writhed neglected and found its reward so late, the soul now free and stirring up a crowd with its pathetic activity, to be like it pure and true—I mean *Jean-Francois Millet, the French peasant painter*. Mr. Hunt says of him, 'For years Millet painted beautiful things, and nobody looked at them. They fascinated me, and I would go to Barbizon and spend all the money I could get in buying his pictures. I brought them to Boston. *What is that horrid*

thing?" "Oh, its a sketch by a friend of mine!" Now he is the greatest painter in Europe.'

That is a painter's verdict about a painter.

One of his pictures is vivid in my mind just now. There is a print of it in that wonderful illustrated magazine, 'Scribner's Monthly,' where engravings look like paintings or idealised photographs.

It is called 'The Sower,' the dim figure of a labourer scattering seed over a ploughed field with one hand, and holding his apron filled with embryo life in the other. In the distance, and lighted up by the sun, a team of bullocks are dragging the plough, and a flight of birds over beyond the seed. That is the whole composition put into bald words.

But as it has been rendered by this painter, it is an embodiment of all which I have tried to explain, the spirit and body of living, working, suffering nature.

What would I not give (if I had it) to see a photograph done like that! and it can be done if you labour enough, know enough, and feel enough.

'The Sower!' As I look upon it I am drawn into it, mesmerised and rendered clairvoyant. I am *en rapport* with the freed spirit which has left along with the delicate aroma of its departing wings a portion of its own personality, its own immortality—vague and tender—greater than Raphael, or Rembrandt, or Albert Dürer, for it has taken the deepest root within humanity.

Tenderly I look upon it, not too boldly, for it seems vibrating with a sensuous existence; it clutches at my heart—sinews as it reveals the parables of Christ, accompanied by sobbing notes of melancholy spirit-music; the far-off strikings of angel harp-strings, indefinite but ravishing.

And the painter's body, that St. John face, with its misty development of hair, lies under the earth. A maddened stag was driven by the hunters and the hounds over the garden fence into the snow-covered garden on that January morning of 1875, past the dying man's window, and ruthlessly slaughtered under the eyes of the dying man—yielding up its noble life for a bit of sport; the hot-red blood sinking through the cold, white snow, and soaking into the covered hearts of the green plants beneath. One up-turned glance of the glazing eyes met the down-turned glance of the glazing eyes, and so, filled

with despair and pity, two souls—the soul of a stag and the soul of a painter—drifted out into the morning light.

CHAPTER III. THE PRIMARIES: YELLOW, RED, AND BLUE.

I. AN APOLOGY TO THE AUTHOR OF 'MODERN PAINTERS,' ETC.

WE may love a man for himself, and admire his gifts, and yet differ altogether from his beliefs. We may go fifteen miles out of twenty with a guide, and turn off our own way the remaining five.

Surely it cannot be called inconsistency to go the fifteen miles and break off at the five; to revere the genius of John Ruskin and love his character, and yet take a stand against him when he directs painting! to coincide with his abstract theories of art, and oppose his practical hints! to praise him in the preface and blame him in the pamphlet!

This is a paradox which the student of man may easily comprehend. The exhibition of vanity, or meanness, or pettiness which last year may have filled me with just indignation or contempt, this year may be met in my mind with over-balancing excuses and reasons. I was close upon it when it loomed up, and it looked a mountain, hiding with its black shadow all the rest; but my distance of to-day has reduced it to its correct size, a dirty mud-heap at the foot of the mountain of nobility,—or the wisdom of the ages has added another year to my growing mind.

Yet I do not regret what I have said, for if we cannot pick the beam from our own eyes, is it not something that we are able to point out the mote in the eye of our brother? It is a compliment which we expect him to return by helping us to clear the more ponderous encumbrances from our sense of vision.

John Ruskin I regard as a master at whose feet no man, however strong, need be ashamed to sit: one as nearly the ideal man as we may expect frail humanity to be—self-sacrificing, devoted, single in the pursuit of his object; microscopic in his vision (herein lies his fault as a general teacher—*he cannot stand far enough back from his picture*), seeking to the core before he will be satisfied, becoming the disciple of the man he would criticise, never trusting to a casual glance of the subject he would describe, going patiently all round it, getting into it if he can. A word to trust as you might the Spirit of Truth—*as far as he can see it.*

He is a bigot, being in deep earnest, as all reformers must be, *having only one right road which they are treading*, but (I put my finger on the weak spot) he has disciples who are too completely satisfied with him, who, having fallen in love, have become blind, and he has the weakness to be satisfied with their satisfaction. The gold is pure which he has refined, the armour is bright which Faith has clasped upon him—but there is a red rust that will get upon the brightest armour if the damp breath of adulation be allowed to rest upon its surface, the arrogant vanity which eats into the soul.

As a philanthropist and moral leader, as a poet and beautiful example, set up John Ruskin.

If the world could follow it, the shepherds more than the sheep, then would it be nearer the standard set up by the Founder of Christianity, further from forms, falsehoods, luxuries. But the world has its own standards of morality, as he fixes his about art; only, John Ruskin is sincere: but, alas for the others!

He is wrong from my point of sight as regards painting, therefore I say so; he is not all gold, but so great is my love of the gold that it forces me to hate in proportion the clay; but would that I could walk in his footsteps for all the rest!

II. THE PRIMARIES: YELLOW, RED, AND BLUE

I dare say you have all stood at times to look at a street showman throwing up three balls in the air, and spinning them about from one hand to the other.

I wish that I could demonstrate this feat, but unfortunately I am not clever enough, neither have I been able to find any friend who could do it, else it would have been a great pleasure to me, and I doubt not also to you, if I could have aided my symbol by introducing to you at this point the model of some long-haired gentleman, with his symmetrical person glittering with spangles and bright textures, who, tossing up the yellow, red, and blue balls, would thus have added amusement to instruction. However, since I have not this artifice to help me, I must trust to your memories of such a sight as I go on.

Yellow, red, and blue: these are the three colours that I wish to begin the game, and with which you are likely also to end it.

The showman pitches up the coloured balls, and as they slowly cross one another we can trace their course and local tints perfectly, even while we are soothed with the harmony they produce all together. Red passes yellow, and an image of orange flashes in front of us, even while we see both red and yellow quite distinctly apart; red passes blue, and purple at once dashes between the blue and the red; yellow passes blue, and green is the result.

Yellow, red, and blue are the primary colours; orange, purple, and green are the direct mixtures of the primary colours, or secondary tints.

The showman gets animated, and the three balls are sent spinning rapidly from hand to hand: they seem all to be in the air at once, blending and dashing about each other until there is no red, or yellow, or blue, no distinct orange, purple, or green, but a thousand indefinite shafts and ripples of colour. Is it red, blue, green, orange, purple, yellow, or gems and sparkles of fire? They are only three, three that are a host, three that have become brown, grey, black, all sorts of browns, every description of that subtle and endless grey.

Can the painter do any better than imitate the street showman with the three colours? Start fair, mix slowly and decidedly, get animated, and dash along, with his entire heart in his work, some thought in his head, and his eye steadfastly fixed on nature, and nature only, while his fingers run over the keyboard to the music she sets before him. He will not require to trouble himself about much else, for it will all come out of the mist in very good time, when he has learned the trick of keeping the three in unity and motion.

The child, when he gets a paint-box, as a rule, begins quite right, although he does it unconsciously. He will paint his picture-book with a red face, yellow coat, and blue decorations. Most likely you will find him disdain all mixtures, except perhaps green, which impresses him as nice—no doubt from its association with the fields, where he likes to run about and play.

The savage, with his tattooing and war-paints, does the same exactly, with the superior significance of his symbols: every twist of the ornament meaning a grade or a power, every streak a motive or a threat. His gods are reverenced only as the mementoes or symbols of the unseen or divine, not because they are stones or sticks, as we so often misunderstand heathenism.

Old Egypt stands to-day, mighty monument of the grandeur of simplicity: with its solid works that defy time, its glaring colours that defy criticism.

Assyria comes after, with her purples, her gold, and her greater refinements. 'White, green, and blue hangings, fastened with cords of fine linen and purple to silver rings and pillars of marble: the beds were of gold and silver, upon a pavement of red, and blue, and white, and black marble.'

These are ladybird wings that send us fluttering back nearly three thousand years, to the hanging gardens by the Tigris, the broad walls and the open streets where the war-chariots jostled and the broad moon hung like a golden lamp between heaven and earth, and mingled her silver shafts with the ruddy sparkles of the perfumed torches, as they shivered and vanished into the darkness of the shadows of the painted boats, down by the porphyry steps that led from the old palace of the king.

Is it the sound of the instruments we are listening to? the voices of the singers? the tinkle of the silver ornaments round the ankles of the dancers? the laughter of the drinking guests of Ahasuerus?—or the snapping and snarling of the jackals over the few spare bones that the last caravan for Baghdad has left on that earth-mound by the river at Mosul?

Egypt stands the queen, with her ageless pyramids and her sphinxes, because Egypt came up first with her first principles in art and science, to which, as we gain knowledge and confidence in ourselves, we must return.

The youth grows out of his pinafores and his first paint-boxes, he gains a *partial* knowledge of art, and like us all when only half educated on our subject, grows arrogant and developes into a very fierce critic.

He also becomes a fine customer to the art-colour merchants, fills his boxes and palette with every conceivable colour that is made, particularly the more expensive sort; cadmiums and rose madders are his delight; he wallows in paint.

He has become so very knowing that where poetry may have been able to fire his fancy before, only paint can now content him. If pre-Raphaelism is the fashion, he will lay in a set of sables and pick away at little threads like a weaver until he is half blind; if it is the low-toned school he affects, then daylight becomes obnoxious, sunlight abhorrent to him; he riots in November fogs and dismal rainy weather, grovels in shapeless symphonies, and the dingy harmonies of the Dutch.

I have tried to like the pre-Raphaelite school, because the man whose word is considered law beyond dispute has said it is the right thing in true art. I have seen Holman Hunt's great picture, the 'Shadow of the Cross,' and could see in it nothing but hard lines and forced symbols as hard as the lines. In Millais' picture of 'Effie Deans' I saw a fair young girl with a world of hopeless woe in her face that brought tears to my eyes. In Hunt's 'Boy Christ' I saw nothing but china-blue eyes and hard little touches, hair like bits of wire, and all devotion worked out of it by the multitude of its pitiful details: I saw time and drawing and infinite work on it, but nothing else. I never saw the original of the 'Light of the World,' but I have seen engravings from it, and although five hundred greater men than John Ruskin were to write that it is 'the most perfect instance of expressional purpose with technical power which the world has yet produced,' I would hold to my own idea—that, if it is painted as the 'Shadow of the Cross' is painted, it is no more than a man dressed in Eastern costume standing at a door with a lamp in his hand, a few creepers beside him, and all worked to death with hard little lines, without anything exalted about it or wonderful in its composition.

There is a world of false humility and gross want of self—assertion in this weakness of bending down to the opinions of acknowledged authorities or time-honoured superstitions, particularly in matters to be seen, as pictures or statuary. The old masters are regarded as infallible, yet in the exhibition of autotypes from the Queen's drawings from old masters, at one time exhibited at the Museum of Science and Art, Edinburgh, I saw many samples of bad drawing, weak handling, timidity, slow-dragging invention—all that marked the draughtsmen as faulty mortals in spite of their great names, and nothing in the whole collection to prove them any greater, but rather less, than our modern men, even although it does approach blasphemy to say this.

Speaking of low tones, I must confess to a fondness for this fascinating affectation. Jozef Israels is more than nice, although I require the mist which gets into my eyes when I try on a pair of spectacles before I can see outlines so soft and hazy, and colours so undecided and sombre, as his are. Corot I cannot see to be the prince of landscape painters, although the critics did call him so, if the pictures which they were then lauding to the skies are samples of his princely style, for I could see nothing more in them than a lot of dirty scrubbing about with his hog hair—and not too much paint wasted either.

To a certain extent this low-toned school seems to have reason on its side, for when we compare our scale of colours with the scale of nature, we find how limited we are, how boundless she is.

White is our only semblance to light, and what a leaden symbol it is when we regard the brightness of our example!

Black is our deepest dark, and how shallow it is when we try to look into the depth of the shadows about us!

And so it seems but right that, being so utterly unable to reach the heights or the depths of what we wish to depict, we ought to send back and keep down every step or key of our board in the same proportion as our lights and our darks are—make our picture, in fact, not so much the imitation as the dim reflection that we see in a window sometimes when there is a dark cloth hung behind it, or in the camera obscura.

Were I comparing styles, I would say that Turner struck a high note in his scale, and rippling up lost himself in white.

Rembrandt struck a low key, and went out of sight in his blacks.

The low-toned school strike a faint half-note, and playing falsetto, lose themselves in dingy obscurity at both ends, never venturing very high or very low.

All are right from their own standpoint, but the Turner and the Rembrandt schools are nearest truth, because they look straight at nature and not on her reflections; and because, as our whites are already so far below nature's light, the sooner we strike our nearest approach, the sooner we shall arrive at our imitation, and *vice versâ*.

To return, though, to our paint: I would fain ask you to regard all beauty as so much mixed colour, something in the same way that the youthful anatomist sees only a lovely dissection in the arm or face that may be sending some other sentimental youth into poetic fits.

I here quote a little from John Ruskin—a man noble and self-sacrificing, whom I can admire, not blindly, like a reasonless lover, but with the qualified reverence of a sensible helpmate. I like to fall in with the fashion when I can. In writing on colour as the test of a painter he says:

'If he can colour, he is a painter, though he can do nothing else.... The man who can see all the greys, and reds, and purples in a peach will paint the peach rightly round, and rightly altogether; but the man who has only studied its roundness may not see its purples and greys, and if he does not, will never get it to look like a peach; so that great power over colour is always a sign of large art intellect: every other gift may be erroneously cultivated, but this will guide to all healthy, natural, and forcible truth. The student may be led into folly by philosophers' (the worthy Professor here holds up unconsciously the red light against his own dangers), 'and into falsehoods by purists, but he is always safe when he holds the hand of a colourist.' ('Modern Painters,' vol. iv. part v. chap. iii.)

The young man is perfectly right to revel in his many colours as long as he can, to dabble about with them to his heart's content, send his shafts of madder and cobalt, terre verte and siennas, and all that he can range out in battle-order, across his canvas. Time mellows painters as it does paint, and where the colour offended them in their lavish youth, in their riper manhood they see, beyond this, many qualities which they never thought of looking for before.

I think a painter is about the very worst critic we can set before a picture; perhaps this may serve as some sort of excuse for the faults of Ruskin. He will be able to dissect the picture, tell you how this part has been worked, and with what, but he can hardly stand on impartial ground, the only position for a judge or critic.

If his forte is colour, he must stop dead at this, and because his sensitive and cultivated taste is offended by some flaw in his particular hobby and firmly fixed habits, he will get no further, and see nothing else; just as a sensitive ear will be offended by a jar in the playing, and lose in the irritation the whole of the composition and thought.

You say, But a picture ought to be perfect. True; so ought the man who has painted it, and perhaps would have been had Eve not eaten the apple.

I never saw a perfect action in my life, far less a perfect picture.

And so also with the pre-Raphaelite; he condemns the bold and broad style, and the rugged painter sees only paltry crotchet work in the pre-Raphaelite. They are all right, and so of course it stands to reason that they must be all wrong to each other.

However, to return to our picture on hand. We have gone over it with our chalk, charcoal, or pencil, and in doing so we must try to be very particular in drawing it thoroughly. First, we will block in our subject roughly and slightly, as a sculptor would begin to hack out his stone or shape his clay. It does not make any difference whether it is a landscape or a figure we are aiming at; we must begin it first with a few marks of distance, put it into squares, divide it with straight lines, measure it with our eye in its broadest sense, box it up, and put rigidly from us all temptations at this stage to enter into details. Leave all the fine curves until we are sure that we have room for them with our square lines; a rough touch for a nose, a mouth, a branch, or a house, it is all the same, and all that we require for the present; more will only distract our attention from the duty before us, which is the exact proportions of the masses, and the position they hold towards each other.

Second stage—go over it carefully bit by bit, use our mental point, measure it all again with our eye, compare very minutely this part with some other part, the breadth of this window or nose with their length, and the breadth and length of something else; look at the relative position of two parts, the angles of imaginary lines that you mentally pass between them, and so on, and so on; in fact, be our own harshest critics, and leave not the smallest space unmeasured or unthought of, previous to our filling it in.

Next we go into details, and by degrees walk carefully over our clumsy outsides, cutting gradually in farther and farther, until we have lost the square angles without losing the firmness which they have given to us, and with perfect assurance and ease dash in our beautiful quivers and curves, not with the harsh, hard, clear lines of a copy-book, but with the soft, broad, breathing lines of nervous talent.

We are now ready for paint, so we will begin to set our palette. We start with white, and put it nearest to the thumb-hole, as it is what we shall use most; next we take the yellows, being nearest the light in colour—the brightest first, our lemons and chromes, Naples yellows, ochres, cadmiums, and raw siennas. You will not need the half of these unless you like. Next follow the reds—vermilion, crimsons, roses, light and Indian reds, or whatever else you please, in decreasing scale of brightness to our browns, and our blues, cobalts, ultramarine or permanent, Prussian, indigo, &c., and so wind up with the darks and blacks.

You can paint a picture with three colours, and you can use all that are in the colour list; only have a method and reason for everything you do, and if a good reason, it will be the proper thing to do. We set our palette thus, because our tints are thus in harmonious gradations from us; and also, if by mistake our brush comes into contact with two colours at once, it will not do so much damage as it otherwise would if such colours as yellow and blue were placed side by side; both in such a case would be dirtied past any further service.

In setting your palette, you may use your own discretion, as I have said, and cram it with all the high-sounding, high-priced range to be found in the many-leaved colour list-books, but one thing time and experience alone can teach you—that the greater your art knowledge, the more limited will be your range of colours and implements. You may begin with the rainbow, but you will return eventually to your earths; for what I hold to be the great secret in painting, poetry, and literature is—simplicity. Fine words, dear colours, only mystify the student and prove the weakness of the worker.

For brushes, in oils try to acquire the use of hog-hair brushes if you would make effective and vigorous work; sables and soft brushes are sure to tempt you, being so much pleasanter to a beginner. But if it is not miniature, pre-Raphaelite, or tea-tray painting which you aspire to, keep from them as long as you can. Do not use softeners either, but rather place your colours firmly, and separately, and purely, so as to produce the effect you desire by knowledge and skill, and not by trickery.

Make your lines rather suggestively than literally, and the larger your brushes the finer your work will be; for if we look at nature we cannot find lines, or if there seem lines they are formed by many cross-divisions so minute and filled with gradations that the finest sable-hair is like rope-work beside them.

We cannot copy the delicacy of nature, for we cannot trace it, therefore we must content ourselves with attempting to give a little of the effect and feeling that we from our distance can trace. This is why, *from my point of view*, pre-Raphaelitism is a clumsy, abortive imitation of the upper surface, and not so true a translation of the whole as the painting of the broad and suggestive worker.

In water-colour we require to use sables for our washes—that is, if it is water-colour and not opaque painting we are attempting.

Now for the subject. There are two ways of approaching it: one with fear and trembling, thinking of all the poetry that is in it, or rather the sham sentiment that we fancy is in ourselves, and would fain make other people believe to be our own outpourings, while in reality it is the effect left on our dazzled mind after reading the matchless cloud-and-water poetry to be found in the pages of 'Modern Painters' and other works by the same author. How fondly we are apt to imagine, as we quote, that we have seen countless miles of transparent cloud beyond cloud, vistas opening up as we gaze, and think so it ought to be painted, as if mortal hand or manufactured paint could do it, while all the time we are only miserable waiters serving up in a flashy way the utterly impossible dishes Ruskin has so finely spiced in his own private kitchen!

Do you think that Turner painted half the beauties Ruskin *sees* in his pictures, thought out half the mountains of thought his admirer makes him think, had a quarter of the intentions the Professor fathers him with?

No! Turner was a poet, and painted, as Shakespeare wrote, on the spur of the moment, with the same glorious knack of being able to leave alone '*happy flukes*', which chance and accident gave them, and this knack, if not the spirit of genius, is a very good substitute for it.

I do not mean to say that Turner painted from impulse only. I have not the slightest doubt that he had intentions, and most carefully planned out all his conceptions, as Shakespeare planned out the fabric, or bones, of his plays; but the great bits of detail, the compact word, the chance touch, the sparkle of wit, the sweep of the hog-hair that made the veins upon the little shell by the sea-shore, the twist of the palette knife that broke the colours into prismatic ripples on the rounded wave—all that his admirer writes as forethought I do not believe. He must have thought on the clouds and waves and sands which he so often watched, the varying shapes and tints they took, the mixture of all he had seen sweeping into shore, and thinking of all this while his deft hand laboured hard to produce the semblance, so it took shape and grew into being; or else he worked away and tried other methods and experiments until the results came, and more wondrous results do come thus by chance than the forced and mechanical labour of mere industry.

We spoil a good deal of good work through overwork. If we could but let well alone we should not suffer the bitter reflections and heartburn of a remembered chance cast away. We go on polishing and working, rounding off this energetic sentence, touching over that harsh brush-mark, until we have refined all spirit out of our work, and finish it off with a smooth surface and nothing else.

To quote once more from Ruskin when he is for a moment sensible; he speaks of the value of finish in the 'Stones of Venice' thus: 'Never demand an exact finish when it does not lead to a noble end. If you have the thought of a rough or untaught man, you must have it in a rough and untaught way; but from an educated man, who can without effort express his thoughts in an educated way, take the graceful expression and be thankful, only get the thought and do not silence the peasant because he cannot speak good grammar, or until you have taught him his grammar. Grammar and refinement are good things both, only be sure of the better things first.... Always look for invention first, and after that for such execution as will help the invention and as the inventor is capable of, without painful effort, and *no more*; above all, demand no refinement of execution where there is no thought, for that is slaves' work unredeemed. Rather choose rough work than smooth work, so that the practical purpose is answered, and never imagine there is reason to be proud of anything that may be accomplished by patience and sand-paper!'

We can desire to read nothing broader or finer than this from any man, for the man must write or paint roughly who cannot do better through his want of education; but if the thoughts are there, it must be well. The man also must write and paint roughly, no matter what his education has been, when his thoughts are quicker and fuller than his power of execution, and it is better to have the rough work and the full thought than the finished work and something lost. But, no matter whether it be science or art that the man is treating, I would reverse the advice Ruskin gives in his introduction to 'Proserpina,' and tell the man to write it in the language that he and his neighbours are most familiar with, and not waste his time locking it up in a dead language that only a few can understand. As to taking a month to each page, if heaven has gifted him with ideas, he will find this as impossible to do as it will be for the man or woman who have the spirit of men or women, and not the essence of fools and apes, to cut the acquaintance who may be in reduced circumstances, or engaged in honest, therefore holy, labour.

The other way of coming before nature is the tersely realistic, that regards the changing glories of the sunset or moonrise with a callous, critical, investigating glance, indulging in no idle visions or fancy images, but dividing the glories into degrees of colour and gradation.

The school of Shelley sings—

When sunset may breathe
From the lit sea beneath
Its ardours of rest and of love.

This cool hand cuts down all the ardours, and dots them lemon, orange, chrome, rose madder, vermilion, raw umber, and cobalt.

And yet we must approach nature with a certain amount of awe and veneration, if we would be painters and not painting-machines. If we have any sentiment in our composition at all, we can no more gaze upon the beautiful or grand without a responsive something being stirred within us than we can hope to eat pork chops the last thing at night and escape the nightmare.

The dash of the waterfall must produce in us more than the *dry* estimate of its sparkling colours, or we are not far removed from the fern that draggles by its edge. A lovely face or graceful form must teach us more than carnation and ochre, or we deserve to be the hero of Campbell's melancholy poem 'The Last Man.' If we do not feel the spirit of the whole while we watch the form, the colour, and lights and shades, we are worse off than the shadowless man, for we have pawned our souls without redeeming that faithful follower.

It may be the spirit and beauty of peachy golden youth, or the spirit and beauty of gnarled silver age, that we are watching. We see the lights and the shadows playing about, the greens, the purples, the browns, the reds, the yellows, the whites, but we *feel* that there is more than this. We dissect hair, we see in the dark the rich brown madder shadows with the purple half-lights and blue gleams, and we know this makes the raven's plume from the right standpoint; or the golden tress, with its mixtures of ochre, green, and red, and we thrill at the dusky loveliness that is crouching in the silky masses, or the angel glory that is hovering round the fair, and so we drink in all the poetry that we must have to refine and gild our realistic common sense before we can appreciate it enough to paint it.

Once with a friend I watched a glorious sunset, and as I stood setting my two palettes—one, imagery, where I was spreading out all my mental stock of jewels, pearls, and opals for the greys, rubies, and cairngorms, and a great many other precious stones from my castle in Spain; with the other palette seeking to snatch from the weak little tubes that intense dun and purple rolling about through the thunder-drift,—seeking to bring down the waves of variation, the orange and the gold and the green and burning flames subdivided ten thousandfold, to my rule of three, seeking to draw down heaven and shut it inside my paint-box,—I was somewhat amused by hearing my colour-blind friend murmur pensively, 'Red-lead and lamp-black.'

That settled the whole conundrum, and I passed on.

How to paint a picture, that is the question. Although imagination ought to be brought with us when we come to nature, it should be as our own bicycle under us, and not like our neighbour's bicycle, riding over us. We must give the spirit of what we see, and no more; for we shall commit a hundred errors if we vainly attempt to give the spirit of the oak while we are painting its bark. Of course we know what the oak has done, we recall all that we have read of Nelson, Collingwood, and other hearts of oak who have spilt good blood to prove that 'Britons never shall be slaves'; and although, perhaps, it ought to give an oak-tree an air of all this as it stands before us, yet there it stands before us, full of knots and wrinkles, with its gnarled limbs flung about it, and its green moss, silver lichen, and amber and purple darting between; and I take it, this is what our painter has to get into his head and imitate. We cannot see past its bark unless it is torn open, and then we may not see the bark, and we must never think of painting what we cannot see. If, by the help of our poetic taste, we can convey to the spectator the sentiment we do see about it, of a hardy, sturdy, rugged sentinel that has done duty there before our grandfathers were born, which goes on in the same impassive way while we lie dead in sleep, and may go on ever the same when perhaps we make up part of the earth and fungus about its roots, unless God's swift telegram, the mighty lightning-flash, or man's paltry axe, gives it its furlough,—if we can do this, as well as give an image of the reality, we have done all we can do—made a noble work and created a poem.

Never mind what anyone else sees in the subject, stick resolutely to what your own eyes tell you, and you must be right. Say someone tells you there is a man coming along the road; you think it does look like a man, but you

only see a splash of mixed colours with a *certain* sweep about it; put that in, and someone else looking at your picture will say, 'You have made a man.'

This is the grand trick of landscape figure painting, for if anyone can see a single line of detail about your figure more than the tree, or stone, or hedge beside him, your figure is a failure and should come out, for it is spoiling the unity of your picture.

So with clouds, water, mountains, trees, everything created above us, beneath us, about us. My harp has only three strings, and were I to finger it for a thousand hours, to a thousand different tunes, it would be with the same variations. What paints sunset, paints sunrise, midday, moonlight; the same colours that sparkle in the bright patch sparkle in the deep shadow, and the variations of yellow, red, and blue are as pronounced and apart in each blade of grass as they are in the white clouds rolling above it, and as distinct in the dazzling snowdrift as in the burning sunset skies,—there is not an inch without its variety, but only a variety of three.

Return as soon as you can to the child with his first paint-box, the savage in his woods, grand old Egypt that must stand for ever; but bring back all your knowledge, so that you may know *why* you painted as you did when you began. Thus will you learn humility, which is only taught by true and great wisdom, and the charity that has a hundred eyes.

We should begin our subject as we first see it. As we enter a room, the first thing that strikes us is the great masses of light and shadows before us; objects are all divided thus, and so we should paint our first stage or working. This is the effect we are securing.

Afterwards objects proclaim themselves: they start out of the masses— chairs, tables, pictures, people. That is our second stage or working—the broadest fact of the individuals.

Thirdly, we see the details, ornaments, patterns, textures.

Lastly, as we get to look more closely, we see in each shadow a world of colour, all the sparkles and gems, and the same in every light. This is our finishing stage, and may be prolonged as far as we like and can go.

With landscape also it is the same. We would paint a tree: the first thing that strikes us is its general shape—first working. Next its great divisions of light

and shadow, when some masses come out and other masses go back, also a general idea of its prevailing tone. Second working—Then, as we work and watch, come indications of branches, the large limbs first, then the less, and so on, until we lose the lines of the smallest branches and can only guess where they have gone to.

There are also suggestions of leaves which we know are leaves, although, as they lie about in all directions, they get mixed up into all sorts of shapes, and come gradually upon us: and this is the third stage of working.

If we paint in the leaves as we know they are shaped, we must get a stiff and unnatural picture, because we are not painting what we see, but what we think should be there; and if we paint each individual leaf as we would copy one set before us, or as we see them in Christmas cards, we must paint in an abortive, unnatural, and exaggerated manner, because, as our tree is so greatly smaller than the tree before us, if each leaf was also in proportion less we could not make them out with the naked eye.

How, then, ought we to do it? Not like a pre-Raphaelite or teatray painter, but as we see it—broadly and in masses, doing what we can with our own clumsy fingers and clumsier tools; and since we cannot get all the details of nature, best leave them alone with true humility as beyond us, and do what we can, and as nearly in proportion as we can.

To do this use hog-hair brushes, stand well back from your picture, and try to keep the spectator back also. Tell him, like Salvator Rosa, that the smell of paint is not good for him, or say he will never be able to see the landscape if he pushes himself so amongst the branches and leaves of the tree, or that it is rude to get so close to a lady's face—anything, only keep him back the proper distance. If shortsighted, let him be content with the description of other people about it, and deplore his own misfortune, for a picture that is painted to be looked at two inches from the eyes can never be a 'thing of joy.'

When before nature, it is strictly proper to adhere as closely to facts as we can, put into our sketch everything that we can see before us, and even at our closest following up we shall not get in a hundredth part.

True, the student is none the worse for a little fancy to help him out of the road with any very ungainly object in front of him, but I doubt if he will find a much better substitute than the objection he wishes away.

The telegraph-post does its part in the composition of the picture as conscientiously as the lovely silver birch, and at a place where the birch would be too much.

We are searching after the picturesque, and stop, caught by something that is fine, and yet when we dissect it we may find it full of the objections and faults which we have been taught to reverence. Shall we alter what nature has done so well, introduce our poor little rules, and tailorise the picture until it stands reproachless?

Rules! nothing seems to me so forced, so curbing as this word. We ought not to draw this as it is, because some of the lines are running counter to what they ought to be. It is a sin against precedent if we put that wall or fence as it at present stands. Good taste and the example of the old masters forbid us to put on this colour, to do that. At every turn we are met by a ticket marked 'Trespassers will be prosecuted to the utmost rigour of the law.' Keep on the beaten track, or else you must expect to suffer the consequences.

I hate all precedents and rules in art, and my advice would be, 'Put in all that looks well in nature, and it will be your own bad work if it does not look well in your picture.'

As to this veneration for the old masters, were they infallible, were they more gifted than we are, had they more advantages for learning art than we have? Yes, one great advantage over us—they had no old masters to annoy them, only the spirit that God gave them to struggle on with, as we should also have did the world not bid us bow down and worship these time-stained old idols. They were great, and so may we become when we are dust and ashes, and time has deified us and stained our pictures to the golden duskiness that is fashionable, and tradition has distorted our sayings and exalted our prolonged labours into sudden flashes of genius.

It is very good practice to copy some pictures when there is something in them that we wish to learn, yet cannot see how to do from nature. For instance, you may learn how to glaze and scumble better from a picture than from nature, because the glazings and scumblings of nature are too subtle for us to follow always so directly.

You will also learn how painters of repute managed a certain phase or effect of colour, subject, or composition. Rubens will liberate you from many a stiffness, and give you in his own buoyant style the liberty and joyful

colouring you may be deficient in. Vandyke will teach you refinement and dignity; Tintoretto, richness; Michael Angelo, the boldness and firmness of handling and drawing, the severity and squareness needful for majestic grandeur.

Amongst our own men, I quote John Pettie for a strength and richness that have never been surpassed, bring what master of long-ago you like to the competition; Orchardson for pure and delicate texture; Sir Frederick Leighton for finish; Millais for realism in its best sense; Alma-Tadema for imitation and learning; and a host of other men, both good and true, who must improve the mind, the eye, and the hand.

Millais has said that an artist ought to begin as he did, pre-Raphaelite, if only to learn the quality of Job. Nature eventually must make him, as she has made that great realistic master, broad and strong, if it is to be, though a whole world of critics were to chorus against it.

Speaking of critics, I think we may divide them into two classes—the psychological and the destroying, or vermin, species. The first class look at a painting or a book as we ought to look at everything—with the bee spirit, to suck out all the honey there is in it. They are of equal use to the public and to the worker; for, leaving one to see the errors that all man's work has, they lay the good before the other, benefiting equally themselves in the instruction they have gained. As for the other class, do they help the work done, or that has to be done? do they add to the pleasure of the spectator, or instruct the worker by their pertness or sneers? Do moths add to the value of clothes? does mildew improve walls? does rust assist the brightness of polished steel? or do white ants strengthen the rafters they bed in?

True, these are all works of nature and creatures of God. The decay must be as useful as the life, or it would not be. But what made critics of this class? From what? For what?

Discreet copying, as I have said, is very good; but there is only one other practice as pernicious as indiscriminate and constant copying, and that I will speak of presently.

What is glazing and scumbling?

Scumbling is going over distance with white or grey, rubbing it hard and dry, so as to obscure the parts that stand too prominently out; it softens

harshnesses, sends back portions, and does its part in aiding the general harmony of the distance and middle distance.

Glazing is the use of transparent colours with some sort of medium, such as madders, siennas, browns, to give richness to the depths, lower the tone in places needful, as foregrounds and such like, that come direct with all their local hues about them; it brings things forward, as scumbling sends objects back.

Tone is the cast of your scale of colour, the setting of your key, the tuning of the pitchfork, to be determined on before you begin your picture, and remembered all through it; and it is the forgetting of this at times which stamps the amateur.

Style.—Of course everyone has his own taste to consult in this, and what you admire you will, consciously or not, imitate, until nature rectifies it and gives you a style of your own. The artist must fluctuate among several styles, always following and trying to understand nature, even while he admires other painters, until at last the scales fall from his eyes, and he relies only on the powers given him when he least expected it. A spark of what is to be will show out here and there until the *to be* has come.

That is, unless when, in their frantic efforts to be original, painters hunt heaven and earth for the most startling effect, subject, or treatment; then they become like French cooks—continually stirring their minds for new mixtures to catch and astonish the public taste, spending all their foolish energies in the spicing of old stale thoughts.

It may be we admire Sam Bough, with his versatile fancy and vigorous touch; or Lockhart, Macdonald, Fildes, &c., with their strong, healthy 'go'; or Herdman, Faed, &c., with their sweet touch and poetic minds; or Sir Noel Paton, with his exquisite drawing, radiant colouring, and originality of conception; or Waller Paton, with his purple and gold; or the late lamented Paul Chalmers, who flung everything into the scale against colour and made it weigh them down; or Harvey, who chose the moral thought; or Gustave Doré, who revels in the image. I could go on naming hosts who have styles distinct by power or affectation, for it is in the style that we show our affectation, as we do it in our walking and our talking; but I would only say that if you wish to be natural and great, think very little upon the style you would take, and more upon the thought you wish to express; be earnest in

your work, and by earnestness you will forget your delivery, and so be both natural and original. And, after all, what does it matter whether people say we are like So-and-so or not, if we are doing our very best? We must find the true *peace with honour*, and the repose that ever follows honest, earnest exertions.

It is also good practice to draw with the point, pencil, or pen as rapidly as possible all that partakes of motion—ships sailing, engines puffing out the volumes of steam and smoke, clouds, water, waving trees, and reeds. Fill up your books and scraps of paper with all sorts of shorthand notes; very likely you will not be able to decipher the wild scratchings again, but they have done their duty while you were scribbling them in by fixing something in your mind.

Watch closely as you sketch, and after you get home think it all out and write down as nearly as possible all about it—the colours you think should be used for it, the shape of it, the comparative size, and also, *if you can*, the poetry and emotions it awoke in you.

Books on painting, as a rule, are only confusing to the mind of the novice—filled with words difficult to comprehend, and of very little use when the conundrum is solved. Like recipe and cookery books, they serve, after you know your subject without them, to warn you against what they advise, also to advertise the many colours you are to flounder amongst for a season. But nature is the best recipe-book: her problems are as easy to unravel, and when read, serve your lifetime.

Sir Joshua Reynolds is very good and sensible on painting, although I cannot answer for his remarks on pictures.

John Ruskin's books are entertaining, splendidly and carefully prepared inside and outside, even to the colour of the morocco and calf-skin; the language as select and carefully weighed as the shade of the edges, and the title as maturely considered as the material on which it has to be printed. It is a great pleasure to handle one of his books, or even to see one of the backs on our shelves; they are like greyhounds amongst rough tykes; in fact, I have often felt sorry to open them, the bindings are such masterpieces of thought.

When opened the pleasure is not diminished, although mystification may set in at times. We sail smoothly over page after page, soothed with the harmony, exalted with the poetry, thralled with the exquisite grace, diction,

and finish; we can hardly think of stopping to inquire what it is all about, it is all so delightful, so ethereal—the work of a great master of the pen.

Read and moralise, if you will, upon such beautiful touches as this: 'Morning breaks as I write along those Coniston Fells, and the level mists, motionless and grey beneath the rose of the moorlands, veil the lower woods, and the sleeping village, and the long lawns by the lake—shore.'

This passage is only one of many that remind me of splinters from the big diamond that was supposed in olden times to flash out of the head of the toad. Copy it if you can with your brush, for it is very perfect in its word-painting, and true to mornings I have seen in Cumberland.

But when he tells you how to paint, beware! for here he is a perfect will-o'-the-wisp, sparkling out with his lovely lights, and luring you on, now over dry land, now over marsh; giving at times good advice, following it up by bad; telling you practical truths or ethical fallacies.

If he was a consistent wrecker, we should get to know his fires and steer clear of them in time; if he was all theory, we should enjoy him as we do other poets; but he is like a man who has built a fine house with chaste design and perfect decoration: it looks all that one can desire, and has only one fault, but that is a grave one—the rafters and supports are *rotten*.

He may be justly praising the old muddy Venetian glass, with its ever-varied though clumsily-finished designs, as compared with the sameness of our superior quality and finish; and putting absurdly silly questions into the mouth of his supposed audience, as if a scavenger who does his work honestly and comports himself uprightly could not be as good a gentleman as the aristocrat who paces by him; and making out what is done for economy, and justly so, to be the result of a false shame, forgetting the parable of the talents, or the utility of working the one as well as the five.

He may speak of the sanctity of colour, and go on abusing the coarseness of Rubens, or the sensuality of Titian and Correggio, to be perhaps followed up by the information that Titian and Tintoretto, when they looked at a human being, saw the whole of its nature inside and out, and painted it so.

He may abuse low tones, and tell us that all which is vile, and deadly, and evil is sombre in colour, although in the same breath he will admit that the tiger-skin is rather pretty, and that some bright flowers and berries are

poisonous, and also that there have been lovely women not quite all honey, past and present.

He is abusing Salvator Rosa, although comparing him with painters of his time—I don't know why; or in his own graceful way changing his tune, and telling us that all good colour is pensive, and that it is blasphemy to be gay.

He may abuse the past painters of storms and gloom, to turn with gloating rapture to the tempests and gloom of Turner.

He may remorselessly plunge Teniers into the bottomless abyss for his degrading subjects, yet praise Turner for his wallowing and grovelling amongst the litter of Covent Garden; advocating his slanting steeples as if that were the proper way for steeples to stand, or reviling some one else for the same thing. How he raves throughout his books on the great man! and how the great man, like old Samuel Johnson with his Boswell, must have laughed, when not too much mystified or aggravated, at the high-flown discoveries of his ardent admirer!

He may tell us that the chief power of Rembrandt was his character drawing, and that he knew nothing of light and shade; or indulge in such weak and heartless exhibitions of the fop wit as when he replies to Constable's remark about chiaroscuro: 'The sacrifice was accepted by the Fates, but the prayer denied. His pictures had nothing else, but they had not chiaroscuro.'

I think I see this great critic leaning back after polishing off this pert, unfeeling, and untrue bit of little smartness, with all the complacence of having written a clever thing; it is on a par with his dress-coat retort to the *Blackwood* critic of October, 1843, about the silver spoon and the orange; on a par with his intolerable remarks on the pictures of Whistler—who, however, did not improve matters by his pamphlet.

He may write about the utter meanness and humiliation of the imitators of woods and marbles, as if a bit of wood or marble was not of as much importance to the art student and as much a part of nature's graining as the bark outside, or the blade of grass that engrossed his microscopic eye so completely that he could not see the majesty of the Alps above him. I can grain a little, and I feel as proud of this accomplishment as I do when I paint a tree or a mountain something like, and never felt degradation either in one or the other.

He may assume the lofty, and retire to his immaculate shell when asked his advice on art, disdaining to give an opinion to a people who dare to tolerate Frith's 'Derby Day,' and live there with his saints and kings, or come forth with mighty condescension and tell the nations to hurry up and avail themselves of his priceless services while yet there is time. I admit all his greatness with true humility, yet I think we must allow that before he was born good works were done in art, and even after the lustre of his presence is withdrawn from amongst us I do not despair.

I know it is the fashion to quote Ruskin and Carlyle. I like them both—Carlyle, because he is cut out of bigger stuff, and, like all colossal work, rougher in his finish; but it is jarring to hear at every turn in life, 'as Ruskin says,' 'as Carlyle remarks,' when Solomon has said it all before, and perhaps many wise sages before him. God has given minds to us as well as to Carlyle or Ruskin, and surely it is better to say in our own way the old truths than recite from books that other people can read as well as ourselves, if they like, merely to show how clever, how ethical, or how well read we are. Read as much as you can, but think out truths for yourselves.

Modesty sometimes compels us to state our authority when we dread to be called the author of something not our own; also there may be times when, like the use of a foreign word, it is inevitable—but the less the better, both for our own selves and our listeners.

It is good at times to do a little wholesome penance, compare our work with that of others, to try, for instance, how our picture looks in comparison with some other picture of the same or a similar subject. Modesty will perhaps point out many faults and shortcomings that we could not find out in any other way; but the most vicious habit in young painters is the perpetual running about each other's studios. To quote the words of Solomon with a slight alteration, I would say, 'Put not your feet too often into your neighbour's studio, lest individuality be left outside.'

We see the effects of this practice in many of the pictures around us every day: all good work in themselves, but with so little difference of style that the only surprise is, the one name is not at the corner of the lot.

It is good to exchange ideas at times, but only at times. On the whole, I am of opinion that originality and individuality are more precious than good workmanship, but both are best.

It is good to be able to copy a tree, or a stone, or a wall faithfully and well, bring out all its variations and time-scars with fidelity; but it is better to paint a moral and a thought, even although it is only half expressed, for the spectators may fill out of their own mines of thought all that you have left unsaid, although it is best to be able to express it to the last letter.

All have different minds, as they have different tastes and habits. Some are literal, and content with the fairness of the earth; they are poets and painters of the real. Wordsworth is a realistic poet, Millais a realistic painter; others are purely imaginative, and paint and write about visions and the unseen, steadfast and serene dreamers of the ideal. Shelley and Coleridge are imaginative poets, William Blake and David Scott imaginative painters. Fancy sways others, and flings them about, half on earth, half in air; excitement like that of the footlights or champagne others, such as Byron and Gustave Doré.

All are to be admired, and are admired, and it becomes a question impossible to answer, which have the five talents and which have the three.

Imagination seems to me a very sublime quality, without much joy or mirth in its composition; it does not require images to suggest creation—'out of nothing it creates'; yet I dare not say that it is a quality more to be desired than the merry fancy that builds its domes and castles out of the clouds, or from the rocks and surroundings draws images of other creations; neither would I say that there was less of power or poetry in the mind that keeps strictly to reality and renders the spirit and the being of all about them. They are all great gifts, to be honoured one as much as another, but none partaking in that fantastic unfinish and impotency called Mystery.

Goethe writes:—

Pure intellect and earnest thought
Express themselves with little art.

And I think him right, for, though mystery may be in vogue and considered fine, I hold to my theory of Egypt, the child, and simplicity in all things.

It is good at times to yield to the inner promptings, and attempt to illustrate our thoughts, imaginings, dreams, and embody the images raised in our minds when we read a story or listen to a description.

The scene rises before us quite distinctly, vague but vivid in its colouring. We try to seize something special, and the whole vanishes; that is our first experience, but by practice and perseverance you will find the characters come to be less shy, and at last range themselves to method, and stay while you are drawing their arms and legs with exemplary patience.

It is good to be orthodox when we can in all that we do, to follow out as far as is consistent with our own sense of manliness the fashions of the day; but it is not good to enslave ourselves either for fashion, popularity, or money. If we cannot do our work consistently, let us do what we can.

If a certain mode of painting is termed proper and 'good colour,' or an affectation of uncertainty or mystery that may look like unfinish, but in reality requires more work than the apparent finish, and we desire to please the artists and picture-dealers, and live as it were for the hour, we may acquire this affectation, if it does not cost too much *thought*; *that* must ever rank above all technicality. But it is a matter of choice which ought to be studied most—ourselves, the public, or the professors. When a line can be drawn without offence to either, it is policy to draw it.

Public opinion is fashion, and not much to be depended upon. What is abused to-day may be lauded another day. It may be led by one man who constitutes himself the leader, and he will be followed if enduring enough to place himself in the front, and brave enough not to be crushed by the sneering and the growling that must assail him for a time.

Titian's flesh tints were called chalky by the critics of his day. David Cox could not please anyone, not even the children; his pictures got turned out or skied in exhibitions, he was glad to sell a sketch for a tube of paint; and we have seen what David Cox's little water-colour daubs sell at now.

As with painting, so with poetry. Did Milton look the poet to Cromwell that he is to us? The relations of Robert Burns thought the kindest action towards him would be to burn his ungodly rubbish.

Is Whistler wrong in his mode of expressing himself? is the natural question that comes up here. I do not know, although I have seen much of his work; but *it* seemed to me all right, only Ruskin says it is wrong, and I do know that Ruskin is not always right.

But, whether right or wrong—and he will be both, as we all are to our different critics with their different tastes—the opinion of one man, or of ten thousand men, can neither make him wrong nor right.

No man ought to buy a name and grumble afterwards if the picture becomes of less value.

Even such names as Raphael ought to weigh as nothing when before their pictures. If the thing is bad in Raphael, it is bad in Whistler; if it is good in Raphael, it could not be bad if it was Whistler.

If a picture is worth 200*l.* to the man who paid that sum for it, it can never be worth a farthing less to him afterwards.

If a man buy a coat, a house, a horse, or a picture, he ought to know *why* he is buying it; and if it is value in his eyes, it cannot, or ought not to, be made valueless by all the newspapers or critics in the world. And if he has no knowledge on the matter, no likings, no opinions, he ought to depend on some one whom he can trust who has knowledge, and never alter afterwards; or he ought to spend his money only on what he has fixed ideas about, or give it away in the cause of charity, about which we all, as human beings, even the weakest, have surely some sentiment clinging about us as a forecast of heaven. If he spends his money only for fashion's sake, he deserves not only to lose it, but to lose also the respect of every man of sense and purpose, for he is a fool incurable.

We cannot all be educated on every subject, but we can all tell what pleases us, and it is our duty to manhood to say so, and not take the opinion of others against our feelings. For instance, if we are eating something nice, is it no longer nice if our neighbour says it is not? or ought we weakly to take the fashionable dish that we abhor, and pay ever so much more for it, with our mouth watering after the cheap dish that we can understand and relish?

Water-colour painting is the use of transparent colours with the ground or paper serving as our white. The treatment may either be by wash or stippling and hatching.

Stippling and hatching is the going over our work with dots or crossed lines. Like engraving, its chief merit is the vast labour it costs, if that is a merit; yet at times it has to be done where washes fail to bring the effect.

Opaque or body colour, like fresco painting, is the mixing of Chinese or zinc white with the colours. A little chemistry should be studied in this work, as some of the other metals do not agree with zinc.

The farther we keep two systems apart, the better and the purer both will be, although the effect is the main object, and all other considerations of less consequence. The more we glaze in water-colour, the more subtle will be our work; the less we glaze in oil, the more satisfactory and firmer will be the result. Yet, obey no arbitrary laws; do whatever brings the conclusion quickest, and it must be legitimate. If your knife does better than your brush, use it; if your fingers, use them. Scratch, scrape, rub, cut, polish, shave, do whatever you think will succeed, and if it does not, try some other experiment until it does come up to your wishes. If the colour you have put on is not the one you need, put its complementary tint beside it and change its character, or dash it over or about it. Have only your object firmly fixed in your mind, and scruple at nothing in the way of experiment. The more methods you employ, the nearer you will be to the ever-changing method of nature.

I have not touched upon half my points, and only *touched* those I have gone over. I could go into details about the manner of mixing up the colours, and how to treat some of the special effects of nature, but that I have already done. I am tempted to draw a sunset, or a storm, or a calm, with all their different objects in the background, middle distance, and foreground, dissect them into paint as I pass down, tell you what is sitting in the flank of one cloud and the total change of shadow in the next, also why it is so, and must be so according to this rule of three.

I should like also to show you the same sportive three nestling in the sun-kissed breast of the same air-billow; quivering in the blue-grey haze of the far distance; floating on the glittering ocean, or diving amongst the deep reflections of the lake; peeping out of the froth and the heavy curl of the advancing wave; dashed into pieces on the dulsy sands; darting about the broad masses of the middle distance; playing at hide-and-seek amongst the branches, leaves, and weeds and rocks of the foreground.

The three are everywhere, and infinite in their sport—two ever subordinate and obedient, advising, enhancing, leading; one ever acting the monarch, yet ever being dethroned and supplanted by one of the two counsellors, to join

the other in obedience and then conspiracy, to leap up, take the reins, sink down vanquished, and all this for ever and for ever.

And on Perspective; for although Gainsborough has said that the painter's eye is the best guide, we must have rules here, if only that we may forget them discreetly.

We must draw our horizontal line, and be guided by it; also know where to fix and keep in mind our points of sight, stand-point, and dots of distance; be able to place our vanishing lines, know where they are going, and why they are so going. We must also know where to drift our shadows, and when to trail them; how long our reflections ought to be, and why at one time we make them longer than the object, and why at another time so much shorter. This is all imperative to the art student, although it may be overdone. The rules are not so hard as some imagine, and, like painting, are best demonstrated in nature. Sit down to draw part of a city with two or three streets slanting different directions, pass lines about from your horizontal line, until you fix on the right slope, and you have gleaned all that there is to get practically out of Perspective.

Many a good picture is spoiled by the painter 'showing off' his knowledge in this line, where a little deviation from the stiff law would have redeemed the whole; just as many a clever speech is often spoiled by the speaker weighing it down with complex and ornate words.

And on Anatomy; for, although the classic Greeks are supposed to be all ignorant on this subject, it is no excuse for our ignorance; the science is now established, and it is our duty to learn it if we would be perfect draughtsmen of the human body and its exertions.

Gustave Doré, through his great knowledge of anatomy, can take the liberties he does with his figures, and yet be to a certain extent natural. Look at his thousands of figures, with their countless twists and contortions, if you desire to know the ease and power the study of anatomy gives to a man.

The Greeks had perfect models. Their customs, exercises, abstinence and games gave them this advantage over us; but times have changed: our climate, our costumes, our habits are all against us, and without the knowledge of bones and muscles we should never discern between the natural and the deformed, and just picture Venus rising from the salt foam with a corset-curbed waist or the traces of a badly-set joint!

And how should we know what ought to be, and what ought not to be, in our model, if we are ignorant of his or her construction?

True, the Greek statues are there, to copy and educate our eyes to the true and lovely; but how are we to know whether the Greek statues are perfect, if we do not know why that lump starts out when the arm or leg is planted so? The study of the Greek statues is about as long as the study of anatomy, and not so satisfactory, but both are best.

And now one word on Exhibitions and Academies.

Exhibitions.—It is good for ourselves to get pictures hung in exhibitions, independent of the good it does to our pockets, that is, when we can. Although I think the intelligent public do not pay so much heed as to whether your name is in the catalogue or not, yet the great mass who get all their ideas from the morning news, and read all the criticism as gospel, lay a stress upon it.

But to see your picture alongside of many, is to see many of your faults; and yet only to a certain extent, for the best pictures for rooms are not always the pictures that look best in exhibitions. They may have qualities too original, or striking, or fine for the glare, and the distance, and the surroundings.

The qualities for exhibition purposes are soberness, not too much individuality or variety, qualities that dovetail their single part with other single-part pictures, so as to make a pleasing harmony of the whole. It is the student's own choice whether he will, therefore, sacrifice his idea for a place in the catalogue, or run the chance of missing that and keeping his ideas.

Of course when he is famous he may do as he likes, and the world will say all is perfect that his hand touches.

Academies must be good when they foster the art youth, encourage originality, train his eye and his hand, and keep active his mind to the true principles of art and the animation of thought; bad if, while they train the hand, they crush out spirit, originality and thought.

CHAPTER IV. ART IN ITS RELATIONSHIP TO EVERYDAY LIFE.

I DO not suppose many, amongst even observant people (unless they take the trouble to investigate the matter specially), can realise what an important factor art has become to the most trivial object of everyday life, or how impossible it is for us to do without its aid at every turn.

By art I mean the embellishment or beautifying of articles of utility or necessity, and the imitation of nature as far as it is possible for us to copy or translate the beautiful and perfect so lavishly spread about us, and bring it within the scope of our hourly necessities.

As an instinct, this craving after the beautiful is developed very early in man and woman. The first instinct of the child, of course, is for food, but the second will be for ornament; it cries for its mother's milk first, and when satisfied with this craving, next becomes attracted towards the fringes and buttons of its mother's dress, or the pendant dangling from the end of its father's watch-chain.

To gratify this early taste, the baby becomes possessor of a gum-stick; but I very much doubt if the baby has yet been born who would be satisfied with a plain, unadorned bit of stiff indiarubber, if it can have its choice between this and the attractive carved coral, with its ornaments of glittering bells.

Amongst early nations—our own for instance, which I put upon the same level as the aboriginals of Australia or the natives of New Guinea—we find the same instinct for art and observation of nature: there is no nation so low or primitive that it does not indulge in ornament.

It is also a curious point in natives, that, the more primitive they are, the more refined they are in their taste, the nearer they are to nature and each other; it is the half-civilised only who depart from the imitation of what they see about them, and indulge in eccentricities and extravagances.

This directness and simplicity stamp each effort of the child and the savage when they attempt to express their ideas—ideas which are prompted by what they see; and the same directness and simplicity are the sign-marks on all the most perfect work of the finished artist, whether he is the designer of pictures, churches, pleasure-grounds, or the costumier who strives to cover the defects of his wealthy patron.

Talking about clothes and the near affinity between nature and art—even in this minor department I remember once the great Parisian autocrat of costumes, Mr. Worth, coming to Melrose especially to study the ruins of that fine abbey to get ideas for future designs in ladies' dresses. His system is to look at the woman who comes to him for advice in this all-important matter, see how she walks backwards and forwards, studying as she does so all her good points and defects; then, being a poet in his own line, he imagines her as the ideal woman, and, without troubling himself about her own tastes or inclinations, he creates a dress in shape and colour which will make her as nearly approaching to his ideal woman as she can be made. This is his great secret and the cause of his success and popularity: he always strives to work up to his ideal of beauty and the perfection of nature in the most direct and easiest way possible.

As proof of this, a friend of mine once went to him to get a costume. This lady could never get any dress to suit her; something was for ever amiss with either the tone or shape. Nature had not been over kind to her either in form or colour, and her dressmakers, as she did herself, always attired her according to the fashion of the hour, which, of course, not being originated for her specially, could not be expected to suit her.

Worth was at last caught in a moment of leisure by this applicant, who had lingered about the threshold of his palace of fashion for some weary weeks before she could gain her point.

The great man looked her over critically, as one might examine a horse for sale at a fair; then he made her walk before him twice, and, telling her 'that would do,' consigned her to an assistant, who took her measurements, her name and address, and gave her a receipt for her fee of one hundred guineas.

A week or so passed, and then the dreamt-about costume came to hand. As the lady remarked, 'It was the plainest and shabbiest-looking frock that ever I saw, *but when I tried it on I looked better than ever I had done in my life.*'

Worth's idea suited this lady because it was fashioned only for her, but ten chances to one it would not have suited anyone else. Why?—because there are no replicas in nature.

This is where a ruling fashion is so ridiculous; it may answer the one who is important enough to bring it into vogue, but it cannot possibly, for the reason I have stated, answer anyone else.

Look along the street at the faces and figures which are constantly hurrying past, each one different in nose, eyes, mouth, expression, and gait; it is wonderful how it can be, but so it is! Look at any park, you cannot find two oak trees alike, nor even two blades of grass.

It is this variety which makes the world so charming, and the world's Maker so worthy of our profoundest adoration; it is all the perfection of art and limitless design, before which we may abase ourselves with proud humility as being a portion of this great originality, and try to imitate some of it with confidence: for, depend upon it, this infinite variety does not stop with outside objects, but is carried on within to our minds, thoughts, and observations. As there are no two objects alike, so no two onlookers can see the same object exactly in the same way, or reflect exactly alike; therefore we must stand apart from all others and be original, whether we wish to be or not.

This is the consolation which I would give to young artists who may imagine, because they are born in the nineteenth century, that they are born a few centuries too late to make their mark in the world. We are never too late for anything unless we make ourselves too late through sloth or timidity; as long as we work with an intention we must always move on, as we were intended to move on. Remember this when your hearts are inclined to grow weak, and you fancy that you are going along too slowly.

King Solomon thought that he knew everything and had been born too late when he wrote 'There is nothing new under the sun,' yet after Solomon came many others who discovered fresh objects to admire—Shakespeare and Milton, and after them Carlyle and Ruskin; and still the busy minds keep turning up fresh and new, fitting exactly to the day which has been made for them. In Solomon's day the countless daisies opened their petals to greet the sunbeam and closed them again at nightfall, each daisy different from all other daisies, while the sparrows hopped about in all their subtle varieties, as the daisies and sparrows have continued to come and go down the ages, and as they must continue while this ever-renovating world lasts, as fresh, as perfect, and as startlingly new as when man first opened his eyes and beheld that wonderful nature of which he was part and portion.

I hold that we have all original ideas, as much as Solomon or Shakespeare had, if we like to use our own minds and our own eyes as they did. We have all our limit, as they had theirs, for Solomon proved that he had reached his

limit, else he would never have written that sentence; he had seen all that he could comprehend, and so gave the rest up as vanity and vexation of spirit.

Job saw more than Solomon, for sorrow had opened his eyes and expanded his senses, drawing him into the heart of nature, therefore he became a wiser and, at the end, a happier man, dying while still a student of the wonders all around him; and this is the religion which we must all seek to embrace if we would advance in wisdom. We must begin, continue, and end as students, with our comprehensions growing as we grow older, never resting in our work or investigations, ever trying to grasp the lessons set before us, and to express as far as we are able what we have learnt.

These lessons in art are constantly about us in our everyday life. We walk through the forest in summer time, under the canopy of green arches, with the upstanding boughs of trees spreading away until they become indistinct in the shadowy distance. What does this suggest, if not the grand cathedrals with their pillars and arched domes? and this is what the early Fathers saw and tried to reproduce in their churches and abbeys. We look up and see the clouds floating above us, sometimes with shapes like cherubs and angels, at other times like demons and evil spirits: so the old painters and poets watched, and got their ideas of heaven and hell.

It is now more than twenty years since I first went amongst those people whom we call savages. I mixed amongst the tribes of Australia, the South Sea Islanders, and the Maoris. I had no better reason for going at first than a boy's wish to see the world, when I began my wanderings, but I was not long before I got a definite purpose, which has moved me ever since.

I had taken lessons in drawing and painting before I left home, otherwise I do not think my travels would have been of much service to me. I also had a habit of not only sketching what struck me as peculiar or useful, but of writing down carefully the descriptions of what I saw as I went along.

At first I wrote down the observations at random, such as, if I saw a sunset I would write something like this: 'Sun half only seen, vermilion growing to glaze of lake, lower half purple spreading out to dun, upper space ochre to orange with lemon; light edges of clouds near the sun, and shadow sides of warm purple grey; above, green back space growing to pearly grey, with rays shooting up cream-tinted, and filmy feathery clouds creamy and flesh-coloured.'

This for the colours; then I would describe the shapes of the cloud-masses from their likeness to something else. Sometimes they would look like trees; then I thought what kind of tree they resembled, or it might be a flying figure, with a distorted hunchback rushing after it. As I followed these fancies it was wonderful what a tragic story that sunset sometimes told me before I was done with it.

Once I was staying with a gentleman who added phrenology to his other accomplishments. He asked me if I never tried to write poetry, and I said, 'I had not'; to which he replied, 'Then try it, for I think you have the gift.'

I sat down that night and attempted to make rhyme, but as I did not know much about the rules, and had no subject, I cudgelled my brains for words and rhymes without considering what was my theme, and therefore I failed because I had nothing definite to write about.

As far as I can now remember, I think that my first attempt was a love-poem; but as I had never been in love, and had no woman to stand before me as a model, and no experience to serve me for the emotional part, it was all vague, and the result was exactly what might have been expected—meaningless words.

Had I contented myself with writing about what I saw and knew, I might have made something.

And this was what I learnt afterwards, after many failures: never to take up my brush or pen unless I had something definite to do—that is, never to depend altogether upon inspirations; have the object first vividly before me, and then it is not difficult to describe it, so long as one does not try to improve upon the model, or go out of the way to write or paint too finely.

I discovered, after a great many failures, that nature cannot be improved upon, or even approached very near, and that the utmost my imagination could do was to put into recognisable, if faulty, shape whatever stood before my eyes, or the feelings which I myself experienced—in fact, I learnt that what we call imagination is not the gift of creating things out of chaos, but rather the remembering of emotions and scenes and real personages, and that the more vividly I could remember, the better work I did.

Then I knew that Shakespeare's mighty genius lay in his vast powers of observation and in his direct simplicity of expression, and that the great

charm of his characters lay in their reality, for they were people whom he had met and studied.

But I did not learn this all at once, as I have said. I had to go through the preliminary stages of vanity and vexation of spirit, stages when I wallowed in paint and ink, fancying myself heaven-inspired, and beyond the necessity of using my eyes if I desired to do anything fine. It was all very well for sketches to look somewhat like nature and to be particular with them, but for finished work much more than this must be accomplished. So I struggled on spoiling canvases and good paper, before the age of common sense arrived, and never valuing the best works of all, which were my direct notes and sketches from nature.

It was the aboriginals of Australia who put me first upon the right track; a miserable, low-caste race they appear to those who see them hanging about the white settlements, clad in fantastic rags, the cast-off garments of the white fellow, and taking, with the rags, all the debasing vices of the conquerors, but a very different race when in their native wilds, with their mystic institutions and hereditary laws.

We are so apt to despise these black fellows, and to classify them all as savages and benighted heathens, particularly if we know nothing about them—as we did with the Indians and Peruvians, Chinese and Japanese, before our eyes became opened to their wonderful arts and ancient mysteries, their sciences, philosophies, and spiritualisms. Nowadays, like all people who take extreme views, we are rushing into the opposite direction, and adopting, with blind credulity, all which we formerly as blindly despised.

Our markets are crowded with Eastern and Japanese wares; our apartments are becoming Oriental, and crammed with those artistic realisations of nightmare monstrosities which the opium-smoking children of the sun delight in. Fortunately, we can purchase specimens of these eccentric artists cheaply, and, for the money, marvellously well done; yet, graceful or quaint as these designs may be, to the art mind they are as dangerous as the opium habit from which they are generated.

They are all morbid outcomes of an unwholesome and unnatural taste, suggestive only of that refinement which is *blasé* of tenderness, humanity, or morality, and which is nearly past all excitements except such as are

monstrous and beastly, the demoralising refinement of decay. Artistic?—yes; we must grant to them the praise of artistic execution; but this is the whole length which we can go in the matter of praise, and this is not enough for art to be of real utility to daily life and its hourly obligations.

Oriental art is pitiless and cruel as a reasonless monster in the lesson which it inculcates—cruel, fatalistic, and emotionless, therefore to us Westerns enervating and demoralising. The real philosophers and humanitarians of the East are contemplators of nature direct, and they only represent the objects of their veneration by obscure symbols, never by blasphemous caricatures; it is the unbelievers of the East and the demon-worshippers who give us these nightmare creations, and who have gone beyond the dreams of Paradise. No flower-land opens up to them in their periods of opium-stupor; it is a land of gloomy shadows and dank, dead leaves, through which crawl reptiles and noxious insects, or ghouls loom up grotesque and horrible, and these weird remembrances they embody in artistic shapes on bronzes, rare lacquer-work and tapestry, and send out broadcast to demoralise the world of modern culture.

And now let us consider the result of all this siren false art upon our daily lives. Insensibly the deadly poison is imbibed in small doses, until the strength and clearness of daylight look garish to us, the direct colouring of nature appears too raw, and we can no longer inhale a full breath of life as it is given to us, unfettered, into our vitiated lungs.

The faith which was all-sufficient for our ancestors is discarded, not for atheism, but for a mysticism infinitely more childish and superstitious than the religion which we superciliously term superstitious. Witness such pitiful exhibitions as those impostors, so-called 'Aissouas,' who recently disgraced London with their disgusting and fraudulent tricks—such-like flimsy performances as we have been accustomed to see at penny shows at country fairs since our boyhood, only in the case of these Eastern shams not half so cleverly executed as the feats done by the ordinary country showman.

This is where art has such a resistless influence upon our daily lives, and why we should be careful to discriminate between the true and the false.

False art will make us cruel and remorseless—that is, the personating and choosing of monstrosities; and the more artfully they are designed, the more degraded and callous we must become, and the more deeply we must sink in

our moral perception of what is good and noble in humanity. And while we sink step by step, the more morbidly vivisecting must we become, and as we have grown accustomed to the study and contemplation of distortion, the more distorted will be our views of everyday life: humanity will represent only a field for the investigation of developed or undeveloped vices and ignoble desires; there can be no possible room for virtue or lofty aspirations in the life which we take up to vivisect; in fact, before we have got half-way through with our cold-blooded, one-sided investigation, it is no longer life which we are cutting about, but a putrid corpse.

So much for those who are artistic or literary under these distorted circumstances. The others, who are not so gifted in intellectual qualities—but who have the same aspirations, and develop in action as the others do in thought—become by unnatural progression such epicures in horrors as the White-chapel monster whom we have come to know as 'Jack the Ripper.'

True or healthy art is content with the directness of the example which nature sets before it, the result of which is faith in beauty, faith in virtue, and a hopeful toleration of vice.

Vice to these students is no more the natural aspect of humanity than blight is the natural state of the leaves upon the trees or flowers; it is a diseased state, which must be endured, but may be eradicated. By constantly watching the healthy life they come to comprehend the causes for the unhealthy more quickly than do those who morbidly brood upon the blighted portions only—i.e. their comprehensions become more vivid, and their minds more robust, for our health depends entirely upon the food we feed upon. People may accustom themselves to feed upon poisons, but if they do, it is utterly impossible for them ever to live upon anything else or to be able to exist without their daily dose.

To come back to my own experience in my search after nature. When mixing among the natives of Australia I got the first revelation of what I ought to do. I saw that they had many wise laws, blending with much that was ugly, gross, and superstitious. Some of their rites appeared contemptible, but even these rites perhaps appeared so owing to my own imperfect knowledge of their origin and the secretiveness of the natives themselves regarding them; yet some of their laws were clear enough and good enough to be adopted by the most civilised races with advantage. Their marriage laws and stern strictness regarding consanguinity stand, with

singular force of natural wisdom, out from a mass of apparently reasonless rites and mysteries.

In their wild state the Australian tribes are a muscular and well-formed race, considering the privations from want of food and water which they have to undergo at times. This scarcity of food and long intervals between rains have forced them to become nomadic in their habits, and account naturally for the want of homes or villages and the rudeness of their places of shelter. Where people are compelled to shift often, they do not care to adorn their temporary homes—a few shards of gum-tree bark are good enough to keep the dew from them at nights, and the sun-rays are never too strong for them during the day. They are accustomed to take long marches and endure hunger and thirst on the way, so that they have no place for weakly members. If such are born, they are promptly killed as soon as the fact is discovered. If they become weakly afterwards, then such are doomed to a life of celibacy, so that the tribe may not deteriorate.

I noticed that their ideas never went beyond what they were accustomed to see constantly about them; that the origin of their characteristic weapon, the boomerang, was the eucalyptus leaf, that long leaf which turns its thin edge to the light, and when it falls from the tree circles in its descent as do those formidable implements of defence; that in their songs and dances they told a tale of nature as they saw it; and then I began to understand that where their strength lay I might find mine also, and so I became a realist, and learnt never to begin a sentence or paint a sketch unless I had a definite object, with its shape, size, colouring, and character vividly before me.

Then I advanced another step in this primitive school of nature. I learnt that these people never wasted words when they wished to express themselves, and so I began to see how much stronger brevity is than ornate and laboured phraseology, and how much finer an ornament is when standing isolated and in no way disguised by superfluous flourishes; and then I think my education was complete as far as the Australian aboriginal could instruct me.

I very soon found plenty to do, and never afterwards wanted a subject. I studied the gum-tree, with its perfect flower, where the male and female are united from birth, and those medicinal leaves which look so sparse, but are so closely put together, the density of which can only be seen when the hurricane blows them about until they are like our willow-trees at home. I

watched the sturdy, twisted, gleaming branches, like great white snakes, so different from any other branches of trees, until I grew to love them.

(I remember how an all-wise art editor once objected to one of my representations of a gum-tree because he said that the branches were so *serpentine*, and therefore not like the trees which he had been accustomed to see. I might have overlooked his ignorant remark, but I found it difficult to forgive his sending my drawing to another artist, who took the *serpentine* appearance out of the branches, and so made them appear like the trees to which he had been accustomed, before it was allowed to be seen in print, and I have often wondered what the people accustomed to real gum-trees have said about this London-manufactured gum-tree.)

Those wonderful gum-trunks, with the bark hanging in long strips from them like fluttering rags of brown sails! Mighty trees, some of them rising four hundred feet into the blue-grey sky, and large enough in girth to make good-sized houses, yet appearing beside their giant brethren just like ordinary trees, until we began to measure their circumference—size is so deceptive in this strange and vast sun-bathed land, Australia.

What a deal I have written already about this one tree of Australia, in all its many varieties, and yet I feel so much more than I can ever express, either with brush or pen; it has grown so much a part of myself.

What poetry may yet be written over its glory, as it has been felt and written about the grand old oak of England! The gum-tree of Australia, with its twisted limbs and tough heart, as broad-spreading as the glorified tree of the Druids, as mighty as the gigantic pine of California, with a character all its own and stamping it alone as a king of trees; an iron monarch against which the axes of the woodmen break their edges and turn aside; a beneficent ruler, for at its foot lie wells of water to quench the thirsty, and in its leaves the most potent medicine to cure disease.

How I have studied it in the rosy dawn when the hidden sun changed the upper branches to vermilion, and the crowds of paroquets and cockatoos which it had sheltered all night woke up at the welcome sight of day; how I have watched it in the sun-glare, with each outline sharply defined, while the strong-beaked laughing jackass bent, over a bare, snowy limb, and watched keenly amongst the underwood for its victim, the venomous snake; and I have been often startled by the bird's uncanny burst of mockery, when, after

darting down and grabbing the snake, it swiftly soared high in air, and from a great height dropped the wriggling reptile: it was then the bird, misnamed a jackass, laughed wildly as it watched the snake fall prone to earth and break its back.

I have seen it too in the afterglow, when the gaunt limbs became salmon-tinted with a ghostly gleam over the forest, where deep shadows were gathering fast; and in the dazzling moonlight, when they stood out like great pillars, row upon row, mile after mile, as I rode along, without seemingly a termination, some with the leaves drooping in black masses, while in other parts great tracts of country were covered with dead wood, where the forest fires had passed and shrivelled up their lives, or the squatter had destroyed them for the sake of his herds; but dead or alive, they stand year after year majestic and assertive of their rank as lords, like solemn sentinels keeping guard over a silent land.

What I mastered in Australia I carried with me to other lands, trying to learn what the tattoo markings and tapu laws meant amongst the Maoris of New Zealand, the punctilios and ceremonies of the South Sea Islanders, and always getting my attention turned back to nature direct when I was inclined to wander from this purpose or grow at all self-sufficient or inclined to lean upon my own resources.

It was my failures which ever and again proved to me that I had no resources of my own to fall back upon, and that I was only wasting my talents when I tried to take my eyes from the face of nature; she had proved herself all-sufficient for every imagination which I could ever hope to conceive, no matter how long I lived, her school the best college, and herself the only instructress which I needed at this advanced stage.

It is a glorious experience this spread-out nature college, which I recommend to everyone desirous of being regarded as original; an ever-varied series of lessons, the chief charm of which is that each student can only take away a little to call his own, leaving a full treasury for whoever cares to come after him.

Copy great masters and read the best authorities; you will see what they were able to take out of this treasury without diminishing its riches; but do not borrow or try to wear their jewelry, for on you they will be second-hand adornments; besides, to do so will be as foolish an act on your part as if you

were to put on a suit of clothes made for and worn by someone else, instead of taking the clothes which have been measured and made expressly for yourself.

Of course you must learn to understand how to choose what is best suited for you, and for this purpose you must go into strict training, so as to learn the laws and rules which these masters all had to learn first, and improve upon as they progressed through the preliminary stages towards that wider school in which no earthly master could guide them.

Like 'Johnny Ducks' in my story of 'Eight Bells,' I left home pretty early to begin my wanderings, but before I left home I had gone through a stiff training with different masters; in fact, I cannot remember the time when I began to study drawing and painting, but it must have been long before I began the alphabet, for I can recollect that event very clearly, with a few of the ordinary incidents connected with it.

Both my parents were artistic and lovers of literature and art. The love for books had been in both families for generations, as well as the taste for travelling; many of my ancestors had been great travellers, while not a few of them had paid the penalty of their lives for their curiosity to see the world.

My father painted mostly in oil-colours, landscape and figure, and he had gone through a very careful training under some of the best masters; my mother painted in water-colours, and her *forte* was flowers and fruit; so that I had the benefit of watching them, and getting trained almost insensibly to myself. I painted my first landscape in oils when I was six years old, a copy of a picture lent to me by my first outside master, before he sent his own to the exhibition, and which he allowed me to sell afterwards for two guineas— to me at the time a very large sum.

I can remember this picture most vividly, for the reason that I had to do it twice over before my father was satisfied. The first canvas was so badly done and enraged him so much that he broke it over my head as a warning to me to be more careful; the second attempt must have been better, for, although he did not praise it (he never praised anything I did), yet he did not condemn it, while one day, as I was sitting under the table unseen, he brought in a gentleman to look at it, who said 'it was wonderful.'

My next master was a German designer from Munich, who taught me ornamental drawing; he would not let me touch my paint-box at all while he

was present, but kept me strictly for over three years to charcoal, pencil, and cartridge paper. At first it was straight and curved lines only; next ornaments and friezes in relief; in my third year he allowed me to draw leaves and blades of grass from nature also in the wintry time the bare trees; finally, before he turned me off his hands he made me arrange flowers and shrubs into groups, drawing them first exactly, and next turning them into ornamental shapes and designs.

After him, I passed through the hands of a portrait-painter, drawing and shading with charcoal only from the life. Then I painted the same in monochrome in oils (I did not attempt water-colours, except to do flowers in the wash style which my mother had painted for many years).

As a relaxation my father allowed me sometimes to paint pictures in oil from nature. With some of my boy friends, I went out on Saturdays sketching. We formed a club, and saved up our pocket-money to reward the best painter, the umpire being the landscape-painter who had all along been my friend and instructor in landscape-painting.

While thus trying to master in practice the A B C of art, through the long winter nights, after I had learnt my school lessons for next day, my father made me read all sorts of books on the theory of art in its many branches. He used to mark off portions which he wished to impress upon my memory and make me write them in my exercise-book. In this way I copied off the greater part of M. Chevreul's 'Harmony and Contrast of Colours,' a very long work indeed.

Then came the rules of perspective and measurements, also artistic anatomy. I worked first from Dr. Knox's book and that of Leonardo da Vinci. Ships had always a great fascination for me, and I used to read and copy from all sorts of books on this subject, principally shipbuilders' manuals and seamen's navigation guides.

My father, besides his painting, had also studied many other sciences— geology, mathematics, astronomy, and botany. I fancy his favourite pastime was botany. He saved me twice from being poisoned, through his knowledge of plants. He used to tell me about the stars and their distances, and how, by the aid of mathematics, he was able to measure space, and from that I began to have, what has been a passion with me ever since, a desire to know all about the early nations and how they grew, with their myths and religions.

So my daily life was impregnated with art and science—art chiefly, into which all the others merge. I may say that I was twelve years grinding at the preliminary portions of my art education. It took me nearly eight years to write the twelve parts of my 'Life and Nature Studies,' after I had gone over the world for the first time, and in this book I have tried to write what I had learnt during my travels and before them—that is, about twenty-six years of art study, and I do not think that I can advise anyone to attempt to master the principles of art in a shorter space of time.

I would divide the time thus: Five years to hard outline drawing (the younger the student begins, the more facile his hand will grow), five years to anatomy and the life, and the rest of the time to the countless difficulties which he will constantly encounter, and which will give so much pleasure in the conquering.

It must be admitted that, at the first, straight and curved lines are no more interesting to the art student than are the pot-hooks in the preliminary stages of calligraphy, but they are both equally necessary for the making of a free and pure draughtsman and writer. By-and-by, when persevered with, these lines become a positive pleasure to indulge in; so much so, that the veteran artist when he is idling an hour away, if he has a piece of paper before him, or with his walking cane, will unconsciously revert to this early practice, and draw flowing parallel lines upon the paper or on the sand. What was once a severe task has thus become a relaxation.

I would not also insist upon only dry and hard grinding during these preliminary years (some authorities do), any more than I could expect a man wishing to exercise one muscle to leave all the rest of the body inactive. I would rather advise students to exercise all their faculties as well—colours, gradation, outside sketching from nature, copying in galleries and from the life; only never let them forget that this is the one muscle which they *must* exercise regularly and without intermission, for it is the all-important factor of their future lives.

Everything helps art, as art enters into everything: music, poetry, science, history, romance; in every walk of life which we may enter upon, it must be ennobled by art, while the draughtsman has a decided advantage over the man who cannot draw.

Are you a gardener? To be a master of the craft you must learn the laws of form, colours, arrangement, and symmetry. A tailor? If you can draw well you will become a cutter-out. In fact, I do not know the profession or trade where it does not enter into and advantage the man who has it to command.

All this it does in its practical, money-making, worldly side, which is to me the under-side of art; for, after all, money-making, although a very useful accomplishment as far as the world goes, is not a very noble or high gift, excepting for the power which it gives to the lucky possessor to do good to his less fortunate fellow-creatures. Where art comes in and fulfils its highest mission is the almost limitless range which it imparts to the votary of intellectual pleasure and ethic enjoyments. We are all born with eyes and senses of taste, smell, and sight, &c., it is true—that is, all healthy beings are so blessed—but it is art which takes the grosser films from these senses and renders them acute, so that each pleasure may be multiplied a thousandfold.

The ears can distinguish sounds as they are given to us. Art makes them appreciate music. The eyes can see hills and valleys. Art makes them take exquisite pleasure in forms and colours, a keener appreciation in all which comes within their range. It is the education and refinement of all the five material senses.

But it also passes these outer gates, and impregnates the soul until the imprisoned Psyche can burst from her fetters and spread out her gossamer wings to the warmth and golden light of the Love-world. Whoever is once really touched by the purifying kiss of art can no more go back to the fog-land of debased desires or commonplace than can the butterfly return to her caterpillar state of crawling. He must soar over the heads of the grubs, joyous and free, basking all the days of his life in the sunlight of sensitive impressions. Pity claims him as her favourite child, and Charity, the divine, breathes upon him for ever with her fragrant, life-giving breath.

CHAPTER V. ON PICTURE LIGHTING.

EVERY art-worker, whether his materials be palette and brushes or camera and dry-plates, must feel the greatest interest in the subject with which we have now to deal.

Lighting is the art of placing the sitter or choosing the landscape under the most favourable aspects for effect.

From this we are able to grasp the form in all its firmness, and see the finest play of colour, or, if ignorant, embody only a disjointed object, apparently badly drawn because it is badly lighted, with the finest passages of colour, and all the poetry and pathos of our intentions lost through lack of a little consideration.

Some painters, in breaking from the Academy rules, show their independence and immature audacity by revealing to the public ugly slant-laws and unpoetic phases of realism; but with those who discard knowledge for a purpose we have at present nothing to do, our task being to speak about a few of the necessary lines of action, and to prove their utility by the effects as seen in nature every day and in the works of those men who have left a halo round their names by their faithful adherence to the laws and truthful translations of the revelations of nature; for the great men of the past and present are those who grew strong by looking on the face of this divine mother, whilst the little men, who are forgotten or may be passing into oblivion, are those who were mighty in their own conceit, who depended only on themselves, and hearkened weakly to the chirruping of flatterers.

This point I wish to place before you rigidly, the unflinching adherence to nature, for it is a much wiser thing to risk forgetfulness by the faithful rendering of commonplace effects and forms than to lose yourselves altogether, seeking after a beauty that is not of heaven or earth. In the first case you may be passed over without comment, yet you know that you have used the one talent bestowed upon you, and if so, you cannot die altogether unknown; but in the other case you will only startle a crowd, as the fiery meteor may startle, to drop out of sight without a trace, excepting, it may be, the trace of a stain.

In light and shade there are what we may term *phenomenal* laws, as rigid in their demands as those rules which can be regulated by measurement and proportion, and which the artist ought to observe as closely as he may do the

more ordinary or everyday phases of lighting; for example, a fly darting suddenly from the deep shadow into the strong light will in the first startled glance assume the proportions of a crow.

In a picture of the 'Tercentenary Students' Torchlight Procession of Edinburgh, 1884,' I intentionally made the horses and portions of the crowd unduly large, on the same principle as the exaggeration of the fly.

My reasons for doing so were just and strictly according to the reality of a momentary effect; I state my reasons in order to show you that I was right in doing so, and also because I dare say this may be one of the objections to my treatment of this particular subject. I take up the position of a spectator whose pupils have been dilated by the semi-darkness, and who, with imagination active, is suddenly startled by the flaring and irregular flashing of the waving torches; shadows dart up to colossal proportions, also prominent objects, such as the mounted police, and it is only by means of this distortion of size that I have been able to give motion to the crowd, along with the weirdness of such an effect.

I would ask all who have seen a torchlight procession to recall the sensation, as closely as they can, when the first burst of torchlight came upon them, for that is the moment I have attempted to fix upon my canvas; and those who have not seen a large crowd under these conditions may imagine what it would be like by the aid of fire or torchlights which they have seen at other times. I would ask you to exercise the faculties of memory or imagination while I give you a brief description of the emotions it roused in my mind as one of the many thousand spectators, and the effect it had upon my seeing faculties, which will enable you to comprehend my motives for working as I did, preferring the *strict reality* of the instantaneous phase or impression to the *actuality* of the known form. (This I give you, not as an apology or explanation for my picture, but as the nearest illustration I can think about, at present, of one of the phenomenal laws of lighting.)

We were standing upon a house roof, looking over the city. Right and left lay Princes Street, with the Mound at our feet, and Scott's Monument in the middle distance.

Most of the time we were in darkness, with the exception of one or two straggling candles at windows here and there, at wide intervals. A mellow glow at the south end of the North Bridge, a blue light behind the

Monument, an occasional rocket fizzing from Calton Hill, also faintly illumined with white and blue fire, into the umber-tinted darkness of that starless, cloud-bulging sky, and the alternating glaring from Hanover Street of rose-coloured, white, and green lights, which dyed the upturned faces of the crowd and the columns of the Institution in a broad line with the scarlet or emerald colour of the fire then burning, for a few pulsating moments of eye-nerve-straining.

Then fell a deeper wave of darkness as the light passed from us, rushing over the heaving masses below, whence rose up that sympathetic thrilling sound which ever grips and holds the hearts of a crowd like one heart, and over the houses, with their lights dashed out for a moment by the passing away of that more intense light, all preparing me for the fantastic sight we were awaiting.

Then increased the murmuring louder in its hoarseness with the sound of many feet trampling, and as we looked towards the North Bridge, where the lamp-lights showed faintly, the yellow glare of the advancing torches gilded the sides of the opposite shops, while the houses on this side became more jetty in their intervening blackness, and in another moment they were blazing over the parapet of the bridge with a motion like the walking of a centipede of fire; and so on, with the slow appearance which distance always gives to all rapid motion, the procession crossed the bridge, hiding behind the shops and houses between the bridge and Princes Street, reappearing again by the Post Office, gliding along to Calton Hill; then they paused for a moment, turned round and came towards us, foreshortened, but growing vaster as they neared, until, with a sudden burst, they were rolling along beneath us, a heaving mass of upturned faces, crimson-tinted, with a river of yellow light rolling along the centre, white flames with orange terminations and wreaths of blurring rose and purple smoke, coats reversed, shirt sleeves or bare arms waving about the torch-sticks, smut-grimed faces, more like sweeps than students, with here and there a colossal blue-vestured guardian angel of order bestriding an exaggerated horse.

This is how it appeared to me and how I treated my picture—as I conceived it ought to be treated; not as I knew the men and horses to be, men and horses, but like the perturbed legions of spectres they for the moment became: ghosts of giants and dwarfs, and other strange forms, like those extinct monsters of the past, all whirling madly past me, a vision of passion and flame crossing a chaos of darkness; an invasion of demons, unreal, yet

fascinating—a nightmare of glittering phantasmagoria of light and shadow, blending colour with intense blackness.

In this illustration I have given you the two most direct specimens of lighting a picture that I can think of; in the one portion you have the light coming from behind and making the objects stand out dark, as in sunrises, sunsets, moonlights, or artificial lights behind figures; in the other portion you have the light thrown into the picture, as from the spectator, or in open daylight, sunshine, or lamp-light effects, when the light is in front, and shadows fall behind or from the side.

I have divided both effects, as equally as they can be divided, into light and shadow, the light occupying an equal space with the dark. These are by no means the most satisfactory methods of dividing a picture, as they are apt to be mannered and fixed; what I would rather advise is, to allow either shadow or light to predominate—shadow, if force is required; light, if air and delicacy are the aims you wish to strive for. Yet, as they contain within them the primal divisions of all lighting, they are the most appropriate for my present purpose.

In both effects the treatment is extremely simple, yet in the one, when the light comes from behind, simplicity and directness are the more strictly necessary; indeed, in painting a subject with the light from the back, the energy of the painter should principally be directed to the gradation of the shadows from misty distance to direct foreground, having as few lights as can be dispensed with for the sake of form.

In the other, the time of day must be considered with the direction of the light, so that it may pass directly and consistently throughout all parts of the picture.

There is one strict rule I would have you bear in mind when sketching outside; remember that the whole of your picture only represents a second of time, the flapping of a drop-shutter over an instantaneous plate. It will never be like nature if the light upon one part falls half an hour before the light falls on another portion; so in planning out the dispositions of your light you must do as the photographic camera does. Fix one second upon the plate of your memory all over the scene, and try to work up to this second.

The mechanical worker, who thinks he is a much more conscientious artist and lover of nature than the impressionist, because he sits down with his

palette and canvas to his easel before nature six or ten hours at a stretch, is much more unfaithful, even to the image he so patiently tries to copy, than the impressionist, who, glancing rapidly and comprehensively round, makes a few swift notes, catches the spirit of the effect, and depends upon his memory, or a faithful photograph of his image, for his detail afterwards. We may blink at this as much as we choose, yet pre-Raphaelitism must come to its proper place in good time, and be shut in with the antique casts of the schoolroom, with the young men and women student days, shut in along with their cross-hatchings and point-stipplings, to be laid carefully in their boxes along with their gold, silver, and bronze medals, and other school prizes, when they come out to face flesh and blood, broad daylight, and the world that will not wait upon the crochet-meshes of meaningless patience.

I would not have a painter work a single line without having a direct meaning for that line—not only a direct meaning, but a very potent intention, which cannot be laid aside without injuring all the other parts of the composition; so in lighting, I wish to impress upon all the necessity for the strictest economy in the placing of the lights and shadows; too much protestation will ever weaken an assurance, so also too many lights will destroy the effect of light.

The other day I passed along a road when the sun was shining, a broad daylighty forenoon sun-effect, and yet that stretch of road only received the full force of it on one portion; silver-grey it spread from my feet into distance; in mid-distance it took the gleam of quicksilver upon it, growing blue-grey as it receded, and fawn-coloured as it neared me, darkening with the ruts and markings of the foreground—detail always produces darkness unless the light shines full and nearly upon it, and then it will be full of acute shadow and strong light.

Let us now divide our present subject, as Burnet has done, into five parts—light, half-light, middle-tint, half-dark, and dark.

He tells us that, 'When a picture is chiefly composed of light and half-light, the dark will have more force and point, but without the help of strong colour to give it solidity it will be apt to look feeble; and when a picture is composed mainly of dark and half-dark, the lights will be more brilliant, but they will be apt to look spotty for want of half-light to spread and connect

them, and the piece be in danger of becoming black and heavy; and when a picture is composed chiefly of middle-tint, the dark and light portions have a more equal chance of coming into notice, but the general effect is in danger of being common and insipid.

'Light and shade are capable of producing many results, but the three principal are relief, harmony, and breadth. By the first the artist is enabled to give his works the distinctness and solidity of nature, the second is the result of a union and consent of one part with another, and the third, a general breadth, is the necessary attendant on extent and magnitude. A judicious management of these three properties is to be found in the best pictures of the Italian, Venetian, and Flemish schools, and ought to employ the most attentive examination of the student, for by giving too much relief, he will produce a dry, hard effect; by too much softness and blending of the parts, woolliness and insipidity; and in a desire to preserve a breadth of effect, he may produce flatness.

'Relief is most necessary in large works, as their being seen from a greater distance than easel pictures prevents them looking harsh or cutting, and gives them that sharpness and clearness of effect so necessary to counteract heaviness.

'Not only the works of Raphael and those of the Italian school possess this quality, but we find it in the greatest perfection in the pictures of Paulo Veronese and Tintoretto; and even the larger works of Titian and Correggio have a flatness and precision which we look for in vain in the succeeding school of Caracci and their disciples, Guido excepted.

'Harmony, or a union of the different parts of a composition, depends upon the intermediate parts serving as a link or chain, either by conveying a sensation of the same colours with those in immediate contact, or by neutralising and breaking down the harsh asperities of the two extremes, and thus producing a connection or agreement. Breadth of effect is only to be produced by a great extent of light or shade pervading the picture. If an open daylight appearance is intended, such as we see in Cuyp, &c., it will be best produced by leaving out part of the middle tint, and allowing a greater spread of light and half-light; this will also give the darks the relative force which they possess in nature. If a breadth of shadow is required, such as we find in Rembrandt, &c., the picture ought to be made up of middle tint and half-dark. In the one treatment the dark ought to tell sharp and cutting, which

is the characteristic of sturdy daylight; in the other, the light ought to appear powerful and brilliant, enveloped in masses of obscurity.'

Burnet, in his treatise, gives also examples of light and shade taken from the different masters. Light coming from the centre in a bright spot or focus, with darkness surrounding it, as in some of the Dutch pictures, where the light comes through a window, from a bright fire, a lamp, or a candle, the effect will be a splash of white upon a ground of dark grey and black; light coming from behind, where the effect is open air with the ground light and the dark work starting out.

Light falling diagonally, almost equally divided, the light portion with the dark.

Light striking into the picture, and falling upon the most prominent object, if in a room, the effect will be dark background; if outside, gloomy skies, as in autumn, winter, or storm effects. In landscape, this effect is apt to produce solemnity, weirdness, or grandeur; if in a room, the sombre yet rich depth of Rembrandt.

Light falling perpendicularly and horizontally, as in doorways and narrow passages, where the light comes in with difficulty.

Light striking across the picture horizontally, as in sunrises, when the ground is in shadow.

Light striking sharply on one side, as when a lantern picture is thrown obliquely against a wall, making the nearest edge sharp against a deep dark, and drifting into shadow by degrees, thus founding the principles of light and shadow. Light-acute, half-light, middle-tint, dark-acute, half-dark, and middle-tint. Burnet gives a great number of examples to prove the justice of his theory, which to give here would only be a loss of time, as they repeat those different orders of lighting, yet I may with benefit quote the wise advice of Rubens to his students, where he says, 'Begin by painting in your shadows lightly, taking care that no white is suffered to glide into them, for it is the poison of a picture except in the lights; if even your shadows are corrupted by the introduction of this baneful colour, your tones will no longer be warm and transparent, but heavy and leady. It is not the same in the lights, they may be loaded with colour as much as you think proper.'

A sheet of white paper or a clean piece of primed canvas will give us a good idea of the value of shadow: make a stain upon any portion of its surface, say two shades deeper grey than the canvas, and you have the effect of light and half-tint. In open-air effects be sparing of your darks, so that strength and force may be the consequence.

A sheet of grey tone paper is about the best medium to impress upon you the value of tone. Make a mark with white chalk and a few darks, and the ground will give all the other qualifying powers needful; the fewer markings you make the more strength you must get in your effect.

In planning your picture, your first care, after the form has been seen to, is to ascertain where the lights are to come from, and upon what they are likely to fall; nature is our best guide in this, yet nature must be followed with great caution, owing, as I have said before, to the rapidity of her changes; also the superiority of light over white, and shadow under black; we see, for example, degrees of light without shadow, and degrees of shadow after the greatest depth of darkness has been attained, and these we can no more follow than we can follow the separate blade-markings on a grass-field; as in the one case so in the other, we must suit ourselves to our limited means and simplify the whole matter, gather our lights into a narrower and more concentrated focus, and depend upon the half-tints and reflections for the greater part of our picture.

If we see a dozen ripples of light, be content with the capture of one light, and let the other eleven become half-lights or vanish altogether; so shall we secure force.

Devote our skill to those half-tones which in reality mean the labour, pride, and test of the painter, even although it is the high lights and deep darks that finish the picture.

As I have said, there are only about half a dozen ways of lighting up a picture—eight at the most—and all the pictures in the world, when painted scientifically, work upon those eight direct or combination arrangements, as in composition the varieties turn upon two primary laws, angular and circular arrangements, and in colours upon three colours, and it is in the strict observance of those scientific ground lines that the entire success of our design or picture depends; but, above all, the whole secret of scientific and artistic success lies in the extreme singleness of our aim; we must not

confuse or combine two opposite laws in one composition, or else the blending will end either in utter failure, or in a doubtful success which will not be worth the trouble and labour expended.

CHAPTER VI. SHIPS: ANCIENT AND MODERN.

IT may be that I am prejudiced by love in favour of the sea and the burden which it bears upon its bosom, but to my mind, man has only been able once to compete successfully with the designs of nature, and that was in his ship-building. When he completed those masterpieces which helped to make Nelson and England famous, he reached the apex of his attempts to rival nature—indeed, artistically speaking, he eclipsed nature's most picturesque effects when he put out such beautiful and perfect creations as those which sailed into Trafalgar, after which he proved his mortality by becoming commonplace; while nature, the calm and unimpassioned, continued her work of beauty and devastation unconcerned, permitting him to blot her plains with his mastless ironclad monstrosities, until her hour of retaliation arrived.

Look at his cities, houses, churches, palaces, and castles in their newness, and you behold objects on the landscape without which it would be more complete; nor until Time has laid his artistic touch upon them—painting them over with delicious grey tones and rusty stains; dismantling doorways and windows, causing a rent here and a crumbling there, like arabesque work of an old-world character; putting the same vividly fantastic faces and figures upon the once smoothly masoned block that he cuts out on the cliff-face, and so harmonising the uncouth evenness with the grandly mosaicked boulder; festooning bare and gaunt spaces with wreaths of ivy, clustering ferns, and gnarled branches, and generally qualifying the russet shades with fresh patches of moss or silver glistenings of lichens—do the crumbling castle and deserted cottage begin to take their places as items in the unity and harmony of general creation.

But the ships of Nelson's and Collingwood's period Time cannot add to or improve; their newness and freshness only help the perfection of their grace and loveliness; from the moment they glided between the greased slips of the building-yard to the solemn hour when they settled down to their last repose, they were objects of interest and beauty.

See them riding on the smooth waters and repeating themselves from the tapering top-masts with the fairy mesh-work of cordage, like a forest of graceful trees in the winter-time, to their massive hulls, all gilt-work, colour and ornament, animate with latent strength and active grace; see them parting the curling billows with the snow-white sails bellied out, as they rush

jocundly on their journey to triumph or to death, looking like winged angels in the sun-filled air: it was this appearance of life and joy which raised man at that period from the imitator to the original creator, and so for the moment lifted him out of himself, and beyond still nature; there is nothing else resembling a full-rigged line-of-battle frigate on the surface of the earth.

See them sweeping into battle so stately and confident; the sentiment of fear or indecision cannot find a lodgment on one of their orderly yards as they swing round so defiantly; when they advance it is with calm pride in their conscious power, when they retreat it appears only as if to test their speed against the sailing powers of their chasers; in the hour of action how imposingly they gather up the clouds of white smoke, like the goddess Juno; and when wounded, how grandly they droop with their broken wings, enduring the buffets of the tempest with majestic protest, or settling down on the quicksand with the calmness of martyrs. There is something mean-looking about even St. Paul's or Westminster Abbey if we compare them with the Alps, but the ship cannot look contemptible in any position when upon her own element, the ocean.

The earliest vessel on record is the Ark, which was about eighty-eight feet less in length than our 'Great Eastern,' thirteen feet less in breadth of deck, and about the same height from keel to deck. History does not enlighten us as to its exact shape, excepting that it had three decks, and we are accustomed to depict it with sloping roof and mastless. Yet at the time it was built the inhabitants of the earth had advanced to a high state of civilisation and wicked inventions of violence and luxury, so that we must suppose they went down to the sea and to war with each other in great ships for Noah to have worked out this monster on scientific principles, otherwise he could not have balanced it from theory only. When it first began to float, he would require a rudder in order to keep it clear of the promontories which were as yet uncovered; therefore, although it is not mentioned, we naturally suppose that it was provided with steering gear. That he built it on the edge of a gopher-wood forest is also a reasonable conjecture, and on a flat, because of the unnecessary labour which it would have entailed to drag so much wood up to a mountain-top; therefore, although the builder and owner had no definite destination, he would require sails to carry him along past the obstructions, otherwise his steering gear would have been practically useless, and he would have been wrecked at the onset of his voyage. Taking all these matters into consideration, I have come to the conclusion that the ancient Ark was not the clumsy floating shed generally depicted, but that it

sailed away from the land of the wicked giants to its lonely destination, Mount Ararat, something after the fashion that I have pictured it, leaving the highly ornamented but deckless galleys of the doomed races to fill up and scuttle.

Like the building of the tower of Babel, that damp voyage must have had a demoralising effect upon Noah and his sons, because after landing we hear no more about ship-building until such times as the merchants of Tyre and Sidon began to navigate the world. The Egyptians had boats with masts and sails for river traffic, as we sometimes see depicted on their monuments and carvings, straight-built, decked boats with slanting prows and sterns, flat-bottomed, and with square cabins raised up in the centre of the decks; these were row-boats generally, and used mostly to carry mummies and mourners to the city of the dead from the living quarters, and for the transporting of cargo up the Nile. They had no war-vessels in ancient Egypt, yet some of their pleasure and state barges, although exceedingly stiff and formal in outline, were richly decorated and gaily bedizened, as were also their solid square houses and walls. Cleopatra's barge was a blending of the Greek galley and the orthodox Nile boat.

Indeed, it is very difficult at the present time to realise the banks of the Nile in the days of the Pharaohs, when on the one side of the river lay the palaces of the princes and nobility, and on the other lay the city of the departed, those vast buildings and high walls, emblazoned with painted figures of heroic actions, so that we may comprehend why the artists preferred flat surfaces to ornate walls; the broad steps leading to the reedy and lily-lined waters, and those gondola-like boats and gilded barges lying anchored beside every wharf, with the dazzling sun laving over the flatness of the land, and grateful shadows cast along every side street or covered mart.

Egypt suited this style of architecture and that description of shipping exactly; afterwards, when the Greeks came with their rounded hulls, crowned prows, and general lightness, traders of silks and purple cloths, the character of the country changed, and incongruities occurred which required the hardy Romans to correct. When the ornate galleys of Alexander covered Father Nile, Egypt lost her air of everlasting repose; but when the shield-lined galleys of Rome swept in, all became right again—the rightness of the castle which has been dismantled; the paint on the walls became dingy, the slime encrusted the granite wharf-posts, and Egypt settled down to her mystical decline.

At the great battle of Salamis, men had learnt to build war-vessels of great utility. The wily Greeks knew the value of small compact ships with strong sharp prows and swift-sailing qualities, because they had become a race of hardy pirates, whereas the voluptuous Persians, studying pomp and show, as did the Spanish later on, sent out an armada of mighty ships, great floating castles, which towered over the waves and were difficult to manage; so the agile Greeks darted in amongst the ponderous giants, and cut them up as our own sea-hero Drake did with the Dons. It must have been a fine sight from the hill-top where Xerxes watched the defeat of his armada, with the combat clear to the view and unobscured by smoke, those mighty hulls lying helpless on the waves with their purple sails, and the dauntless Greeks rushing down upon them, while the blood-red sun went down upon the hapless scene of destruction.

The Romans took their cue from the Greeks, and built small ships, vessels that walked the waters like centipedes; an ugly but ominous sight they must have appeared in their snake-like approach upon the enemy, dangerous in their steady utility when drawing over quiet waters, but almost useless in a storm.

After this time ships returned greatly to their primitive condition, and, like the Vikings, sea-rovers went in for small craft, deckless boats about the size of fishing craft, with easily managed sails; boats which could be worked quickly in rough or calm weather by a few men. These were the ships which devastated Europe and taught the shore-dwellers a lesson in naval warfare.

From the Bayeux Tapestry we are able to form a fair idea of the kind of craft which William of Normandy used to invade England—small one-masted boats, holding on an average a dozen men easily, although, I dare say, on this occasion they would be crammed like herrings in a barrel. An uncommonly uncomfortable voyage that must have been to the mail-clad warriors, with their war-steeds to look after in those cramped quarters; it must have made them doubly resolved to stay in England once they had reached it.

We see another example in Froissart of vessels of the fourteenth century, in which they had increased the size of the ships somewhat, without altering their shape much, but having three masts, instead of one, with single lateen sails on each. The anchor as we use it now comes into prominence in these pictures; but, if the men are drawn in proportion to the size of the ships,

exercise was not one of the benefits of a sea-voyage in the fourteenth century, and one is apt to sympathise with the Crusaders on their journey to Palestine. To us, who have gazed ruefully on the stormy waters of Biscay Bay, even from the lofty deck of a P. and O. packet, the experience has been a sad one; but such a voyage must have been simply pandemonium to those brave knights of the Cross in their cockle-shells, trying to look dignified before their esquires, with the weight of chain-armour added to sea-sickness, and no space to turn about.

During the time of the Lancasters and Plantagenets times improved a little with seafarers. We have the long awning-covered oar-galleys, capable of seating fifty or eighty slaves below, with accommodation for the passengers above; also properly decked vessels, with forecastles and stern cabins and deck houses; and shrouds for the use of the seamen when raising or lowering sails. They still used the single sails on the masts, and required a number of sailors to work them properly; here also we find the first appearance of tops where men could be placed for fighting purposes. At this period the ship as a picturesque object was beginning to take shape, but it was far from being a 'thing of beauty.'

In the fifteenth century we come upon the 'Henri Grâce à Dieu,' built for Henry VII., which is the nearest approach to a ship as we understand it. It is a four-master, with bowsprit, and three yards on each mast, with main and fore tops, and shrouds reaching up to the caps; a vessel fairly bristling with guns, and having seven decks to the cabin and eleven to the top deck of the forecastle. At this time Columbus had discovered the New World, and men were paying attention to navigation as a science.

The next advance is the 'Sovereign of the Seas,' built in 1637 for Charles I.: a three-master, and very nearly perfect in the matter of symmetry. Between the building of the 'Sovereign' and the 'Grâce à Dieu' England had made her first bold bid for the supremacy of the seas, and distinguished herself as a great maritime nation by giving birth to such heroes as Drake and Frobisher; after this she steadily advanced in her sea craft. The Armada was won by splendid sailors and very sorry ships, as far as appearance went; but after this date they improved until they reached perfection, as we can see in such ships as the 'Royal William,' 1670, on to the splendid wooden frigates and man-of-war ships carrying from seventy-four to one hundred and twenty guns, such as the 'Victory,' immortalised by the death of Nelson.

Those grand old days, when the ship and the men she carried were one and indivisible, are a dream of the past. When we began to sheathe our ships with iron and reduce our masts and rigging until they became shapeless monsters, the pride and security of the sailor vanished. The ship is no longer a portion of himself, it has become a dangerous machine, and he is only a passenger on board. In olden times, when the ball tore up the ship's side, the heart of the British seaman bled with her, and while she waited like a wounded lioness on his aid, and he rushed with his plugs and oakum to stop the rent or fix up the broken yard or mast, they were as man and wife; now, like a treacherous monster, the ship goes to the bottom when hit, and destroys all on board.

There was give and take in the olden days, like a bout at fists, and Englishmen appreciated the manly sport; now it is treacherous massacre and destruction to friend and enemy alike. The ironclad is as much the enemy of her inhabitants as she is of the rival against whom she wages war. What pride could the true British tar take in that pitiful siege of Alexandria, when all he had to do was to batter down a defenceless city from a safe distance, compared with the sailing into action at Trafalgar, where it was give and take? While, as for the next great naval engagement, when ironclad faces ironclad, what chance will they have for their lives? One sure discharge from the latest invention, and the doomed vessel will go to the bottom of the sea, like shot-laden and sewn-up corpses of messmates already 'gone aloft.' It is cowardly murder, not daring warfare, that we have arrived at in this nineteenth century of science. It was in the olden days of sailing vessels, when the seaman controlled every portion and worked lovingly upon every object of his ship, that the sympathetic affection for each plank grew upon him, until it became dearer than a landsman's house to him—indeed, it not infrequently usurped all other ties, and became to him wife and relations as well as house. As I come myself from a sailor breed, I know the engrossment well, and can understand the feelings of the captain who would rather sink with his beloved vessel than abandon her in the dark hour of danger.

But when ships became propelling machines, they no longer belonged exclusively to the sailor: he is only husband of the upper decks and now almost useless yards. The engineer is really the master of the position, while the sailor has become merely a scullery-maid.

The same may be said about iron ships. What sailor of the grand old school can take a pride in cold iron or cast steel? Dibdin's songs are a dead letter here. Indeed, I don't know any modern poet who could wake up enthusiasm over wrought or cast metal when it is used as a floating machine. 'Hearts of oak' we can all understand as Englishmen, for the oak is ours by birthright. But who can grow affectionate over 'plates of iron'? It is cold and deadly in its passive state, and when damaged it is beyond repair; it has to be taken back to the smelting factory.

Therefore, thinking upon this subject in an artistic sense, and regarding the future of great guns, torpedoes, and metal plates from a humanitarian point of view, while admitting that we have floating mantraps and murder machines nowadays, I place the limit on ship-progress as objects of gallantry and perfection at the date when we introduced steam machinery into them. They then sacrificed their poetic and artistic characteristics for commercial utility; while, as for their use as war-machines, that is a doubtful point upon which they have yet to be tried. One thing we do know, however, and that is—war no longer depends upon personal bravery; it is entirely a question of scientific accuracy and mathematical knowledge.

As a painter, I prefer to go back to the wooden walls of England for my inspirations; to the engagements between the giants and the plucky pigmies in the glorious fight of 1588, when the pigmies, like the Greeks at Salamis, knocked the giants into cocked hats; to the battles of the Nile, St. Vincent, Trafalgar, where each man had to do his duty without the dread of being blown up to the sky by some underhand torpedoes, or sent, without a moment for prayers, to the bottom of the sea by some superior and longer-ranged guns. I like best to think upon the days when men got heated up by glory, and fought hand-to-hand with their cutlasses and pikes, swarming over the sides of the grappled enemy with true British shouts, rather than to picture them standing in silent and grim order five or ten miles away from the enemy, waiting upon their doom. It does not seem sailor-like to see them watching like automata on the effect of each shot; to my mind, as an artist and a warm-blooded Englishman, it is too cold-blooded for Jack Tar.

We all know, from the original or from reproductions, Turner's picture of the Last Voyage of the 'Téméraire,' with its stately yet helpless dignity, compared with the fussy impudence of the long-chimneyed little tug-steamer which is towing her to her last home; the hoary veteran is doubly pathetic to me in view of all the *improvements* which have taken place in war-ships

since that splendid sunset which the great painter thus depicted: compare the 'Téméraire,' symbol of its kind and age, with, say, the 'Royal Sovereign' of 1891.

The 'Royal Sovereign,' with her solid smooth sides and back-sloping bows denuded of bowsprit and jib, with her stunted masts and mean-looking cordage, is a poor thing by the side of a first-rate man-of-war of any date up to 1855, with its filmy intricacies of rope-work, yards, and uppers. Do the waves and the winds claim a unity with the ship now as they did then? Compare a fleet lying in the roads now with one a hundred years ago, as depicted on some of the canvases of Loutherbourg, Stanfield, or Turner, for the best reply to my melancholy question. Even the Bay of Biscay has been shorn of its grandeur by the introduction of those great hulks, which cut over its gigantic waves with hardly a shake. Twenty-five years ago I could appreciate its might from the deck of an Aberdonian clipper; last time I passed through it and saw its raging from the saloon deck of a P. and O. steam liner, it would have looked ridiculous in its mimic wrath only for a passing glimpse I had of a little brig which it was playing high jinks with, as it tossed it up and down like a toy boat on a cauldron of boiling water.

I am sorry that we have had, so far, the best of the ocean, because we have lost a great pleasure when we go to sea—the thrilling excitement of being in a proper gale. I find it very hard when I now go upon the ocean to recall the fury of the storms which I have been in during past years;—that time I rounded Cape Horn, when the ice-charged waves appeared like mountains and valleys as we looked at them from the deck of our almost doomed vessel; that time when we were driven from the shores of Africa almost to within sight of America in one furious tempest; when the tropical typhoon broke upon us, and our three-master appeared like a dingey in the trough of those curded waves, while the lightning blazed and the fire-balls dropped from heaven and went past our creaking sides like red-hot shot into the seething turmoil. Ah! we cannot half appreciate the marvels and majesty of the ocean nowadays; it has become a sycophant to us, and only expends a little bombast for our benefit, as a relaxation after those superb ocean dinners, while we smoke our pipes or cigars on deck.

And yet not quite a passive slave is this mighty ocean to us modern epicures; there still remain the Goodwin Sands, the iron cliffs and the sunken rocks, to prove that man, in spite of his advancement in mechanics, is not yet complete master of the situation.

Biscay Bay may look played out as it vainly tries to curl its yeasty fury over the comfortable decks of the two-wave-long liner, which passes serenely over the crests with hardly a vibration more than the propellers give us; but if the screw chances to snap, as I have known it do in other waters, then what is she?—a huge log battered to death by the savage fury she has so long defied. Sunken reefs start up at times when least expected, and then, with one rasp, the ironclad hotel becomes a death-trap, whereas a wooden ship might have floated.

As for those mysterious, treasure-crammed sands, the Goodwins, like the poor, they are always with us, and always ready to drown their victims. Every year they claim their due of sacrifice, from the skittish smack to the ponderous East Indiaman, from the coast steamer to the heavy ironclad. Once the ship touches fairly with this siren, there is no parting; it is a gentle but tenacious embrace, and then come the rending of hair and the throwing up of arms as the sins of our past rush back upon us and prepare us for the choking of the remorseless slime.

And those iron cliffs, that, in the honesty of their rugged rage, break the masterpieces of man to fragments, they are better than the treacherous sands, for they do their work quickly, and with the aid of the angry waves.

There she is, the full-rigged piece of perfection, driving gallantly to her doom, with her curved bows, glistening sides, and ornamented stern, and aloft the forest of light wood and lichen-like tracery of cordage, her sails all furled, like a beautiful woman who has gathered up her skirts and means recklessly to run on in spite of wind or weather; so she rises over the crest of the shore-hurrying billow, and looks her best in that last supreme second of time.

A lurid instant the lightning plays about her perfect symmetry as she steadfastly gathers herself for the plunge; there is no fear or timidity about her as she rises for the last time, only the defiance of desperation; then the clash of doom comes, and she has dissolved like a spirit in the midst of the dazzling white mist.

CHAPTER VII. ILLUSTRATIVE ART: PAST AND PRESENT.

IT is not my purpose, nor is it within my province as an artist and illustrator, to give the history of illustrative art, with its rise and development; I leave that side of the subject to such masters as William Andrew Chatto, Austin Dobson, and David Croal Thomson, with the other specialists who devote themselves to the historical as well as the critical qualities of artists, past and present.

My present intention is to write as a workman about the work he is constantly engaged upon. I wish to describe the qualities of the different illustrators as they have impressed and influenced my work, trusting that in this I have a fair, open, and useful field before me.

I approach the subject with the greatest diffidence, because, when a man begins to analyse his own particular work, he occupies the peculiar position of being his own critic, and must either make a sacrifice of his feelings—i.e. his vanity, and natural desire to cover up his weaknesses and pose only on his few strong parts,—for, of course, every man who has had experience must know in his inmost consciousness his strength and failings (although it may not always be advisable to reveal the knowledge even to himself, far less to his critical friends),—or else be ruthless and strip himself bare for the benefit of those coming after him.

If I were only a critic, I could enter the lists in a jocund spirit and tilt away right and left as critics mostly do, satisfied that no one could pierce my armour and place me *hors de combat*; but when a knight goes to the tournament with armour a little worse designed than many of the coats of mail he is facing, or, at least, when he is aware of the sad fact, he does not ride forth so joyfully.

Nevertheless I shall endeavour, as far as possible, to lay aside my *amour propre* for the sake of my readers and give them the benefit of my experience, even although I may be wounded badly while I am doing so.

I take a few of the illustrated books which lie handiest to me at this moment, and make them the text for my remarks, which, as I have already said, I intend to make strictly practical rather than historical; therefore, I shall only touch upon illustrative work in the more distant past in so far as it may apply to the canons which I have laid down for myself to follow, and no further.

An illustrated book, to be perfect, ought to have nothing intrusive about it; no single picture ought to assert itself unduly, and so make the text with the other illustrations appear mean, washy, or weak. If the keynote struck is to be rugged strength, let there be no incongruity of super-refined and delicate lines; let the text be bold and assertive enough to suit the quality of the illustrations from the title-page to the end, so that the reader's eye may get accustomed at once to take a distant view of the whole, and not have to push the book back from him to arm's length on the one page, and bring it close to his eyes at the next. Books are like pictures, or ought to be—either gallery works, or produced for the cabinet; either to be admired from the distance, or else examined with a microscopic lens.

A coarsely painted picture requires a strongly designed frame; a book with coarse or strong effects in its illustrations also requires a strong text, deep head-lines, massive headings and title-page, and ornate binding; and to see the full beauty of this, and how perfect is the harmony of the lettering and edge-lines, I can only refer my readers to one of the earliest of wood engravings—the 'St. Christopher,' dated 1423 (original in the possession of Earl Spencer). This seems to me a very perfect specimen of what ought to be, in quality and just balance. The drawing is in outline, massive and decided all through, without a single unnecessary line; the descriptive lettering is black-letter with broad band round it. In its present position, in the centre of the modern text, it suggests two ideas—either that it is too coarse for its present surroundings, or else that the text is too fine; therefore, to be seen to proper advantage it ought to be enclosed in a black-letter text. Contrast this as to general harmony with the two *reduced* copies of outline work on page 72 in the same work; here the illustrations, although bold in the original, by reason of the reduction, have been brought more into unity with the modern type. You can see both pictures and text in the first glance without any extra effort, whereas in the 'St. Christopher' page, the picture intrudes itself, and almost requires to be covered before the reader can enjoy or settle down to the text. Of course, in a work of this kind, where different specimens of engraving must be shown, the authors have no choice in the matter, and perfect unity cannot be studied.

Looking over these old engravings, one cannot help being struck, not only with the boldness and decision of the technique, but also with the consummate restraint and knowledge of effect displayed by the worker. Perhaps amongst our modern living men Walter Crane is the only artist who exhibits a similar courage and grasp of the essentials. (See his 'Queen

Summer,' published by Cassell & Co., for some of the best and most characteristic work he has yet given to the public in book form.)

The next stage in illustrative art which we have to mention is where cross-hatching has been introduced, to give depth and richness to the shadows. The earliest style of work shows only outlines, which are in many cases to be preferred to more elaborate work, particularly when inserted with the text; after this, shadows are suggested by single lines, as in the specimens which I have quoted.

Cross-hatching appears to have been used first in the year 1486, in a frontispiece to the Latin edition of 'Breydenbach's Travels,' which was printed at Mentz by Erhard Reuwich. The name of the artist is not known—a sample of modesty characteristic of the early inventors; for the work upon this plate is as beautiful and elaborate as it is unique at this early date. With the introduction of cross-hatching, used at first directly, horizontally and perpendicularly, we get the *feeling* of colour and tone in illustrative work which are its most pronounced features at the present day. In this we have advanced, and are still advancing, day by day to a perfection of feebleness, with lack of distinctive character and force. In outline drawing we have not improved since the close of the fifteenth century—to wit, the Poliphili of 1499, where the lines are perfectly modulated to suggest light edges and shadows.

We next come to the beautiful work of Albert Dürer, where he uses the cross-hatching diagonally, as it is executed at the present day, with broken lines and dots, where such were required. In fact, this rare artist seems to have had all the tricks of the trade at his command, and to have paused at no device in order to gain his effect. I shall not describe any of his work here, as it is sufficiently well known, with the influence it brought to bear upon illustrative art generally.

When taking up the practical side of an art, it is only a waste of time to enumerate all the different workers who may have left their own particular, if not always very prominent, marks in the pages of its history. I would rather call attention, in the short space at my disposal, to the men identified with the different great epochs, such as the unknown outline workers, the men who aimed at tone and colour, dating distinctly from the time of Albert Dürer; the distinctive chiaro-oscuro workers, amongst whom I would exemplify Rembrandt; the purely tone artists such as Turner, the grotesque

in Hogarth and Cruikshank; and next take our modern men who carry on the art at the present day, and exemplify a few such prominent workers as Small, Parsons, Barnard, and Abbey, although the army of first-class illustrators is so large at the present day that it becomes a difficult and ungracious task for me to mention names at all.

The different stages of progression in illustrative art may be broadly defined after this fashion: the time when artists drew directly on the wood with pencil or pen only, and engravers followed their hard lines; the date when bold effects with Indian ink and Chinese white were introduced, and engravers were permitted to use their own lines, and so became liberated from the trammels, and could first lay claim to being original artists, as well as the men who drew the designs which they cut; the last and most satisfactory stage, when photography stepped in and became the umpire between artist and engraver.

In the first stage the engraver was a mechanic pure and simple, unless he drew his own design, or could take the liberty of improving upon the artist's lines. If, however, it was an experienced artist, the engraver simply copied, and did not trouble himself to think much, so long as he got his lines out clean. In the second stage, when he had wash drawings on the block, there was seldom any appeal from the artist; he had, it is true, the option of lightening up his picture on the proof and saving his reputation somewhat by making a few bold and hard lights where his other effect had been lost; but this was all that was left to him, because *his original drawing* had been cut up.

Now the original drawing is seldom destroyed; it stands to the bitter end, and settles any disputes between engraver and artist, because the engraver works only upon a photograph from the original sketch, and has it all along beside him to work from as a copy as well as to confute him if he is a bungler, which is a right and proper state of things; for now the indifferent artist cannot flatter himself or steal the reputation of the skilful engraver, and the unqualified engraver cannot lay his faults on the shoulders of the artist; each tub must stand upon its own bottom.

After Albert Dürer, with his delicacy and finish, as well as spirituality and suggestiveness, we come to Rembrandt as the most perfect master of chiaro-oscuro that the world has produced. At the present day we cannot hope to

surpass him; we are satisfied if we approach somewhat near to his matchless gradations, depth of shadow, and lustre.

There was considerably over a century between these two influences; but it was a progressive century, as the numerous book-plates throughout Europe can show. The school of Dürer gave the illustrator the first real hint about colour; Rembrandt showed how much power may be had out of a flat surface.

From Rembrandt to Bewick the merits of the different book plates vary. Nature, however, did not occupy much room in their calculations. Bewick was, perhaps, our first great realist, for all his studies were drawn uncompromisingly from the object itself. Before his advent the illustrators, like the novelists, were content to interest their audience; but after Bewick it was found necessary to study accuracy as well as sentiment and effect, and this we continue and try to improve upon at the present day.

Hogarth, as an illustrator, gave a turn to art which it had not before. It is always a pleasant thought to me, as a native of Britain, that, while looking towards Germany and Holland for our early inspiration in illustrative art, we must return to our own shores once again for its revival, to Hogarth, Bewick, and Turner, with Constable (as a painter), for the apostles of that realism, suggestiveness, and satire with which the other nations now strive to lead off. As in literature, so in art, we were the original creators of those styles, to acquire which our students now go to France and Belgium.

Shakespeare made Goethe, Schiller, Hugo, and Zola. Constable and Turner created the modern French school of Impressionists; Bewick the realistic draughtsmen; Hogarth the satirists of the pencil. We may be a heavy nation and apt to take a joke sadly, yet we have had our humourists also who have been appreciated by other nations as well as by their own, and perhaps a little more so.

Amongst modern men—that is, comparatively modern men—who have had a great influence in book pictures, I would mention, in landscape art, Turner as the first; in caricature, Cruikshank; and in general force of black and white, Doré. These three, I think, I may safely place as having the greatest influence in their different walks.

Turner I now quote as the most imitated painter and illustrator that ever lived, which is about the surest test of his individuality that can be given.

Individualism as well as mannerism, alas! for the main body of the imitators could pick up only the mannerisms, without getting one touch of the genius which made him great—those bald sunlight effects which somehow remind us after a grotesque and wearisome fashion of the master whom they have vainly attempted to follow. How often have we taken up a volume of steel engravings in the half light, thinking that we had found a collection of Turner's works, until we brought them to the light and realised our mistake at one stunning instant! The invention and poetry were totally lacking, the effect dry and empty, and the design meaningless.

Ruskin is quite right to go into raptures over the great genius of Turner, and in this he shows his own perception of true poetic power, inasmuch as he makes a mistake in overestimating Creswick's black-and-white work; but that he should close his eyes to the glaring faults of Turner, or rather, that he should call these faults virtues, is simply reducing the weight of his critical influence until it is not worth using. If he *will* hold up for praise blemishes which even the most ignorant can see for themselves, how is it possible for them to set him up for a guide in matters which lie beyond their knowledge?

The tree work in most of Turner's illustrations and pictures is not drawn from nature, and the trees have no natural characteristic about them—in fact, they are monstrosities in the vegetable sense, and no preacher in the world, no matter how eloquently he may discourse, would be able to convince a gardener that these are the correct sort of trees for these landscapes, or that the pictures would not have been improved by properly-drawn trees in place of these unnatural monstrosities; and, like the realistic gardener, I must also say that Mr. Ruskin could never convince me that a single breath of the poetry would have been lost had Turner drawn real instead of imaginary trees.

His ships are not the kind of craft which practical seamen would care to venture beyond the harbour-bar in, if they even cared to risk their lives so far to sea, although they may look very nice and picturesque to a landsman's eye. Stanfield was a much more correct painter of ships, in spite of all that Mr. Ruskin may have written to the contrary, as any sailor could tell him; and, therefore, I contend that the drawings and paintings of Turner would not have lost any of their poetic charm even although he had tried a little more to please the sailors, and given to them ships in which they might have been able to sail and fight.

At times, also, in spite of his exquisite drawing, his architectural work is not beyond reproach, and may be pecked at by a very immature and even budding professor of that exact science; yet in this department his faults are trivial compared to his frailties in other departments.

The shapeless dolls which he introduced and so often crowded into his compositions (with a few exceptions) are simply atrocious, and would not have been tolerated from an inferior artist. In his illustrative work he is seen at his very worst in this respect; witness most of the plates in Moore's 'Epicurean,' the 'Rivers of France' series, &c.

But in his effects he stands unapproachable,—in his dreamy delicacy and subtlety, his skies and water and aerial perspective,—in his suggestiveness, multiplicity of detail and complete unity of the many parts in one harmonious whole: the colour with which his black-and-whites are invested is so thorough that any artist can define each tint with which he would have coloured his black-and-whites, or what he used in the sketches from which so many of his illustrations were made.

For these great qualities Mr. Ruskin could not indeed praise him too extravagantly, for these raised him leagues above any other landscapist, before or after him, and might well excuse any other faults in detail; but for all that, no critic has a right to extol in one artist what he would justly condemn in any other.

His direct influence on illustrative art made a distinct epoch in this branch. Artists no longer stuck to the hard-and-fast laws which had curtailed them before; they became suggestive and poetic, and no longer confined themselves to the stationary effects of mid-day, when objects are seen photographically, but gave their pictures the atmosphere which they so often lacked before. Turner is the father of the suggestive and impressionist schools, and perhaps one of the ablest of his modern disciples is Alfred Parsons, an artist who has had the genius to pick out the best of his master without taking any of his faults; he has imbibed the poetry and discarded the extravagance, and never in his most dreamy effect does he lose his grip of nature. For the truth of my remarks I would ask you to study two illustrations which lie handy to me at this moment, where the effects are somewhat similar: the 'Rouen' (from the Seine) by J. M. W. Turner; and 'Still Glides the Stream and Shall for Ever Glide' (the River Duddon), by Alfred Parsons, which was engraved in Vol. 75 of 'Harper's Magazine.'

I would now select a few of the illustrations from the most modern of our artists and books to show how these lessons of Turner have been utilised in the best sense at the present day, along with that rigid adherence to nature which is one of the most prominent characteristics of the nineteenth century, an exactitude for which we as artists are indebted to the revelations of photography perhaps more than to any advance in our own personal knowledge of nature, for I dare say the artists of past times looked as lovingly and as keenly at nature as we do to-day, only that they had no realistic camera to put them right in their impressions, as we now have.

We know from the camera how a lightning-flash really looks, what a horse is like when at full speed, the different actions of a bird's wing when flying, the true shape of each wave in a storm, also the swing of drapery in a high wind, and how men and women really appear when excited; for before the days of instantaneous photography the painter was apt to be deceived, and take as one several motions and effects.

When speaking of the direct influence of a great inventive genius like Turner's or Constable's, I may point to works which do not bear the smallest resemblance to their style and mannerisms; for instance, I may point out a piece of work marked by all the characteristics of the modern Flemish or French schools, or I may point to the work of a figure-painter, and quote him as a conscious or unconscious follower of Turner or Constable. It is very likely that the artist has gone to France or Holland for his own art finish; nevertheless, those schools which gave him his finish borrowed their own manipulative qualities from either or both these rival painters.

In the new illustrated edition of 'Lorna Doone'—that masterpiece of Blackmore's—I notice nine or ten Devonshire landscapes which are more distinctly Turneresque than many of the modern books exhibit. They are drawn as a rule with fidelity to nature, and engraved with sympathetic tenderness, perhaps in some cases too tenderly and over-finished for the purpose and effect. The most imitative and to me the least satisfactory effect is 'Watchet on a Regatta Day'; the best, as far as sky-work is concerned, is 'Dunkerry Beacon Fire.'

In this same volume W. Small exhibits his powers at their full strength in his colossal figures, startling effects, rich shadows, and tender backgrounds; the last picture of all simply swims in the colour and lustre of mid-day.

C. W. Wyllie is another free and faithful worker who has had the best of Turner and Constable measured out to him in a French fashion, as most of our modern English work is fashioned. Davidson Knowles displays this also in his dreamy suggestive work; William Hatherell, too; with a host of others whom I cannot mention for want of space.

The modern tone or wash work, as exhibited in the 'American Magazine,' 'The Century,' 'Harper's,' 'Scribner's,' and in 'The Magazine of Art,' shows the effect of Turner more and more every day. Fortunately the hard and laborious reign of steel engraving is over; as, I think, nothing can be more unsuitable to book illustrations than steel engraving, and nothing more suitable than a first-class woodcut, when carefully mounted and clearly printed. The steel is always hard and metallic, whereas the wood gives all the tone and colour of the drawing; and now that we have the numerous process inventions to reproduce pen-and-ink drawings, and so give all the characteristics of the artist, it becomes only a waste of time and money to employ an engraver of any talent to produce any other kind of work except tone drawing; and as for the indifferent workmanship which might have satisfied the public before the advent of such magazines and papers as 'The Graphic,' 'Black and White,' 'The English Illustrated Magazine,' 'The Magazine of Art,' with the American works already mentioned, and others of the same class, the less expensive process work, such as I generally use in my own books, is infinitely to be preferred.

In speaking of George Cruikshank as an illustrator, I do not refer to his qualities as a caricaturist, as those are sufficiently well known from the numerous works he has left behind him, and of which some of the finest specimens may be possessed for a few shillings by anyone so desirous, in the re-issue of his 'Comic Almanack' published by Chatto & Windus, where in the two bulky volumes may be had this artist's best work during the best eighteen years of his art life.

It is his delicate outline and etching qualities that I would call attention to, which have influenced the pen-and-ink workers of the present day. Most of his designs were done on copper, but in a few cases he worked for the engravers, and these do not show up so satisfactorily. Indeed, although I believe it to be a law with 'Punch's' proprietors to have all their pen-work engraved on wood, and thus keep to the old traditions; artistically speaking, I think they are wrong, and suffer accordingly, now that zincography is able to give the artist's work line for line, with less of his delicate work lost and

none of his characteristics destroyed, as must be the case in many instances, even with the finest wood-engraver. Indeed, I would rather have some of the best work as given sometimes in 'Ally Sloper's Half Holiday' and 'Pick-me-up,' pure and simple as it is, than I would have the wood-engraving imitations of pen-work in our national comic leader, 'Punch.'

'Punch,' as a high-class paper, appeals to a certain and select order of readers, but in the sense that Cruikshank was comic it is not at all funny. 'Ally Sloper' is the only paper of the present day to whom the peculiar genius of the old caricaturists has descended; his Hogarthian satire and Rabelaisian humour is, in this much-illustrated weekly paper, reproduced in modernised costume and surroundings. Parisian nattiness and smartness blend with the broad buffoonery with which Cruikshank delighted his audience of the past generation. We are not so simple in our tastes (more is the pity); therefore, instead of the horseplay of the clown and harlequin, we have Tootsie Sloper and her erratic but impecunious and disreputable parent, with her own Frivolity friends to disport themselves through the pages; yet, inasmuch as 'The Comic Almanack' faithfully held up, in its own particularly good-natured way, the weaknesses and follies of the day in which it was produced, so does this happy-go-lucky paper exhibit the froth of ours.

Ally Sloper is a distinct creation, as I may say also the Elder McNab is; and as the first hits off the shady cockney, so, as a Scotchman, I must own to the grotesque fidelity of the latter. For the past twenty years I have watched the natural progress of the old humbug, Ally, and at the present day can read about his ever-varied doings with undiminished pleasure. To continue such a character without wearying old readers for twenty years is, to me, the surest test of his vitality.

Like Rembrandt, Cruikshank's correctness of drawing might be objected to, yet, like that other great master of the needle, no one could surpass him in his knowledge of chiaro-oscuro and balancing of parts; but it is in the subtlety of his lines, and the expression which he was able to give with the least labour, that he stands unapproachable. At the present day those who admire the dexterity with which Mr. Harry Furniss can cram in multitudes of characters into his cartoons for 'Punch,' may only look at one of the crowded scenes on a small scale, such as 'Lord Mayor's Day' in Cruikshank's 'Comic Almanack,' to see where the inspiration comes from.

Before the revolution which photography caused in illustrative art, that wonderful native of Strasburg, Gustave Doré, burst upon the art world like a flaming meteor, and gave quite a turn to artists and engravers. Before his coming, draughtsmen had worked on a white ground with a thin first wash, afterwards hatching up the details with a four or six H pencil; but Doré, in his frantic hurry to produce his exuberant fancies, discarded all these slow methods, and used a black ground with a few dashes of light and half-tone to express himself, as in some of his Inferno scenes, or a thin wash of light grey and some lighter touches, as in his Paradise pictures.

For example, 'The Vision of Death,' for flimsy yet immensely clever touches of half-light and high-light on a jet-black block: here the figure of Death with his scythe sits astride a reinless horse, with figures of dragons, angels, and demons coming after him like vultures on the wing.

This is one of the most effortless yet best balanced pictures in his collection. As Doré worked, I should say he produced this conception in about half an hour, if not less. The figures are rushing along pell-mell amongst dark rolling clouds, and the artist has been in a similar hurry. It is extravagant and theatrical, as all his work was, and sketchy in the extreme: but it is about as good a sample as I can call attention to for this description of art.

Doré's system was an extremely simple one, and straightforward. He fixed on a single light, and set to gathering as much shadow about it as possible,— a broad light, in which he placed as many of his characters as he could cram,—and then set to fill out the shadows with as much detail as he could cram into them; for a sample of this, see his 'The Prince in the Banqueting Hall' (I quote from Cassell's Doré Gallery), 'The Mouth of Hell,' 'The Gathering of the Waters,' &c. &c. The composition is of the same naïve character throughout most of his weird and fantastic conceptions.

The workmanship, compared with the artistic work of to-day, is atrociously coarse and unsatisfactory, although it suited his original and fevered genius as no other style of work could have done. He flung out his imaginings with a lavish hand, after the manner in which Rubens painted many of his pictures, and he could not wait to finish off; yet, take him all in all, he gave an impulse to book-plate work such as no other illustrator had given before him, and made the workers coming after him more courageous and less afraid of their masses.

In his Francesca groups, however, we have not this reproach to make against him, and as for the drawing from which his masterpiece was painted, or which was drawn from his picture, we can only stand and admire. This is a perfect poem, and lifts his pencil from the ruck of his other wreckage as much as the few exquisite lines which relate that romantic episode rise out of the dreary monotony and catalogue of woes which the Italian poet Dante treats us to in his faulty Inferno.

This Doré Gallery is not the book I would recommend a young artist to have beside him as a guide unless he has been cramping his hand and mind over such examples as Bewick; yet to anyone getting too finicky in his work a brief study of Doré will do the same good that a short course of scene-painting will do the landscape-painter; it will set him free, and give him a little more 'go.' In such pictures as 'Samson destroying the Philistines' he will learn how to make a vast crowd on a small scale as well as, if not better than, from any other source.

Doré worked always at a furious pace and without much meditation; his memory was so retentive that he could reproduce, or rather translate, whatever he once looked upon. I believe he took no notes or sketches, but trusted to his wonderful memory entirely. I have been told that he went through Spain when preparing for his 'Don Quixote' at express speed; that he painted his 'Christian Martyr' picture in six hours, and did not retouch it. Salvator Rosa did the same with his work, painted a picture between daylight and dark, and composed a poem when the lamps were lit.

Doré could not paint directly from the model or from nature, as all true artists ought to do, or else *force themselves* to do. A student of mine was once sketching outside when Doré came upon him and asked to have a try at his sketch. My pupil was working in oil at the time, and, in about five minutes after Doré had taken the brushes in his hand, he returned them (with the oil and turpentine running down the handles, and the canvas in a hopeless mess) with an impatient groan. When a boy I met him once in London and raised him to the seventh heaven of delight by my enthusiasm over his 'Christ leaving the Prætorium.' Doré never ceased being a boy; but he was a very extravagant youngster.

What an overpowering crowd of lions he gives us in his 'Strange Nations slain by the Lions of Samaria'! There were enough in that circumscribed space to demolish an empire, almost as many lions as the 'Daily Graphic'

correspondent, the daring 'Randolph,' encountered during his late trip to Africa: 'The glade appeared to be alive with them.'

Doré drew directly on the wood, as did all artists of his time, and as I also did when I commenced illustrative work, and by his example taught us brush-work instead of laborious pencil-work—*i.e.* we *painted* our subject, with perhaps the exception of a few finishing touches with a fine brush, on to the block, choosing a light or dark tone for the groundwork, as the subject required; and the less we did in the way of finish, or rather pencil strokes, the better the engraver liked our work and the better he worked himself. It is eighteen years ago since I did my last drawing directly on the wood, and I for one was not sorry when photography did this part of the work for me, for after that I could work as I had been accustomed to do with my sketches, on paper and cardboard.

To Mr. Bolton is due the honour of being the inventor of printing by photography on to the wood, and this invention of his gave the biggest push forward to book-work that it ever had.

Formerly when an artist had to paint his subject on the block, he was forced to hold his brush and not lay on too much colour, or else the engraver could not cut through his crust of Chinese white without danger of taking off large scales. He had also to be careful not to wet the block too much, as that would spoil it. The block sucked in the moisture like blotting paper if he painted thinly; so that this, with a hundred other troubles, curbed his dash very seriously.

Now we can pile on the paint as much as ever we like to get up our effect, and leave adroit brush marks all over our original. The good engraver likes the bold dash and characteristic brush-work of the painter, and I must say he imitates it with rare skill and sympathy. The photographic print on his block reproduces all these eccentricities of the artist, and gives the appearance of the lumpy lights without troubling the engraver to cut through any crust, for the film on the block is infinitesimal in thickness. He works away at that film without any unnecessary vexation, with the double advantage of having the artist's sketch before him to study from as he goes along; the result of all this being that the public have the opportunity of comparing the artist's original work with the engravings, when they are shown in exhibitions; and also the benefit of purchasing the original sketches for their smoking-rooms or libraries; while the publisher or artist has the decided advantage of being

able to get some more money for the designs, instead of having them totally destroyed by the engraver's chisel—a boon all round which we owe to Mr. Bolton and his timely invention.

I have often been asked how a book ought to be illustrated, and I wish now to answer that question to the best of my artistic ability.

When a tradesman, a plumber for instance, is asked by a foolish proprietor how many pipes he ought to lay on to his new property, it would not be unnatural if even the honestest of that mysterious craft were to reply, 'As many as you can afford, sir; the more the better!'

Perhaps I ought to go on that safe rule also; but as a foolish artist, with a rigid sense of propriety, I must sink my own interest and regard the book only as something outside myself.

My opinion is, that if a book is to be illustrated with more than a frontispiece and vignette, it ought to be illustrated thoroughly throughout. It ought to be an *édition de luxe*, or else a book with only a frontispiece and vignette.

I think that every book bound in cloth ought to have a frontispiece at least; if possible, also a vignette for the title-page. When I publish a book I always try to persuade my publishers to go to this expense.

If it is a novel of a sensational or exciting nature it does not require any more. The tasteful reader, when he takes up a book, likes to be introduced to it with a well-drawn, finely-executed frontispiece; he naturally looks at that first because it opens first to him.

He lingers for a space over that frontispiece, and is either attracted or repelled by it. If it is a bald, commonplace group of figures, without action or sentiment, something that he is in the habit of seeing on every hand, if he is artistic or romantic he will be indebted to that frontispiece; for, taking that as an index to the character of the work, if he does not want commonplace, he will lay it down respectfully and seek out some other amusement.

If the frontispiece has been drawn by a sympathetic artist, the interest of the reader is touched straight off and he turns next to the title-page.

Here he may find something to linger over, a dreamy vignette *à la* Turner, or an artistic commonplace which may suit his purpose. I prefer, as a book

collector and a member of the Ex-Libris Society, a vignette either quaint and unique, or else one dreamy, soft, and suggestive, something of the style of the best editions of Sir Walter Scott, or of the old world of art, such as Walter Crane can give us, or a delicious Birket Foster, a Turner, or a Bewick; something which will tempt us, providing the binding is good enough, to paste our book-plate inside the cover and put it tenderly among the other kind friends of our solitude on our shelves, *after* we have read it— something, in fact, which may tempt us to order from the publishers a special copy bound in morocco, so that we may honour the artist who has delighted our eyes, as Esther did Ahasuerus.

As a good man who has gained an audience by a favourable introduction I would leave the author to do the rest. When once the reader has started on the story, he (the reader) does not feel grateful for any distraction. If the book is worth reading he wants to get right on with it without any interruption; if, however, it fails to interest him, he will lay it down after a few chapters and most likely send it on to some friend, or lend it out, or bestow it upon some charitable institution, or sell it with other works of the same kind to a second-hand bookseller.

In a scientific work or a book treating on special subjects which strictly require illustrations, so that the reader and author may be *en rapport*, the illustrations may be few or many as the text requires. This may be left to the author and the publisher entirely, because the reader lays aside his artistic sense of unity for the sake of the information he requires.

A properly illustrated book should be illustrated on every page. My ideal of such a book is to have to every chapter a head and tail piece, with marginal designs, running up and down wherever the text appears, in pen-and-ink or etching, for I hold that only outline drawing can harmonise with type as highly ornamental as possible. No tone-drawing should ever be introduced where type appears; but each chapter or poem ought to be separated by a full-page plate in tone, wood-engraving if possible, or the best process tone-work.

As much attention should be paid to the index and fly-leaves as to the other portions, whilst the binding should be in perfect harmony.

So the *édition de luxe* will be looked at and admired with the respectful care shown to a lady at a ball, while the book with frontispiece and vignette will

be fondled over as affectionate husbands ought to fondle their well-dressed, but not over-dressed, wives.

CHAPTER VIII. ART IN MINOR DIRECTIONS.

THE ART OF GRAINING

CHARLES READE, in one of his smart romances, makes his Bohemian hero learn the art of graining in an *hour or two*, sufficiently well to be able to go about the country and make a good living by giving lessons to and painting show panels for the master painters.

This lively novelist, with his customary happy Hibernian manner of jumping at conclusions, reveals his own ignorance of the subject he had taken up, by giving the reader minute details as to the way his hero worked. Thus, he landed at a country shop, had a panel planed and prepared, and grained it *the same day*, getting his cash and the admiration of the country house-painter, and striking another village or town the next day.

I do not know who gave Charles Reade this information, but that it was the most wanton nonsense any apprentice in the trade might have proved to him in five minutes; indeed, if he had used his own eyes when the painters were working in any of his residences, he must have seen that the feat was impossible, even for the smartest hero of his collection. Ergo, Charles Reade, on this particular occasion, sat down to write about a matter of which he knew nothing whatever, however much he may have probed into other subjects.

Let me explain how far he erred, for the benefit of those outside the trade.

A panel, which is intended to be a show panel, or indeed, any panel, when it leaves the joiner's hands planed and dressed, has to undergo the following preparation before it can be grained.

It first gets what is called the *priming*—i.e. a thin coat of lead, oil, and turpentine with drier, which will take, in warm weather, a full day and night before it is in a condition for the second stage. In winter weather it may take two or more days.

If any knots are in the wood, these have to be coated with a preparation called *knotting* before even this priming is put on, which makes the delay longer.

When the first coat or priming is dry or hard enough to stand being sand-papered, it is then made smooth by this process, the holes are filled up with putty, and the second coat, a mixture of white lead tinted to the colour of the intended graining-ground, and used a little thicker than the priming, is laid on and allowed to dry thoroughly, fifteen or twenty-four hours being the shortest space of time for this second stage before it is ready for the third.

Again, when hard enough it is sand-papered and reputtied, and then it gets the third coat. In cheap jobs this might be the graining-ground, but in the case of a show panel, a fourth coat would be required, or perhaps a fifth, before that panel would be ready for the grainer; thus four to six or eight days would be the time wanted before that panel was ready to operate upon.

The panel being ready, the grainer would commence with his imitation; the first day he would grain, if oak, with oil graining; if soft woods, he would use distemper colour, which would be thinly varnished over, and so require at least another day to dry.

The next day would be devoted to over-graining with distemper and varnishing. Thus that panel would take the smartest workman from six to ten days from the hour it was planed until it was finished, as any practical reader will bear me out in saying.

There is a legend related about one of Murillo's pictures, the 'Virgin and Child,' of the same description, and with about as much probability.

It is related that once upon a time Murillo had been well entertained by an abbot, and in returning his thanks for the hospitality received, he expressed his regret that he had no canvas with him, otherwise he would have repaid the kindness with a picture. The abbot at once presented the painter with his own table-napkin, and told him to use that, which Murillo did, producing in the same day a picture which for richness and effect he never himself surpassed.

I will not say that Murillo did not use that napkin as a canvas: I only assert positively that he never painted that picture upon it the same day, for the simple reason that it would have to be primed, either with distemper or oil, and receive several coatings, each coat requiring to dry, be smoothed down, and recoated before ever he started painting, even if a stretcher was not made for it. He may have painted the picture in one day after the napkin had been prepared, but I venture to say, without fear of contradiction from any

practical artist-colourman, that Murillo was the guest of that hospitable abbot for several days after the napkin had been presented to him.

Although that autocrat of art, John Ruskin, has declared vehemently against the imitation of woods and marbles as an art, yet as a protest against his hasty and unprofessional verdict, and as one who has spent years in acquiring the art and teaching it afterwards to my house-painter students, I now take up this subject as a very important one, and will try, as far as a practical teacher can put them upon paper, to give a few of my own methods in this branch of art, for the sake of those whom it may concern.

Let me suppose that my readers are students and young house-painters or amateurs, who have not had the opportunity of getting instruction in this highest branch of their trade. I suppose, however, that they know enough of the preliminaries to be able to prime and prepare their panels, and have made them all ready for the purpose of trying to grain upon them.

THE ART OF OAK IMITATION—OAK GRAINING

We will take oak first, as it is the most generally used in the business, as well as one of the hardest to master, although as an imitation it is more mechanical and less truly artistic than any of the other imitations.

The ground required for oak is buff colour, either light or dark, according as the age of the wood is intended to be represented. To make this light tint, a little yellow ochre, with white lead, drier, oil, and turpentine, are all that are required; while if it is very new wood, the ground should be the colour of rich cream; if old oak, the ground colour can be darkened according to taste with Roman ochre, light red, and burnt umber.

One precaution must be strictly observed if the grainer wishes to produce clean work, and that is, to be sure that his ground is perfectly firm and dry before he begins, so that this ground is not likely to be torn or rubbed off with the combing or veining. I like a ground to be dry but not too hard or oily, as when dry, but soft, it will produce more feeling work, particularly if the grainer is using the most useful of all his tools, the thumb-nail.

A grainer's thumb, like a miller's, has a great deal to do with the making of sham oak; therefre you may easily distinguish a professional oak-grainer by

the length, strength, and tender care which he lavishes on his thumb-nail. It ought for this purpose to be kept long, and carefully rounded and smoothed.

The tools required for this work are a box of assorted combs, two or three pieces of soft cork cut with notches, plenty of soft cotton or linen rags, and that properly trimmed thumb-nail. He will also require for oak-over-graining the same brushes which he uses in the soft woods; camel-hair softeners, grainers and over-grainers, with wipers-out and sash-tools, &c.

The next thing he will make up is his scumble. This is composed of burnt umber, yellow ochre, drier, boiled oil, a little beat-up putty or whiting, and a small quantity of water. By mixing all this up together you produce something like a stained megilp, and may thin it with oil and water as you go on. A little of this goes a long way, as it has to be spread over very sparingly and equally.

Get a good specimen of real oak, well coursed with *champs* or 'veins,' and set it up before you where the light will fall best upon it; then, after rubbing down your grounded panel with fine sandpaper, and dusting it carefully, you will put a little 'scumble' upon it with your sash-tool, and spread that over equally and thinly with a larger brush until the panel is covered. Take your largest toothed comb, and trail it steadily down the panel from top to bottom, wiping the comb carefully after every passage. It is better to trail the large comb in straight lines, and afterwards use the smaller or finer toothed combs with a shake to produce wavy lines. When you have passed the combs over the panel in this way, first the coarse comb straight, next the medium size with a wave, and lastly, in portions, the finest size comb, your panel is ready for the artistic portion of the work.

Combing does not take long to learn if the worker is cleanly in his habits, but to make a natural and pleasing variety in 'champing' or veining takes a great deal of practice; indeed, unless the worker has artistic gifts, he will never be able to master this part of the work perfectly.

A young grainer ought to keep a sketch-book always in his pocket, and wherever he sees a fine bit of work, make a careful drawing with his pencil of it; he will thus be able to get variety in the markings of his wood. He ought also to practise constantly when he is at home on a panel with his thumb-nail at *rat tails*, so as to get dexterity and grace, because there is a vast amount of freehand drawing required in this portion of the work.

The first thing he has to study is the composition of that panel; the large markings come first. Here he may linger tenderly for a time with his rag-covered nail wiping out square, oblong, and round patches, and softening and half cleaning out parts with his narrowest and finest toothed comb, also rag-covered. At this portion of the work the true artist comes in with his manipulations, like the manipulations of the etching printer with his ink on the plate; and I am positive that if John Ruskin had but tried to copy a piece of real oak with the same tenderness and patience with which he has so often copied old masters, he would never have dared to decry the art of graining.

As in etching, perfect cleanliness and an unlimited supply of white, well-worn rags are indispensable to a grainer if he wishes to succeed in his art; yet, as the professional grainer is generally a dashing-looking fellow with artistically long and bushy tresses and Vandyke beard and moustachios, the maid-servant's heart generally succumbs to his charms before even he has unpacked his traps, so that he is not at all likely to run short of clean rags during his campaign.

If any of my readers will take up and examine a piece of polished oak, they will be surprised to see what a multitude of strange devices there are in it; cabalistic signs and figures which are for ever varying as they shift about in the light; strong markings in places, with a crowd of slender flourishes trailing away from the bolder designs. These slender flourishes are vulgarly termed 'rat-tails.'

Now, to comb a panel properly requires some practice and taste, but to be able to wipe out these rat-tails requires a great deal of practice and a greater degree of discretion, so as neither to crowd the panel nor make it appear meagre; the bolder figures with the softened parts require about as much real talent as is expended upon making an original sketch from nature, and a great deal more than would be wanted over the copying of an old master.

The comber and rat-tail draughtsman might easily qualify himself to copy an old master, but the adroit inventor of the bolder 'champs,' which occupy the centre of the panel, is already qualified to produce a monochrome direct from nature; if gifted with the colour-faculty, and if his power of making these 'champs' prove that he has mastered form, he might aspire to any height on the artistic ladder.

The panel being combed, grained, and cleaned, is left to dry, probably one or two days, as the weather chances to be, after which the grainer proceeds with the finishing off.

If he has been imitating a piece of real wood, like the artist with his picture, he will select one of the many changes which the different lights reveal to him on that bit of wood: thus, where the light strikes direct, the figures will shine out whitely; but out of the range of light they will appear dark. The grainer who is an artist will take as his guide the light falling from the windows, and where they touch directly upon the doors or dadoes or skirting-boards, there he will place his highest lights, leaving the darker portions to be put on during the second stage.

If it is a door he is graining, he will put the 'champs' and rat-tails in the panels, plain comb the upright 'styles' or sides, and make knot-work on the cross-bars; to make knots he uses his finger with a dab first, then with his notched cork *draws* the outer waves which recede from the central knot, finishing off with a few flourishes with his nail. When this is done he will soften the whole effect by trailing his finest comb over the cork-work. To do this with more artistic effect he will use a comb of which he has purposely broken the teeth at intervals. Every grainer breaks his own combs and cuts his own peculiar notches in his corks to suit his own fancy, and, like a good painter with his brushes, he does not like any other worker to use them.

The over-graining may be finished in one working, or if the job is an expensive one, continued, in a very subtle spirit, over several workings.

For this he requires in water-colour Vandyke brown, raw and burnt siennas, a little blue-black, some stale beer, a sponge, a piece of chamois leather, one over-grainer or more, a couple of wipers, sash-tool, camel-hair softener, and a few sable or camel-hair pencils or 'riggers.'

The stale beer he uses as a medium to keep the door or panel from 'sissing,' or running off in globules—i.e. to make the distemper colours lie flat and cover the oil paint below; also to act as a fixative when the pigments dry.

Before the grainer begins to work he soaks his chamois leather in the stale beer and washes his work carefully over; this stops the 'sissing' tendency. He next dips his sash-tool charged with beer into his water-colours. Vandyke brown will be the tint mostly used in oak, although as he proceeds he may require in portions touches of raw or burnt sienna, or where he wants to

represent the effect of damp and green in the wood, a little blue-black or even a touch of Antwerp blue. The over-grainer must be an artist, or he had better shade his work plainly with Vandyke brown, and do as little over-graining as possible.

He will next with his sponge wipe out lights here and there, and with his scumblers or over-grainers trail them over the underwork, softening the harshnesses out discreetly with his softener. With his wipers—i.e. short stumpy flat brushes—he will take out straight horizontal lights here and there on the styles, draw shadows together with his softener on the cross-bars, and generally work or *fake* about so as to produce the effect of light and shadow.

When this is dry, which will be in about half an hour, the work is ready for the finishing stages, the pencilling of shadow veins and 'champs,' and loose over-graining.

He uses his riggers or long-haired pencils with a free but careful hand, still keeping in his mind how the lights from the windows are likely to strike upon his work. After this is dry, he takes his longest over-grainer, and having charged it with a thin wash of colour, he first draws a hair comb through it to separate the hairs, and next passes this wash in tremulous lines over his work, *where required*, softening the lines adroitly with his softener as he goes along. The work is now ready for the final stage of all, the coat of varnish.

This is how a piece of imitation oak is wrought up by a skilful workman, very similar to the way in which a drawing or a painting is produced. If the workman is hurried, through cheapness of price, or ignorance, the work may be like the abominations which so often greet us on common doors, or those awful oleographs which decorate the walls of workmen's cottages; but if well done the result is such that it must gratify the eye of any lover of nature, because he can then look upon the very best sample, or rather translation, of the wood, in the same sense that a fine picture is the translation of the finest and most select portions of nature.

My friend, and in many points my revered master, John Ruskin, writes about the degradation of work of this description. I protest against this view as erroneous. There can be no more degradation in imitating a brass kettle or a cut cabbage than there can be in imitating the Alps or the ocean in its

different phases, if the imitation is a conscientious one; and certainly, if this is permitted on a canvas, why should it be condemned on a door, or a mantelpiece?

Get the very best of the real article if it is possible, of course, in preference to the imitation; but rather than get a faulty slab of marble or an uninteresting panel of wood, try to rest content with the imitation and selection of the rarest and best. I would personally much sooner live with sham virtue than open vice; we may live on and glean happiness from the first, but we can get nothing save disgust and misery from the last.

Besides, if truth and reality are to be the standards set up, art must be abolished at one fell swoop, for art is the embodiment of falsehood, as falsehood is the imitation of truth. The portrait is not the man or woman any more than that false oak panel is the wood it represents, or the shilling any more than the symbol of the pleasure or comfort it stands for. We are all dealing in shams and equivalents; even the outside landscape which charms us so greatly is not reality—it is only a combination of light and optical illusion.

THE IMITATION OF SOFT WOODS

Under this heading I take maple, walnut, mahogany, satin-wood, and all the other foreign and home woods which serve to decorate our houses and ornaments, for the same materials and tools are required in them all.

MAPLE WOOD

The ground of this wood, like light oak, should be of a delicate cream tint. I think the imitation of maplewood is one of the most delightful and artistic of all; there is so much variety in it and so much play for the fancy; it also liberates the hand of an artist as much as scene-painting.

Some painters do this work with oil-colours and spoil the whole pleasure of the work. I must insist that all soft woods ought to be worked in water-colour, because oil cannot give the delicacy of the more transparent medium.

Begin as I have already written about over-graining, with the stale beer and chamois leather.

Then dash in your ground, composed of a thin mixture of Vandyke brown and raw sienna. You will have your colours placed in separate pots, so as to dip your sash-tool into one or the other tint, always using your stale beer as a medium. Pitch your sash-tool, fully charged with moisture, about your panel with free and reckless splashes, twirling it about in parts, until the whole effect appears like a thunderstorm in sepia. Then, while it is still wet, fold your hand in a loose way and knock the backs of the fingers slackly and flatly against the panel, making long dabs all over it, yet more leading to the centre towards which you have drawn your shadows with your sash-tool, somewhat after the form of a tree with the branches spreading out. Soften these flat dabs, and also the coarse work of the sash-tool, lightly and delicately with your softener; then take the tips of your four fingers and dab the 'eyes' about, softening these off still more delicately with the 'badger' or softener.

After this is dry, proceed to over-grain it as I have described in the oak, only with your pencils accentuate some of the eyes where you think it is needful.

The styles and cross-styles you must do according to fancy, wiping out parts, trailing the over-grainer over other portions, putting in an eye where wanted for variety, or a knot, yet taking great care not to crowd the work; and always bear in mind that, although knots may look attractive to you, they are considered blemishes from a cabinet-maker's point of view. When you have done as much as you can, varnish.

MAHOGANY AND WALNUT

These two woods are manipulated in exactly the same way, a groundwork dashed in with the sash-tool in the form of a tree, and wiped out and over-grained. Mahogany is simpler in the over-graining and softer than walnut. For mahogany you require burnt sienna and Vandyke brown over a salmon-tinted ground; for walnut, Vandyke brown alone, over a yellow or buff ground. In mahogany most of your work is done with the badger or camel-hair softener, with just a little over-graining. With walnut most of the work will be accomplished with the over-grainer and riggers or pencils, after the

groundwork is dry; if portions are stippled with the badger in the first working it will be all the better.

To stipple is to hold the badger or sash-tool firmly sideways, and strike smartly against the panel with it; this gives the appearance of a great deal of minute work. When over-graining, study how the lines run in a real piece of walnut, and try to imitate them closely with the knots. Satin-wood and most other woods are imitated in the same way, with distemper colour and stale beer. Practice, with perhaps a few practical lessons, is all that is required, provided the worker has adaptability, to produce a good grainer.

ON THE IMITATION OF MARBLES—BLACK AND GOLD

I take this marble first, partly because it is my favourite marble, and partly because it leads directly from the working in of soft woods, as I like to see it done.

Many painters lay in their ground with black in oil, and when dry go over that again with yellow and white, also in oil. This is the way to do it cheaply and inartistically, and, therefore, not the way that I would recommend as an artist.

My groundwork for this marble would be exactly the same as that used for oak—a rich cream colour.

Over this I would splash and stipple about roughly in water, or rather stale beer, colour, a changing coat of raw and burnt sienna, with an adroit blending of Vandyke brown; in fact, produce the wild thunderstorm effect in warm tones that I did on my maple panel in the first working.

Then, while the water-colour hurricane was drying, I would get my hen's feathers and hog-haired softener in order, with the fitches and colours required; for the next stage, as it is done in oil-colour, a hog-hair softener is required.

Then for materials. A hog-hair softener, two or three small flat brushes—i.e. fitches, with a small sable brush, half a dozen stiff hen's feathers, a mixture of Japan gold size, turpentine and oil, and some lamp-black and white-lead.

The black and white spread upon your palette separately from each other, the medium make thin with the turpentine, something in this proportion: one-third oil, two-thirds turpentine, and a sixth portion of Japan gold size.

The rust markings or gold-tinted veins in this marble usually take the form of a shallow, half-dried stream of water meandering amongst boulders and pebbles; fill in these boulders and pebbles, large and small, with your black paint, leaving the underground like a rich golden stream to follow its course between them. Then, when you have done this to your satisfaction, blend a little white with the black so as to produce an unequal grey over the black markings; soften very slightly so as not to break the sharp edges, which must be kept firm and hard at this stage; next take a sharp-pointed stick—i.e. your brush-handle will do if it is pointed like a blunt pencil, and scratch out some small veins through the larger masses.

By using the Japan gold size the paint will very soon *set* and become 'tacky'—that is, when you touch it with your finger it will be found sticky, therefore dry enough for the next working, the scumbling with the feathers.

Dip a feather into the thin mixture and draw it across the white so as to get a thin film; flip this in a free way over the marble, half obscuring some parts, leaving others clear and hard, and only a thin semi-transparent and milky-like film over other portions; soften these films as they run, and the result will be an exceedingly rich effect, like shells and fossils and grey veins passing over and through the black and gold.

When this is dry, varnish it, and you will have produced a marble which for richness and lucidity cannot well be surpassed. The method which I describe is old-fashioned, and rather slow, but where time and prices are not to be considered, it is well worth the extra labour in the satisfaction it gives to the worker, and its infinite superiority over the other method, which will always lack purity, richness of detail, and all the other added beauties of variety; for to paint light colours over black is always bad form, and a mistake, as the black absorbs the light colours and gives them a dull and heavy appearance.

DOVE MARBLE

This is another lovely marble if properly done, as it is filled with fossils of all kinds, and the imitation of these natural curiosities is an artistic task which brings out the best qualities of the grainer.

Generally the ground for this is stone-colour, and the materials are the same as for the black and gold marble—i.e. black and white in oil-colour.

Spread over the slab or mantelpiece a thin and carelessly mixed blending of the black, white, and medium, so that when it is covered the ground shines generally through that scumbly coating with portions all irregular; then take a long studying look at your work, and with your sash-tool put in the dark grey portions loosely, leaving the covered ground for the light as you might if painting a picture; rub in your larger masses roughly; soften these off lightly, and next proceed with a feather smeared with white to put on your light veins; again soften with your hog-hair tool, and with another feather, dipped amongst the black, make dark veins, crossing light and dark where needful, until the effect is all filmy and delicate.

Finish off with little touches and flecks of black and white on your feather-tips, so as to produce stronger veins, remains of fish, shells, and the other fossilised life with which this marble is crowded.

The Italian marbles, such as sienna and other varieties, are done in a similar way, with the difference of colour. All marbles, with the exception of the first working of black and gold, are worked in oil-colour, although, of course, as in wall-papers, they may be worked, after a style, in body colours, and when done in distemper they are finished off while the colour is wet.

Granites may be imitated either by sparking the colours on by striking the charged brush lightly with a stick, or else dabbing them on with a sponge; a nice blending of the two methods produces the most natural effects.

I often pass painters producing on shop fronts marbles of green, blue, and red, which, although pretty, represent no earthly stones. I have stopped to ask them what they were making, but they could not classify it or give it a name. They had learnt to work from other grainers, and never paused to inquire what they were producing. Many of these grainers never studied a piece of real marble in their lives, and possibly would not like the sober reality if they did come across a specimen or so in a museum. The subtleties

and time-markings would mean nothing to them, in the same sense that a real bit of Nature would not appeal to the man who had spent his efforts in copying flashy oleographs.

Now, this sort of graining is very abominable to me, as I dare say it would be to John Ruskin, or any other diligent searcher after truth.

Every grainer ought to know where the specimen he is imitating or reproducing comes from, and what has caused those veins and markings which he is putting in; then he will be able to instruct the masses and satisfy the botanist and geologist: for as he paints he will be preaching a sermon on the stone, and writing out a record of the world's history before man came on the scene. He will not then put meaningless figures into his marble, but every flick and curl of his feather will sketch in the broken remains of an extinct race: and in this way we distinguish between the artist-grainer and the unreasoning mechanic.

Alma Tadema has shown how an artist can imitate marble, in his Roman masterpieces, by his care and tender manipulation. He has raised the art of the grainer to a very lofty pedestal indeed. In the Royal Academy Exhibition, where crowds gather round his antique revivals, it is not so much the noble Roman men and maidens who force the cries of admiration from them, as the broad spaces of white and coloured marbles which predominate in these compositions; those time-stained, rusted blocks, with the slight suggestion of a flaw here and there; the iron-stains showing through the subdued lustre of the Roman limestone; the polished pillars and inlaid floors all kept under control, with the veins offered only as an apology at rare intervals. This art of fidelity to nature and rigid restraint have made him the grand master-grainer of the age.

And yet I have seen as fine specimens of imitation marble as ever Tadema produced on his canvases wrought upon a show panel, only that I have not seen the same masterly modesty and restraint. The producer of the show panel, as a rule, exerts himself too much, and attempts to put into one panel the results of a whole palace, and that is the mistake which makes his work appear superficial and unreal. Alma Tadema puts no more work in his slab than what appeared in the slab he copied so literally, because he never permits his imagination to run away with him, while he has nature to guide him, and that is the secret of his wonderful success.

And this example I would impress upon every grainer, young and old, who may aspire to produce something great in his own line of life; for the work on a door, a dado, shutter, skirting-board, or mantelpiece, is of as much importance as the fresco on the plaster above—those frescoes which have been the pride and glory of the best of our old masters.

The grainer who desires to be remembered must possess himself with the true diffidence of the uncompromising realist.

After he has mastered the freehand of his craft—i.e. the technicality and manipulation, he must set diligently to learn the causes for those effects which he has been trying to imitate, and aim at giving a specimen as free from blemishes as possible—that is, he must give his patron only the most perfect specimens of the stone or wood which he is striving to realise.

He must learn that a block of white marble which has stains and veins in it is rejected by the sculptor and the monumental mason as faulty. In the cemetery at Stirling there is a very lovely piece of sculpture-work, representing an angel watching over Margaret Wilson, the virgin martyr, which was purchased comparatively cheap by the donor, William Drummond, because it had a flaw or vein in the knee. If this statue had not been thus blemished, it would have been considered perfect, and much more valuable.

Veins and blemishes in white marble are often caught at by the grainer to emphasise his work and make it more marble-like, but the great grainer will try his hardest to make his work look like marble without introducing this blemish. The other marbles are easy if he will but be faithful to his copy, and guard himself from exaggeration and the crowding in of details—the rocks upon which so many split.

But when the grainer can produce a panel of white marble to look so like marble that it can deceive the spectator and yet be flawless, then he may take his seat amongst those immortals who painted fruit to deceive the birds; and whatever any other critic may say against it, I hold that he is a great and a true painter.

CHAPTER IX. DRESS AND DECORATION.

DRESS

IF all the many matters which require reform in this world, I place the two above mentioned, and, while holding my own opinions with respect, demand of everyone to reverence his or her opinions with equal respect.

I think that we dress altogether wrongly, and would point out as an artist to artists the ugliness of it: to the broad masses whom we delight to serve, the folly and unwholesomeness of it.

I hold that we eat and drink altogether wrongly, and would like to point out as an artist to artists the brain-clogging effect of it: to the people, the expense and *unmanliness* of our customs. I would fain, while exposing my own follies, hold up a mirror to others, showing as a warning where I cannot be a guide.

In decoration, my second subject, I would fain point you directly to nature; look straight at her, each with the desiring eyes of a lover, and she will satisfy you all.

I suppose, in spite of the melancholy groans of some and the cynical snarls of other dyspeptic subjects, that we all agree, without exception, to love this life when we can have it tolerably free from pain, or the pinching of poverty, and find this much-abused world quite good enough for us and our purposes.

The weather is never altogether just what we would like it to be: it is either too wet or too dry, too hot or too cold, to be exactly to our taste; the direction of the wind bothers us—in fact, there is a happy medium which we cannot strike; and yet, with all the shortcomings, I doubt if there is a single sane Christian who would like to go to heaven one second before his or her time. Of course, we except the unfortunate insane, who rush away on the spur of an evil moment.

For my own part, I wish I could live a thousand years, and envy the constitutions of the antediluvians, who could take time to do their work properly, although I will confess to moments—neither few nor far between—when I make myself as miserable and disagreeable as anyone could imagine, and yet live.

The earth is all right about me, the weather is passable, the machinery which moves me along would be perfection, if custom, and fashion, and general *debility of will* would only let it alone, and permit it to do its work in its own way, and with its own conditions.

Nature endows us with tastes as simply correct as the horse's; and custom teaches us to endure, with martyr persistence, habits that are as difficult and dangerous to learn as they are hard to break from.

Nature bestows upon us skin all over our body, like that upon our face, and custom covers up part of it, until it is so sensitive that it cannot be exposed; and fashion bids us bare it at the wrong moment, or else load it with all kinds of unwholesomenesses.

True Art stands by the side of Nature, both ridiculed, both lamenting; while Fashion and Custom, ever capricious, ride on triumphant.

For example, take the feet: I prefer to raise my eyes from the earth—to begin, as men begin to build houses, from the groundwork upwards. We muffle them in wool or cotton, and cramp them inside the stiffest of tanned skins—dead skins over living skins—and think that this can be healthy; we shape them according to a fashion—square, round, or pointed toes—never according to nature and the foot which we ought to imitate, therefore not at all according to true art, which must follow after nature, never after fashion, which must always be utterly false and ugly until it emanates directly from nature, and then there can be no god Fashion; for every man and woman will create their own ideal from themselves, and not from any brainless *demi-monde*, and their modesty will not run counter to the virtue which the great Creator planted within the human mind, nor shame be created over what He said was well done.

We hobble about within our wrappings with feet that swell and sweat and steam unwholesomely, bathing them when they have become intolerable with the exhalations from the living skin, and the impurities which they have drawn out of the dead hides.

We hobble about with our raised heels and our square toes, admiring one another, or envying one another, for the smallness and the tightness of the cramping, never revealing, till some one tramps upon them, the painful fact of bunions and corns, which, in silence and with Spartan endurance, we are

growing all to ourselves, in order to reach the ideal that the world has set up for us to follow.

A host of other ailments are the lively produce of our efforts; but, as beauty is my aim, I will pass them over, content to regard the ugly abortion which that most lovely portion of a faultless machine has become.

The overpowering influence of fashion even on well-balanced minds must not be overlooked. When crinolines were in vogue, even men of taste were weak enough to admire the fearsome abomination—at least, they admired the creature inside that circumference, to which usage made them blind.

None of us admire the Chinese ideal of a foot, yet we are ready to grow poetic over the *chef-d'œuvre* of a shoemaker; we sing to the boot, for of course it would be impossible, not to say imprudent, to sing about the foot.

Once I lived near a woman who had lost her nose. At first I thought this a great disfigurement, and did not like to look in her face, but by degrees I grew to lose the first horror, and I dare say might have grown to think the want an improvement in the way of faces, had I lived near her *long enough*.

We admire the Greek ideal, because the Greeks had perfect untrammelled nature to copy. Their models were not curbed by stays or tight-lacings; their training was severe, and their eyes were accustomed to flowers. Luxury and sloth were crimes in Greece; in the high times of Greece, I mean, when simplicity was admired, and slaves were the Sybarites, naked men and women vied to show perfect limbs, not rich attire. The barbarians were the fashion-mongers.

What so like the classic ideal as the Highland woman who puts on boots at the church-door, and doffs them again with the benediction?—useless to her amongst her native hills—an agony endured, because the poor thing imagines that it looks respectable and religious-like.

What so unlike this idea as the fashionable votary, while she strangles and strains to get out of the superfine, creaseless kid cages? Did they look like mice peeping in and out as she tripped (limped) along according to the poet? Who wants to see mice under petticoats? Who, with poetry or taste, cares to see feet that can be compared to mice? And can those long, splay, aristocratic, high-heeled, superbly-arched, pointed-toed, tightly, so tightly-fitting, importations from tinsel Paris be called feet? Alas! they are all that

the envied, favoured one has to represent what God Almighty was already pleased with. He gave her roundness, which she has flattened—fulness, which she has reduced—softness, which she has made hard; all that He did she has attempted to undo, until what she is dipping into the tepid and aromatic bath is neither useful for walking nor tempting to the eye. They are white enough—almost white enough for leprosy, except when the boot has been perchance extra hard; then they are red or horny, according to the time the bruise has been endured. Soft underneath, where nature meant them to be hard—so soft and useless that a crumb under the carpet causes them to double up—hard and lumpy where nature intended them to be soft! How modest fashion is to hide all the uglinesses she creates, and what fools men are to rave about a piece of leather!

Our Highland girl, with her boots slung over her shoulders, and the marks all washed away in the streamlet she has just passed, is springy in her gait as a young stag, lithe in her movement as a young panther—every fleshfold has its own room to move and make grace; the heels are broad to meet emergencies, round where they rise, flat where they press the earth; the soles hard, as they ought to be, to encounter the roughnesses, with an instep just big enough to skim the ground, not high enough to attract the eye—nature is far too subtle for that; flexible and free, the toes are dimpled loves, each carrying his own pink sea-shell, with blue veins that run over strong sinews, and appear mellow under the gold of the sun-flush—an ankle that is godlike in its concealed strength, and the portion of a leg that might serve the painter as his model for the huntress Diana.

Fashion makes us bond-slaves. We put on boots to keep out the cold, and they soak in the damp; stockings to help the absorbing process, and thus confirm the risk of consumption. Nature makes us all beautiful, or would do so if we gave her a fair chance; and we spend years in bringing nature down to a level not to be described in any simile. Nature meant to endow us with sinews and muscles to give and take a squeeze, and we poultice them all over until they are flaccid, and shrink at the slightest force.

Nature made the Greeks, and the Greeks owed what powers they possessed to the restraint they displayed in letting nature alone. Art, having no human nature now left unspoilt, points to the old Greeks. Taste admits art to be right, yet yields to fashion, while that graven calf stands with senseless hoof upon the roses and the lilies, calling itself the God of Modesty, Purity, and Taste—a modesty which ordains the female to cover her hands and feet, and

lay bare her breast; purity which can show a naked arm, and blush to show a naked foot.

We cannot improve upon the naked foot. The hand may wear rings, and to degraded senses look improved (we who look straight to nature, and find the finish of the Creator finish enough, doubt this—but let that pass); the neck may have its chains, the ears, the arms, and ankles, even the nose, rings, according to the fancy of the wearer or the taste of the nation. I do not like rings, or anything that divides the lines of symmetry, yet if one part be covered, gold may be worn with advantage on other portions; but I defy any cover or ornament yet invented by man to improve the foot which God has already so beautifully covered.

The world is all false—false aims, false motives, false pride, false modesty, shame bred from impurity, blushing at what it should be proud of.

If we dared, we would fain set up woman as she dawned upon primitive man. Imagination pictures to us the first male and female, without a physical flaw, in the perfection which the Creator considered costume sufficient. Reason may bring forward scientific theories respecting the origin of man, but the poetry of our natures will not permit us to accept of them. We like to see that young man fresh from the hands of his Creator, meeting his mate with her first blush of womanhood in those spring-tinted glades of Paradise; we like to think of the child-minds waking up, each drinking in the other's fascination, each unconscious of its own perfection, filled with the new-breathed life, the joy of existence, the lavishness of surrounding nature, alone in their joint humanity, the centre of myriad wondering eyes, with the great Eye of dawning Day laving them and all creation in that rosy light.

We like to see her standing breathless before the splendour of that youthful manhood, soft mists wreathing from her like a bridal veil, her blue eyes like the forget-me-nots, into which her tender feet are sinking, pushing back with those shell-tipped, tapering fingers the wealth of golden tresses which roll from the azure-veined, ivory forehead, that she may be the better able to peer within those wells of amber brown, all unknowing of the loveliness she is herself revealing.

But the world has fallen from that state of purity, and we have the sordid substitute, shame, to warn us against any return; therefore we must perforce drape our ideal before we can present her to the many eyes. Yet in our

draping we would consult nature with grace, rather than fashion; cover our woman without losing her identity; imitate naught except her own lines, in her drapery; let her breathe freely, move easily, and appear before us as she ought to do, wide-waisted, a woman with the look of a future matron, and not the rickety imitation of a wasp.

Fashion is a mighty power, and yet, after all the periods and changes with the world, we must return to our admiration of the ancients.

We must love our girls, no matter how they are costumed, and love will make the costumes appear becoming; yet, can we compare the intricate flounces of to-day with the grandeur and grace of those simple antique folds, without deploring the influence of that 'Monster, Fashion,' which compels *Love* to make such an effort?

Think of our gigantic headpieces, and then of the classic plait and coil; in the one case measuring four instead of the classic eight heads to the figure.

Compare the gigantic hoop, with the clinging robe which revealed sufficient for grace without offending modesty; the easy swing of the antique, with the affected limp of the modern.

Although we know the story of the first body covering of foliage, it is difficult to trace back to the first foot cramp. An old legend has it that when Adam was forced from Eden he bruised his foot, in the hurry, against a bar of the massy gate, and so, with the pain, thought upon a bandage.

Pain is mostly our first, and most effectual, instructor. The red-hot poker must be a pretty sight to the eye of innocent childhood; the touch generally suggests the necessity of cultivating the organ of caution. So with man, the ignorant; he covered his body because sin showed him it was naked, and tied up the wound upon his bruised foot because it smarted.

Granted that the roads are hard, and the feet of the wanderers unfit to encounter the roughness, the sandal of the ancients comes nearest to our ideal of a graceful protection. To those who must have luxury, who have wealth to spend and like to spend it on themselves, what a glorious opportunity is here!—straps inlaid with gold and gems, the poetry of the jeweller expended in chaste designs and ornate extravagances—straps that catch a thousand sun rays, and break them into prismatic splinters; gems that get loosened from their elaborate settings, and, rolling amongst the grey

dust, attract the beggar's eye with their flashing, and fire the hearts of the finders' friends with the fleeting joy of possession; straps that leave the toes free room to move, and be seen, open to the fresh airs of heaven, like the hands and face, with the same advantages of getting dust-grimed, and the same chance of getting often washed; straps that may cost a fortune, or be had at a quarter of the price of boots.

What a delightful custom after the sandals were doffed, when the guest entered, and the women of the household brought water and towel as the welcome home! Think of it, on a summer march, with your feet sweltering and blistering inside cramping boots—the comfort of it, the beauty of it, when the tired feet were placed on the mat, or amongst the rushes, rosy, fragrant, and purified!

In summer, ay, or in winter either, are we warmer gloved or ungloved on a winter day? Which protects the nose most in a frost, a veil or a handful of snow rubbed briskly over that organ? Which feels the cold most, the Highlander with his kilt and bare legs, or the Sassenach with his drawers and breeches? With the hands and the feet, habit solves the problem; our summer is a Calcutta winter.

Fashion is for ever changing. Why? Because men and women cannot feel satisfied with their inventions—because the instinct of the True is in us all, and we are miserable when we attempt to beat it down. God gave man a costume which man cannot rival, and man must come back to it before he is satisfied. It is well to foster a taste for china or old books, to rave of the quaintness of Queen Anne, the shepherdesses of Watteau, the flowered vests and cocked hats of the beaux, the patches and periwigs of the be-hooped and be-bustled belles, cracked plates with fragile morals, manners of the stage— all that the idiots who get up the forced ecstasies rave about; but the talk grows low-toned, and the tinsel tongues are hushed, as the Apollo and Achilles, or the Venus and Andromeda of the Greeks, loom up, with the grandeur of their God-beauty clinging to them like an imperishable robe. Where is the mock modesty that dares to blush before these perfections? Gaze upon them long, and learn the secret of the changing fashions.

Men and women must yet learn to dress so as to move and breathe freely and naturally before they reach the point where fashion will stand still—having folds that fall simply, short for action, long for show. Woman must appear yet before us as she should do, supple and free. The world must yet wake up

to the truth and purity of beauty, and to do so must come back to its Creator—delicacy weighed in the scales with the virtues of nature; the beauty of strength admired, before the whiteness and softness of the drooping flower.

We must love all that is beautiful. The naked form of a woman is beautiful, but the folds of a loosely-fitting, simply plain costume are also beautiful, and perhaps the whiteness and softness gained, if it can be gained without loss of strength, by shading it from the sun, is a point gained; for it is lovely in its fragility—a loveliness which the air of heaven would roughen, which the eye of day would cover as thoroughly as a veil—subtle gradations which are never seen except by the painter.

Cover it, if you will, with soft folds that will fit to the motions, not with the snaky outer skin which reveals the shape completely, but without a touch of the multitude of colour charms. We can never return to the innocence of Eden until we fling off the clay portion of us, and look upon life with spiritual eyes. Then the ugliness of sin and crime will make us droop our eyes, but never the perfection of nature.

I have seen people turn with blushing faces at the sight of a naked child, as if it was something to be guilty about. Education had debased their minds. In the South Seas I have watched the sexes together plunge into the coral-washed waves, and discourse on passing events ashore, and they had no thought of shame. Nature had left them where education will bring us all, if the time ever comes when knowledge can be surmounted.

Choose, while you must dress, each a fashion to suit yourselves. Begin with the figure which your Maker has given you, and assimilate as nearly as your material will permit your fashion to that figure. Consult the hygiene of that form, and make your fashion subordinate to those laws. Perfect health and perfect grace go together. Consult the colour which nature has given to you, and place the colour of your costume in harmony with that, to keep that colour, when dressed, exactly in the same position as it is when you are nude; for depend upon it, if you are in health, no heightening or lowering will ever become you so well.

Remember that fashionable colours may have suited the particular woman who made the fashion; seldom anyone else.

Think you are as good a woman as any other, and bring pride to the rescue. You have equal right, through the royalty of your perfect womanhood, to make a fashion as any duchess or *demi-mondaine* in the land.

Banish false hair, which only heats your brains and wears away your own hair, besides carrying dead impressions and nameless diseases into your system.

Banish hats that hide or *kill* faces, or weigh down heads. A light cover for the sun, if fierce: *yet the hair was given to man for this purpose*.

Banish stays, which murder not only yourselves, but the races coming after you.

Banish waist-bands and petticoats, which are deforming your hips. Look to the waist and hips of the Venus of Milo for my meaning.

Live for yourselves, and for the future. Be the founders of virtuous and wise Titans. Saturn is not nearly dead yet, and Rhea is still kind, if you will. But as Jove fought for life, so must you. On the milk of goats he grew strong to defy Father Time, the devourer. Be strong to defy the laughter and the sneers. Set up an Image of Life and worship this only, for this is the earth-symbol of God.

DECORATION

Art, in the general acceptance of the term, is all that is apart from mechanical dexterity; as the man is not his brain or heart or muscles, but the immeasurable force which controls and moves all these parts, so Art is that immeasurable force that appeals to and speaks through all our senses. Truth is the primary principle of art; the lever of life, the mainspring of society. If we are not true to ourselves, we cannot be true to one another; therefore, our plans must come to naught. Madame Modjeska, one of the greatest of living actresses, is said to be able to do two things at once—to present to the public a face expressive of the most intense agony, shedding tears, and *seemingly* writing a letter which is breaking her heart, and *actually* making comic caricatures on the sheet of note-paper. Admiring this gifted woman as I do, this is a knowledge to shudder over. I hope it cannot be true, for if I thought of art reaching this doubtful state of perfection, I could never again see all

the agony of that acting, only the mockery of the caricatures. Falsehood is not power; it may impose, but unless the actor, or the poet, or the painter, can lose himself or herself in the part with which they are involved, all the rest is only nerve-twisting, meaning nothing, conveying nothing.

Beauty is the embodiment of truth, as man palpable is the embodiment of soul. Falsehood may come draped in the appearance of truth, which is beauty, but that only testifies to the rigid impersonation of truth; falsehood, being hideous, has to come like truth before it can impose.

Beauty being thus the incarnation of truth, and the mission of art being to present this body to the senses, it becomes the stern duty of artists to find out what she is before they attempt to reproduce her. Hence also art takes its proper position in the world; hence its utility to society.

Truth is the binder of society, the leader upwards; Beauty, the form of that divine force; Art, the interpretation of that holy principle; Honour, Faith, Trust, Love which casteth out fear—all are outsprings from the spirit of Truth, which Art has to present to the people, and teach them to see and love.

Beauty, therefore, is the chief quality of art, and while the standard of beauty rests in our eyes—a perfectly formed face often appearing repulsive, and a figure seemingly faultless devoid of grace, whilst the expression and the action transform the plain face and common figure into beauty and grace—so old age can be as beautiful as early youth, and the ugliness of power made to embody rugged grandeur.

But although we create our own ideal of beauty, it is the mission of the painter, poet, sculptor, novelist, and dramatist to educate the world, and refine and elevate their creations and ideals; and this mission is not fulfilled in the mind that merely reports the tittle-tattle of everyday life and no more, or that relates the improbable adventures, frivolities, and vices of a fashionable upper ten thousand, nor the burlesque or comic opera, that turns to buffoonery all those sentiments which tend to melt or ennoble in the language and moral of the tragedy, from which they draw their ribald nonsense. Nor is it fulfilled in the poem that only deals in mystery and new-forged words, that mean nothing unless the suggestion of a harmonious sound—unless the reader fills it up with his own suppositions; or, if meaning anything, only suggestions which the writer is too cowardly to tell out

openly and therefore knavishly sends forth to engender its own poison under its specious and subtle mufflings of musical jargon.

Nor is this mission fulfilled in the picture that speaks a soft, hazy blending of harmonious tints, because a weaver can do and mean as much with his loom, or the display of a dexterous manipulation learnt, as any other dexterity in craft, by rule. Neither is it fulfilled in the scant imitation of a bit of nature, although here more than in the meaningless blendings, because any old stump lying by the roadside, with its moss and time-dressing, must look beautiful, although with no great credit because of no great effort of the imitator, and presenting none of his mind, which is the vital force we look to for elevation.

We turn to the Greeks for our ideas of refinement. They have left nearly perfect forms in ornament, architecture, and sculpture, and they have also left examples, in their habits and mode of living, that they were simple to severity. When I speak thus I except the debauched followers of Bacchus and Venus; for these poets, like Anacreon, belong to the decline of Greek life, and therefore must only be looked at as the foul fungi and rotten growths bred from decay.

The early Greeks fulfilled their mission, because they gave us beautiful forms to look upon, beautiful lines, beautiful curves; the Egyptians and Assyrians fulfilled their mission, because they gave us massive forms and gorgeous tints; the savage tribes fulfil their mission in their fantastic images of terror; the early painters fulfilled their mission, because they sought to raise up feelings of devotion, or pity, or horror in the spectator; the modern painters, bowing down to the golden calf, paint what will suit best, and sink their art into a trade and traffic.

Give painters commissions, is one suggestion to create high art; so far, good for the buyer. Painters must live, as preachers must live, and the labourer is worthy of his hire; but the painter who is also a preacher ought not to think of the price of his picture. Robert Burns had the true estimate of his poetry. We cannot judge a picture by its price. If it is a true effort, it is part of the painter's soul, which cannot be bought. Let him not say it is worth 400*l.* or 3*l.*; rather say it is not money-worth; take it and give me what I need to live: it is mine for ever, because I made it, and I only give it up to hang on your walls, in that I need your help to be able to live and work.

Ornament or decoration being one of the many outcomes of art-teaching which can be applied to the continuance and comfort of ordinary life, we take it up in its broadest meaning. To ornament our persons rightly, first studying the laws of health, cleanliness, and sympathetic attraction; to bring grace into our language, and actions, and morals; after we have administered to the sense of sight and smell, that we may always be lovers and ideals to our wives, banishing from us utterly all habits and liberties that tend to destroy the lovely gloss of that first love; words that may lower or corrupt; jests that may rub off the modesty of first friendship; actions that may tend to deaden the finer romance of the tender dream; all these come within the category of Decoration, and require to be carefully studied.

To ornament our house discreetly, so that we may always find a pleasure in the sitting down, a harmony all over that will soothe us after our day's work; a quiet *colourless* patterned paper will be as cheap as a gaudy glaring, and will *comfort* you where the other will not;—a knowledge of how little is wanted to make life pleasant, a method to get true style, and save money, an idea of the decoration or useful laws of colour;—a taste in the way of books and dress and behaviour, a general *blandness*, which etiquette aims at, improving the high *tone*, which some aristocrats have, and some must pretend to learn, and which may be acquired by any one studying the first law of Christianity, which selfishness, and coarseness, and falseness cannot successfully imitate or keep up for long, no matter what title comes before or after their names, or the pedigree they may be able to tot up, or the appearance their tailor or dressmaker may give to them;—which only require the instincts of honour and truth to do it all to perfection. It does not really matter whether you use your bread or fork or knife at the orthodox moment; if you can keep down the scoff or the sneer where another has tripped. The fork or knife mistakes only want a hint to rectify, the sneer or scoff cannot be rectified, for the one has been the want of knowledge, while the other has been the want of soul: the one is a *novice*, to be trained; the other a *cad*, to be kicked.

That there are tastes acquired, and instincts born in us, we all have hourly and abundant proofs.

But the love of ornament I take to be an instinct bred in the bone and born with the breath. We have records when and how the world began, but never a record of the beginning of ornament.

Adam saw that Eve was fair to look upon, and she, I doubt not, long before the serpent tempted her, knew of a method to deck up her tresses so as to increase the fascination.

In this world, and age, and short life, when science has taught us the fallacy of our eyesight, and the imperfection of those organs which the Creator gave to us and called good; when knowledge must be concentrated and bottled into the mind like a quintessence, over-proof, we have no time for wandering amongst words; with our girls, scientific and exact, Cupid must learn to be brief with what he has to tell and not dally with soft nothings. Language must be chosen for its directness rather than for its elegance, if the speaker would not be flung aside like the useless rubbish his weak flourishes have made him.

Pure ornament, like pure language, should be simple in its construction and expression, clear in its meaning, with just sufficient embellishment about it to interest the imagination, leaving the intention honestly revealed to the passing glance. The truest lines of grace are the plainest; the most majestic designs are those freest from detail; the greatest charm about the disposal of drapery is in the fewest folds, big folds, falling straight; the best dressed men or women are those costumed the quietest. The sign of a lady and gentleman is simple, unaffected ease—an ease which embraces the comfort of all round so completely that the effort cannot be observed, only the effect, which is kindness and equality. The cynic cannot be a lady or a gentleman, for the province of a cynic is to wound, therefore what cynics gain through being feared they must lose in one boon, that of being loved.

Culture or education does not make a lady or a gentleman; much oftener it makes prigs and insufferable pedantic bores, by rendering the woman and man—through her or his very surface *cramming* of technical names and scientific phrases, without the more complete training of restraint or the polish of consideration—offensive by the air of utter knowledge they put on during conversation, or worse than offensive by the patronising leniency they assume towards the ignorance supposed to be around them.

I have seen fearsome clowns whose boorishness raised all the brute within me before I had talked to them five minutes, to whom Euclid was a relaxation, and a volume of Tyndall or Huxley regarded in the form of light literature.

The utility, or rather the necessity, for ornament runs like an artery throughout our lives, not only in our houses, and dresses, and persons, and possessions, but in our morals and manners; hence my passing observation upon the latter, first:

The savage, with his tattoo and war instruments, attaches a religious importance to it. The lines in the face of the Maori, which mean each curve a grade in his knighthood, or caste dignity, until the face and the body are covered with symmetrical designs, tell to the initiated a family history of sustained honours and glory; and this is the utility of the ornaments of the Maori: indeed, it ought to be the intention of ornament, as of all arts, to serve another purpose than mere show, which is only the flashing of a paste brilliant.

From the days when man, like Jacob, set up his immortal stone, to the classic altars of gold which the Greeks and Romans set before the statues of their gods, it marks an epoch, and points towards an aim.

I cannot conceive man content with his rough tanned skins, and his knobbed branch club, or sharp stone fixed into an uncarved handle; void of the instinct of decoration, his woman, like himself, squatting in the sun, without any other intention than to eat, fight, and sleep. No race on earth has been so low, no time so primitive, that love did not lighten it—love the subduer, the purifier, the knight creator. And love never yet shot his arrow where squalid contentment reigned.

The women wove their mats, and the men cut out the handles of their tomahawks. The moist-eyed young Kotori listened to the pipe of the stalwart Toa, and thought of flowers to adorn her braided locks. And the warrior plucked the tendril from the tree as he passed through the forest, and wound it round his brows that the maiden might like him all the better. Cupid first, and afterwards Mars, breathed into the spirit of man the stern necessity of ornament.

Primitive man then looked straight at nature in his adorning of his surroundings. Inspired by love, he became more sympathetic in his tendencies, courteous to the female, zealous of his self-constituted rights, like the Count Falko in that matchless German poem-story of Sintram, more appreciative of the beautiful about him. Fruit attracted him by its colouring, and bloom, and shape, when before he had only thought upon its taste; he

fondled the dog which before he only noticed by his rigid discipline; and from the twisting of the real leaves and flowers round himself and his accoutrements, he grew to imitate them in relief and colours, so that he might have the remembrance always with him when the originals lay withered into dust; bringing to the wigwam, wharè, hut, or palace, the green of June in the white sheet of December, stamping on the icy heart of winter the glowing monogram of festive summer.

So with his animals. The favourite dog was immortalised in this rude, primitive way; the wild beast whom he had fought and conquered single-handed, as David did the lion—boasting about it at camp-meetings, taking it as his ensign, with the motto, 'I did it all.' So every man became his own sculptor, historian, poet, and herald; and when language failed, he attempted, by carved ornament and painted symbol, to fill out the want.

I like a consistent boaster. He is honest if not modest, and honesty is far to be preferred to that contemptible mock-modesty which inclines a man to hide what he must have been proud to inherit. Hereward the Wake, in Charles Kingsley's romance, is a fresh boisterous character whom we must like better when he rode sarkless out to meet the foe than Hereward the false lover and astute politician, who could forsake the woman who had suffered by his side.

I cannot appreciate the poet who is so modest that he requires pressing to read his manuscript. He must have felt that he was doing something worthy of being read or listened to, or surely he would never have wasted his time over the elaboration of the thought; and thinking this, he is an impostor to pretend to cover that honest outcome of his pride and not seek his reward.

Does not the painter paint his picture to be seen, and can anyone admire the modesty that will not hold it up to the passer-by?

Give me the Hereward of the brush and pen; the man who button-holes you like Coleridge, and, shutting his eyes, recites all the ideas which he thinks are fine; the Swinburne who can see his own beauties and not be ashamed to point them out; the Walt Whitman who sings about *himself*; the man who works for praise and is not ashamed to ask for his reward.

Is it subtlety to mask over your meaning with words? Is it the mark of high-toned education and refinement to pretend to comprehend this category of manufactured and meaningless words, this jingling of obscurities?

Is it a sign of ignorance to frankly confess that this sort of thing is beyond you? Then I don't admire subtlety; I don't pretend to be high-toned, I glory in my ignorance. 'Sartor Resartus' does not seem to me to have any special mission. There are strong passages in it, disconnected pieces that I look upon as a vocabulary, and use accordingly; but the author to me represents neither a seer, a prophet, nor a moral teacher, but only a used-up, tobacco-smoking, ill-natured old man, who ill-used himself, his wife, his friends, and did nothing beyond stringing together a few volumes of vivid expressions to enlighten the nineteenth century. But he understood the ornamental part of language, and for that I like him, if for nothing more.

To leave a modern savage and return to man the primitive. War taught him the utility of ornament, how to make objects and curves to inspire the foeman with horror; and in this we see the first departure from direct nature watching, to invention; the lion or boar was not fearful enough, so he combined their ferociousness and made a mixture.

Religion stepped in next with stiff rules and unalterable decrees, and man no longer sought to imitate nature, but gazed beyond her to the mystic symbol of the unseen. An error in the first instance, in the ornamental expression of her imagery, became a fixed law, as in Egypt and India, where century after century the lines were repeated without the slightest variation, and a conventional false symbol served instead of the clumsy but truthful imitation of the savage.

The Greeks stand the exception to all the barbarism of the world about them; they rose to perfection by quick degrees, and that is about all we can say of their art history. They were refined and simple in their manners, rigid in their habits, before the Olympian court was arranged into order or Homer had invented poetry. Hardy health was their aim and stalwart beauty their standard. The flowing grace of their own unfettered limbs taught them the purity of true art lines. Vintage time was a joyous season to be remembered during winter, so they raised pillars to mark their joy, and cut upon them memories of the vine leaves and honeysuckle which they had watched clinging over their porches in the golden hours.

Very early in the world's history man found the use of metals, and learned by mingling to harden them. The first statues and ornaments were formed by hammering the metals and beating them into plates and cords to lay upon or twist round blocks of wood and stone—a slow, hard, laborious process with

little effect. These were the days when Vulcan and his demons burrowed in the earth's vaults to forge the armour of Mars.

Gods with glass eyes and the stiffest of limbs yet bore a resemblance to human beings. Egypt was working away content with her foldless draperies and indiscriminate finishing of detail, handing down from father to son their arts and sciences—everything hereditary, from the many grades of the priesthood to the low office of the accursed dissector of the sacred body to be embalmed; building her mighty monuments and laying on her rigid tyrannic colours—the harmony of law that was right by chance.

Phœnicia was waking up and gaining a name amongst nations; the dyed stuffs and embossed golden cups and clean-cut coins of Tyre, Sidon, and Carthage, which sent out laden ships and grew rich through industry.

Greece was striding on through wars and revolutions and conquests, art and ornament grew strong and refined, and thus became daily a stricter necessity. Their own habits were simple, but their gods were extravagantly administered to. Homer taught them to sing, and to work broadly and delicately.

Homer, the grand old man, the blind beggar who could look with those spirit eyes into centuries, who assembled the gods in order, placed the immortal stragglers in poetic arrangement, utilised the court of love to his own imperial cadence, and became the father, not of his own tribes only, but of all nations. What had their battles done but for his pen? Helen were a forgotten sin, Troy a fleck of white dust—all the heroes of that deathless romance only the vanished marshalling of an ant-hill; for what are we after our lives have gone unless the poet or the novelist creates us afresh and gives us actions that will not die? What is our pain or our pleasure to the partner of it all? We cannot feel theirs, they cannot know ours. My sorrow will not let me judge of yours, for I look upon yours from the outside—a sight, the glimpse of a covered volcano—while mine is here where I can see it no more than you can, but my living soul is writhing in the flames. Will my pain give me yours? No! and so the griefs and passions of two centuries dead and unchronicled cannot stir a thought.

The writer lives and cries: 'Come out, O Lazarus! shake from you the dead cerements, live as you lived, think again; and as you think so shall your thoughts be fixed and roll through Time.'

Homer lived and sang, and heroes rose, and virtue became tangible, and right was fixed, and wrong grew a thing. The painter and the worker in stone and metal had a theory. Beauty was fixed by the Judgment of Paris, mythology became a living creed; while he, the blind father, spake on, sang on, unheeded, yet insensibly becoming the educating founder of a school where the world must enter and learn till the end has come.

As Homer did to the Greeks, so the novelist does for us—presenting to our eyes the world we have not seen, society we may not enter, manners we could not know but for him; virtue gets the reward, vice gets the punishment, the knight of chivalry inspires us with the desire to emulate. The noble path of honour is pointed out, and we glow as we read, with the desire to follow: what sermon could teach us more? The theatre is a church of refinement and morality, teaching us how to act in this world, which, as inhabitants, we require as much as the tenets of the next, about which we know nothing: so the novel. I have read all kinds of fiction: George Eliot, who tells us things as objectionable as the author of 'The Lady of the Camellias'; Dumas, who points out the virtue of fidelity even in a *demi-monde*, that false heroine; Zola, the needful man with the muck-rake. I have seen the novel-reader world-wise, and the philosophy-devourer a fool. Novels are the histories of humanity: they teach us a wisdom that years of sorrow only could reveal; through them we may look into the hearts of men and women and not be deceived by the smiling mask of deceit; they bring to us a world we dare not visit, telling us what we ought to know about sin and suffering; they inculcate knowledge in a pleasant way, preaching to us virtue and nobility, warning us of falsehood; in them we go out to the Valley of the Shadow of Death and are able to conquer the Monster without any risk of scars, to pass through the world and yet be pure, to know all things without tasting of the forbidden tree: and can the preacher do more?

Ornament your houses, ornament your persons, your manners, and your morals; even morality can be made very ugly if it is presented to us gaunt and square—without the undulating lines of forethought and forbearance, without the graceful folds of divine charity. I have seen morality brought out and held up such a forbidding skeleton that the soul artistically inclined shrank back aghast from the weird spectre.

Take one short half-hour to glance over your own faults of a morning, and you will be astonished at the perfection you see around you. Think but for a

few moments upon the wisdom you have gained in your earth sojourn, and I defy you to open your mouths when even ignorance boasts.

It is so nice to be sure of our subject, to sit down and listen to a tinkle of babble and know what ought to be, to enter the room we have decorated and feel that there is nothing wanted, to look into the mirror and feel we are dressed, to clasp our friend by the hand and feel we are united: that this is contrast sufficient, and harmony through it all.

I have said nearly all that is required about ornament, because I intended to speak to you in a general way. True, I might tell you about the rules of the Greeks regarding ornament; how they modelled, punctured, painted, and fired their vases; how they preferred a cameo to a costly stone, a bit of mind to a rare flash; but what would that avail to what I want? I want my friends to be men and women, to have a reason for all things, to know why the scarf goes round their neck or the boots upon their feet.

I don't want them to like Henry Irving only because he is fashionable, or to talk cant about pictures. I want them to be honest—to like, and openly say so, in their ignorance the things of ignorance, and come from the outer to the inner circle by degrees and openly. I want my friends to eat, drink, dress, and sleep as they ought to, as creatures who have inherited an immortality; who are all one (except by learning), patrician or plebeian, and who aim at refinement; not to be dazzled like weak moths by a glitter, but to enjoy the light if it is a good light, yet not to mistake the farthing dip for the electric flame; to look past the splendid expression in a poem or speech and see if the centre line is straight; see what the motive is, for that is the soul of the poem or picture.

I have met men and women with souls so colourless that, but for the bodies which gave them a place, they would never be observed; souls which could never reach a heaven or be carried the length of a hell, but with the dissolution of the carcase; which might, through an outside effort, be able to flicker up for a moment, but must eventually collapse, and be blotted out as completely as the droppings of a meteor on a midnight sky. The *reflection* of a *religious* or an *atheistic* colour may pass over them, as the sky colour is cast upon a fragment of jellyfish lying in a sea-side puddle, but they are no more than that shugging mass; the colour goes or the tide leaves them, and they are immediately rendered void. The Egyptian has a dog who sits waiting on souls of this description, who repeat other people's words, who

borrow brains from books, and can neither feel wicked nor good of themselves. The forty-two avengers relate their actions, the Judge weighs them in the scales: there is no heaven for them, for the heaven wants self-illuminated spirits; there is no hell for them, for they are not bad enough; so the Judge scoops up the scales and the limp soul flops into the watchdog's open jaws, is gobbled up at a gulp, and so there is an end of that poor ghost.

The Hindoo, the Chinese, the Moor, and the Oriental like gorgeous colouring and intricate lines and twistings in their ornament, because they have been accustomed to see nature in her most lavish way. The sun never blinks his eye, or seeks to cover his full strength where they are; straight down he flings himself upon Rhea, and she, the earth, responds with the fervency of a consuming passion, or the love fever of a sea-voyage. There is no place for grey here—it must be white, yellow, red, greens of the richest, russet of the most positive, purples that are not disguised: the fumes of the panting mid-day may be pallid, yet it is not the pallor of ashes, but the gas-haze which quivers above the white intensity of the bloom. Jungles, and closely-knitted bush-tracks, where the speckled adder swelters in the rayless fire; up, down, over-laced, across, there is not an inch which is not covered with its tendril patterns—not a patch where light can pierce that has not its cluster of orange or vermilion blossoming. Life is a delirium in those tropics, the night a fever, and the day a dream; and can we expect calm thoughts to be displayed, or reposeful hues, when even the moonlight is a golden thrill, and stars are shining globes of magnifying power?

Those who live in the north, where the skies are softened veils, and the lakes are placid sheets—where the soul is braced by the north wind, and subdued by the gently wafted west—may well be refined. They are classic born, and to love the simple in ornament or life should only be the effortless yielding of their wills to the instincts of our race.

Study comfort first when you plan your ornaments: if it is a garden or a park, plant the trees that will shelter you best without hurting your health or offending the eye. Build your houses for the sake of the street, the street for the sake of the town, the town for the sake of the land in which it is cast. Assimilate your taste with the taste of other people, sacrificing a little yourself to get some things from them, but not too much; for Jerusalem was kept clean (if it ever was kept clean) by every man looking after his own doorstep.

Plan out your rooms for health: first must come cleanliness and fresh air, next grace and comfort—be comfortable before you are beautified. Get space first. Put out as much furniture and accessories as you can; no more chairs than you want for visitors, no more tables than you strictly need; look round your walls and relieve the blankness with a picture, or a plate, or a vase, or a cast, just to fill up a bareness, not to call attention. We cram on ornaments when we want to cover or screen a defect.

Have your furniture consistent with your room. If you are Orientally inclined, and like a glare, be Oriental to the uttermost—do not stop short at a footstool or a tea-cup; but if you like to rest in your houses, and to be able to think while you rest, have all things plain and sober. Homer and Milton were both blind, and the great serenity of a noble purpose shines like an unflickering alabaster lamp from both.

Do not mix things if you can avoid it; if it is a lion you are making, never blend it with an ape. Observe the flowers and fruits of a season when you plan out a scroll of flowers and fruits, and never bind winter to summer; they cannot agree, and it is better never to join than have to divorce.

Every ornament must have a backbone to start with, or it will fall to pieces as surely as a society-girl would collapse without her whalebone stays, the modern substitute for the backbone of Mother Eve.

Therefore, if you wish to exercise an influence on the world about you, and raise the ideas of beauty, seek after health first, comfort next, and beauty will follow of its own accord.

Every man and woman ought to be able to draw as well as see a straight line; should be able to take down the impression of the place they visit as well as they are able to write out descriptions of it in their letters home; they ought to study painting, and know the reason for certain colours being mixed and put on, because taste, although a natural gift, is also an acquired habit up to a point. Imagination is a universal power shared by the lower world as well as man: the dog dreams and hunts or fights, thereby proving that his brain is repainting a scene gone by.

I may describe a picture in words, and you will all see the image of it vividly in your brains, thereby proving that you might reproduce it if you had been trained. As I briefly describe some view in words, your brains will have photographed the picture, for it is instantaneous work with the brain; and the

wondrous part of it all will be, that the picture I describe and the picture I draw will not be as you think it is going to be—at least, I cannot hope to be so vivid in my word-painting, for every mind has its own way of calling up the pictures which we hear or read about, each mind taking up its own standpoint, and seeing differently the general aspect and self-constituted aspect.

In fancy I take up a piece of charcoal (the most delightful and freest of all art work), and with a few dashes of my charred vine wand may transport you to the balmy South, where ice the thickness of a sixpenny piece is a sight to boast about, and mosquitoes are an incontestable fact.

This piece of charcoal, which we take on faith to be the remains of a vine stalk, even as I name it conjures up the vineyards I have seen, and my memory is flung under avenues where the broad leaves and the purple clusters hung down, and, interlacing, broke the intensity of the mid-day glaring. I look down a clustering summit to a gleam of deep blue ocean and snow-white strand beyond. This is what the word vine has done to me, and something like this, or perhaps, if not so realistic, more beautiful, would have been the mind-picture even if I had never actually witnessed the vine lanes. Memory is brought into action in my case; in yours, who may not have seen it all, it becomes the higher quality, creation or imagination.

The human mind is the most perfect painter we can have, without a limit to its invention or a stop to its rapidity—each word becomes a fixed photograph, instantaneously drawn out in all its parts, and coloured to the last hair-stroke.

You see it all, but take a pencil and try to make it corporeal. As you sharpen the lead it is all there, vividly distinct; but while you are thinking where to begin to reduce it into form, it becomes a slender suggestion of dancing outlines—you dash in the first stroke, and it has become an indefinite blurry mess.

That is our difficulty—the reader and myself—for I can see before me just now a full round golden moon in the softest of green-grey hazes, with the thrilling effect of the theatrical limelight all around it; not a cloud in the misty atmosphere shows above that balloon-like ball; it is lying light as a Chinese lantern on the exotic-freighted air; floating over the dim film which represents a mountain in the mid distance; pouring down a flood of white

ripples on the river or lake; making a mass of indistinct shadow under the tree roots—liquid shadow where the water laps the winds, velvet shadow where the grasses and plants are all mixed up; an ebony line of carving runs up the shafts of the feathery-crowned palm and the bulby banana tree; a broad black fan drops across the outer rim of that electric circle, as the banana leaf quits the shelter of the broken shade-work and asserts its independence; the tendrils are twisting about, but a pale sparkle alone reveals them; the big spider is hanging from his lair, but a diamond point only shows us where the dew is caught upon the gossamer web—all is breadth and shadow, or glittering silver flame, but our hearts go into the shade that is manifold, into the thickness of that impalpability, and our nostrils drink in the swimming perfume of the lilies and trumpet tree; and although it is but suggested, we can see the tracing of the palm fringes overhead, we can feel the heat of that languid night.

To recapitulate. Dress for your own comfort, and you must please everyone round about you. Eat for the sake of health—that is, eat to live—and you will have sound teeth, sweet breath, and merry months. Love will come to you early and stay long beside you, for years are only grains of sand in the calculating glass of Cupid, if the hand which holds it is steady and moist. Time limps, and an hour is lingering pain; or else flies, and the brown locks change to silver in a song of joy.

CHAPTER X. SOME OF THE OLD MASTERS.

A CURSORY EXAMINATION

WE will, in this chapter, take a quick run round the walls of our great National Exhibition, at least round that portion of it where the early masters of painting are at present represented.

I am going to give my impressions about those masterpieces which have been secured by experts for the benefit and pride of the nation; speak about them without any more reverence than the modern art critic might talk about a Millais or a Leighton, or any other living master who by reason of his body being still with us, and being still able to eat and drink, places his work within reach of the everyday critic; and in this spirit of independent impartiality I wish my readers to try to follow me.

I intend to give to these old pictures all the praise that I can bestow consistently with my own art knowledge, because being one of the owners of them I do not wish to decry my own property. Indeed, as a painter I should like to make every allowance for the faults of men who, coming before the modern masters, had so many more technical difficulties to overcome than their successors had at the start of their professional education; but I wish to look at their works as the production of human beings who lived in their own times as we do in ours; in fact, I want to look straight at them, without regard for their names, and tell you, as students, the pictures which are of the greatest value to you as well as to me, and point out why, in my opinion, they are thus valuable.

Therefore, if you are not prepared to follow me in this spirit, you had better read no more of this chapter, for I may shock your sensibilities with my remarks. If you cannot look past the halo which Time has placed round the head of Raphael, for instance, and view the man in the same independent spirit in which you would look at the work of a man whom you might meet any day in the street, do not go on, for I shall only rouse in you a fury of scorn or indignant pity; and although I do not mind personally being considered a presumptuous fool and iconoclast, still I have no desire to lash anyone into fury or make him stain his soul by hatred. I would rather keep the whole world happy and at peace with me than rudely disturb the serenity of their pet delusions.

Still, in spite of my own inclination towards comfort, I must tell the truth for the sake of those who wish to see things as they really are, and not as they have been taught to believe they are. I will try to be plain if terse, and while extolling the virtues, point out the smaller vices, without considering my own private feelings in the matter.

For instance, I have been taught from my earliest years to regard Raphael as removed beyond criticism, to accept all that came from his brush as almost divine—himself as the perfect painter of perfect pictures. Judge, then, and pity my feelings, when, with a temerity approaching to the suicidal, I begin my critical and analytical remarks with the picture which, 'by common consent, is considered to be one of the most perfect pictures in the world,' as 'it is also one of the noblest embodiments of Christianity.' I refer to the 'Ansidei Madonna,' No. 1171, purchased for the nation from the Duke of Marlborough for 70,000*l*.: the highest-priced old master perhaps in existence.

Let us regard this great picture quietly for a few moments, and try, if we can, to forget its price and its painter, while we analyse its composition and other artistic qualities, i.e. bring it down to the standpoint of a picture painted by a living artist, and exhibited, say, in last year's Academy; for that is the way I am going to treat them all, for the benefit of the student who may wish to copy them as well as of the ordinary owner, who desires to learn why his representatives have paid so much for his property.

From a decorative point of view I readily admit that this is a fine work. As the design for an altar window, to be reproduced in stained glass, it seems to be much more suitable than as it is at present, inside a frame.

But it is not the finest picture in the world; it is not even the best example of the same master that we have in the National Gallery; it is greatly inferior as a painting to 'Pope Julius II.,' No. 27, which is, in technique, the best work we have of Raphael's. It is not nearly so good in its design as the Garvagh 'Madonna,' No. 744; nor in expression can it be compared to the 'St. Catherine of Alexandria,' No. 168.

As a painting it is not a success; in design it is stiff and commonplace in the extreme. The throne of the Virgin Mother is an ugly dividing blot in the picture, allegorical although it may be in its accessories and details; it is a hideous box which breaks the picture into three parts, and utterly destroys all

sense of unity and harmony. The emblems, although freely enough painted, are forced and badly placed. The Virgin Mother's face has no expression, unless it be that of inane contentment. She is certainly not studying the book which she holds on her knee and fingers so affectedly. The baby Christ is well painted and good as a baby, but He is held with too careless and limp a hand by his emotionless and expressionless mother.

I have no fault to find with the figure of the good Bishop Nicholas of Bari; it is realistic and natural, and stands as a Bishop might stand if reading aloud from his prayer-book to his congregation. But St. John the Baptist is not nearly so satisfactory a piece of work; the position is strained even for ecstatic contemplation; the advanced leg does not seem to be connected enough with the body, and in its pose appears to be pointed with the exaggerated attempt at grace of a dancing master; therefore, although the general colouring is *pleasing*, and the manipulation of detail easily managed, without too much minuteness and labour, this picture is not a work which I would advise students to copy, if they wish to cultivate good composition, perfect drawing, and general unity.

As to its intrinsic value, I should price it at 8,000*l.* instead of 70,000*l.*, because I do not think the best picture in the world is intrinsically worth more than 10,000*l.*, no matter how rare it may be as a picture pure and simple. In consideration of its merits, which certainly counterbalance its demerits, I would fix its price as it now stands at 500*l.*; but because it was painted by Raphael Santi, and therefore has its value over and above its merits as a work of art, I put it at the figure I have named—500*l.* for the picture and frame, and 7,500*l.* for the name of the painter *and the antiquity of the article*.

I limit the price of this work of art because, while the great bulk of the nation, to whom this Raphael belongs, are writhing under the awful ills of the direst poverty and affliction, it becomes us as units to consider whether we have a right to spend so much money upon a single picture with the starving owners of it all round us; to weigh it in the balance and think whether the spiritual or artistic pleasure which the contemplation of that work gives or may give to the educated masses is a just and fair equivalent for the starving or slaughtered thousands which the money that purchased it might have kept in comfort and life. If the work of the ever-living Raphael is not sufficient equivalent for a starved thousand or two, if it does not yield complete satisfaction to all, in their every phase of contemplation, then I

hold that the dead and gone Raphael has cost the nation 62,000*l.* too much, which might have been expended better in other art directions.

Personally, in spite of all that I have read in praise of it, this picture does not give me complete satisfaction as an artist, and none whatever as a devotionalist. Perhaps it may affect the general masses differently, however.

Returning to my favourite, or, as I consider it, the best National Gallery example of Raphael, 'Pope Julius II.,' this is a work of art which may be examined by both artist and amateur with unqualified pleasure and instruction. It ranks with such realistic masterpieces as Rembrandt produced, and it is almost as unaffected as the 'Portrait of a Tailor,' by Moroni, No. 697.

It is painted in a rich colour scheme of red; warm, ruddy complexion, scarlet cap, and cape lined with white fur, and a soft, creamy under robe of some woolly material, with red and gold tassels on the chair behind. The hands and finger rings are splendidly painted, the expression is masterly in its combination of power and repose. Anyone can tell at a glance that this is a true likeness of the Pope, taken when he had an hour of leisure, and faithfully reproduced without any attempt to idealise. It is said not to be so well authenticated as some of the other works by this painter, but for the purpose with which I now write it is better than any of the others, and of most value as a study for the copyist.

The Garvagh Raphael, 744, 'The Madonna, Infant Christ and St. John,' is a picture not too dear at the price it was bought for, viz. 9,000*l.*, for it is well worth 2,000*l.* more than the 'Ansidei Madonna,' in consideration of its superior composition, chiaroscuro, drawing, and colour. It is all beautiful and human. The comely mother with two lovely children beside her gives us the true divinity of holy maternity; the landscape behind is deliciously and tenderly painted, and the only blemish in the composition is that discordant and mannered pillar behind the Madonna, placed there for the too obvious reason of throwing her face, with that of Christ, into better relief, as in the Ansidei picture, and, like it, spoiling the concord with its heaviness and the stiff, stage-wing-like uniformity of the two windows behind.

168, 'St. Catherine of Alexandria,' is a sentimental study of a robust and soft-handed young woman, with a sketchy background in umbery tones. It looks like an experiment of Raphael's, and in pose is almost grotesque in its

lackadaisical rapture, yet it is finely painted as to flesh tones and other details. So also is No. 269, 'The Vision of a Knight,' which is, as an example of this painter at the age of seventeen, positively marvellous; yet for all that, although the design is good, and the composition freer than the general laws at the time laid down, as a study for the young painter it is not good; it will make him too easily satisfied with himself and with his drawing. Still, it has its special interest to the painter, as revealing what Raphael could do in his early student days.

My present task, however, is not to waste time going over the indifferent works in the Gallery, but rather to point out, as they occur to me, those masterpieces, the studying of which may educate the mind of the outsider to whom Art is a mystic term, and advance the student in his education as a painter.

I therefore turn from the formal and affected Ansidei to a picture which at the present time is placed near at hand in the same room, as I think it will make your minds rebound with real relief; at any rate, I know that it will go far to educate you in the knowledge of what a good piece of masterly work is. I refer to No. 1315, 'Admiral Adrian Pulido Pareja,' by Velasquez.

For a full and sympathetic account of this great painter's work, the student cannot do better than read 'Annals of the Artists of Spain,' by Sir William Stirling-Maxwell, published by John C. Nimmo, in four vols.

This portrait comes upon us like a revelation of ease and masterly handling. There is nothing like it in this respect in the whole Gallery; indeed, it was considered so life-like when it was first painted that King Philip mistook it for the man himself, and gave it a royal chiding for wasting his time at Madrid. Sir Joshua Reynolds says of this master: 'What we are all attempting to do with great labour, Velasquez does at once.'

I fix upon this portrait because the copyist will learn more from a single figure than from a crowded composition, and the drawing out and copying of this work will do more to make a master of him than any other study.

It is like painting direct from nature, with a teacher of great experience at your elbow to prompt you as to the right brushes and colours to use. It is all fire, dash, and vigour, bold and free as the best work of our own contemporary, James McNeill Whistler. The drawing is perfect and the

colours are nearly as brilliant as when they were first put on. Here, as in the works of Shakespeare, we have the 'mirror held up to nature.'

Opposite to this work in the present arrangement of the pictures we have a companion as to size and quality, although not quite so simply treated, No. 1316, 'An Italian Nobleman,' by Moroni—the painter of the most perfectly natural portrait in the National Gallery, No. 697, 'Portrait of a Tailor.'

In the 'Italian Nobleman' the quality is so good and unforced, the art so covered up, unobtrusive, and natural, that the student is apt to begin copying without considering the difficulties before him; therefore I would advise him or her to turn first to the Tailor's portrait before he tackles this less perfect, yet more difficult, 'Nobleman.'

This, the Tailor portrait, looks at you to-day as quietly and modestly as if still waiting for your instructions, with his shears in his hand, as the original must have done more than three hundred years ago; it is so highly finished in all its details, so perfect in its expression and pose, and, as I have said, so undemonstrative on the part of the master, that one is apt not to wonder he had no honour in his own country. It takes a painter of some experience to appreciate Moroni properly, as Titian did, although ordinary spectators will hardly pass it over without saying 'How natural!'

The other pictures of this rarely gifted master all bear the same stamp-mark of matchless workmanship and power of depicting character: No. 1023, 'Portrait of an Italian Lady,' in red satin dress; 742, 'Portrait of a Lawyer,' in black velvet; 1024, 'Portrait of an Italian Ecclesiastic;' and 1022, 'Portrait of an Italian Nobleman.' While the student may satisfy his cravings with that likeness of 'Pope Julius II.,' No. 27, and perhaps one of Raphael's infants, he cannot do better for himself than take the whole of the Moroni works, and follow up with what he can get of Velasquez.

While giving these hints to students about single subjects, I will run over those heads or portraits which have mostly impressed me as being more or less useful to take in this course of study for their special qualities, after which I shall take up some of the larger compositions, and finish up with the old landscape and seascape painters.

No. 852, the 'Chapeau de Poil,' by Rubens. For ease and strong colouring, as well as expression, this is one of the best for a young artist who *has experience enough* with his brush to paint it quickly. You may labour with

improvement upon the portraits of Moroni, but you must work quickly and decidedly when you attempt to reproduce Velasquez or Rubens.

There are two portraits which I have always been fascinated with for their delicacy of execution. One is 585, 'Portrait of Isotta da Rimini,' by Piero della Francisca, and the other 'The Doge Leonardo Loredano,' No. 189, by Giovanni Bellini.

Both have been painted about the same period, at least within the same century, the fifteenth, and are distinguished by their high and minute finish and tenderness of outline; they are both well worth copying.

The 'Ecce Homo,' No. 271, of Guido Reni, is a good study of pain, and also good for the copyist because of its free and sketchy execution; it ought to be copied, as it was painted, in one working. Thus, the student who desires to be successful in his work ought to study the original well, and determine, *if he possibly can*, how many workings the master took to complete his work. In this case, Guido Reni began and finished his sketch at one sitting, meaning it only as a rough study for some larger work. Rubens did a number of his in the same method; indeed, if the artist is decided enough about his effects and intentions, he will endeavour to finish his work as far as possible in the one working, for oil-painting, like fresco-painting, is apt to look hard, artificial, and waxy, if worked over too much; in water-colour the artist need not place any limit to his different workings.

The best and richest colourists, with perhaps the exception of Rembrandt, finished as they went along, particularly in the flesh portions. The drapery and accessories may be retouched without so much damage, but excepting those masters who cultivated and depended upon the art of glazing, most of the best men finished their backgrounds and draperies before they touched the figures, i.e. their pupils did all that was in those days considered subordinate parts, and left the flesh for the masters to do at the last: a great mistake on the part of the masters.

The other pictures of Guido Reni are not worth much consideration. His 'The Magdalen,' 177, is a fascinating study for young people, as it is intensely sentimental, with lavish masses of fair hair floating about, while the face expresses a sweet abandonment of *large-eyed* sorrow. I am afraid that I must echo John Ruskin's sweeping verdict on his 'Susannah and the Elders,' and say also that it is 'a work devoid alike of art and decency.'

The 'Portrait of Himself,' 690, by Andrea del Sarto, is a piece of rich, quiet colouring and fine drawing; so also is his other example. No. 17, 'The Holy Family.' He was counted one of the faultlessly correct painters of his age, and his pictures command high prices. They are excellent alike in tone and the other academical qualities which are useful to young painters who aim rather at mastering the technical difficulties of their art than the imitating of style; therefore, I recommend this portrait particularly as an early subject before grappling with such overpowering masters as Rembrandt, Velasquez, Murillo, or Moroni.

For a young artist wishing to form a good manner on the old masters before he takes to the new, I would recommend him to take as a course the following masters in the order in which I place them. Begin with Fra Filippo Lippi. I do not mean the whole of his compositions, but a few of the solitary figures. Take next that spiritual and melancholy picture, No. 275, 'The Virgin and Child,' &c., by Sandro Filipepi Botticelli, and copy it all through carefully, particularly the *soft, yet artificial, outlines* which he gives.

Take next the Venus in that splendid masterpiece by Angelo Bronzino, No. 651, 'All is Vanity.' I do not know anywhere in the whole National Gallery a picture where the flesh tones on a nude figure are more perfectly painted. There is hardly any shadow at all about this figure, and hardly any positive colour, yet the flesh stands out voluptuously and softly, and the drawing is exquisite.

Next take Moroni, whom I have already described, and after working at him conscientiously, release yourselves by taking up Murillo and Correggio—his 'Mercury instructing Cupid in the presence of Venus,' No. 10. Rubens, copy just a little. Velasquez, copy the whole of his examples, and lastly try Rembrandt. You may then study one or two of the living masters, if you think fit, *and have the time*. If you have worked conscientiously with the earlier masters and in the spirit of the later ones, I can trust your own judgment to choose which modern man you are inclined to follow for a little while; but if you have got the gift of the true painter in you at all, after the course which I have prescribed, I expect you will dash along and try for academical honours, without any further delay, by aiming at originality; for amongst the mighty circle whom I have mentioned you will have discovered a style all your own, and I predict that it will be a good style.

Hans Holbein, the younger, is a fine man to copy if you wish to get a firm grip of your subject: there is little or no sentiment about him, but what he saw he painted with fidelity and care. No. 1314, 'The Two Ambassadors,' is a picture which is not only interesting as a painting, but also for the uncouth historical object which occupies the centre of the foreground, a kind of *ex libris* puzzle, meaning the painter's name, which does not improve the painting as a work of art, even although Shakespeare does mention it, or puzzles of the like description. It appears to me unworthy of any painter to spoil his picture with such a childish mystery as this elongated or distorted projection of a human skull, hollow-bone, or *hohl bein* represents.

I do not pretend that this is a great picture—none of Holbein's are. Henry the Eighth was a man of strong material tendencies, who liked things tangible, and who was without a particle of imagination, tenderness, or ideality in his composition, and therefore this German materialist exactly suited him. Hans painted men and women as he saw them, without attempting much in the way of grouping or posing; he painted them hard and fast in their extravagant costumes, with all their family jewelry upon them, and as many accessories round them as he could possibly cram in, because he loved to work and did not think to spare himself a week or two longer of patient energy, care, and labour; but he painted well what he did paint; therefore I recommend him to the young student who is disposed to become ambitious, Frenchy, dashy, and careless before he has learnt how much, or rather how little, his brushes can do to bring his ideal to fruition.

In 'The Two Ambassadors' the student will find all sorts of articles crammed in for the purpose of giving the painter something more to do. He had no higher aspiration than his august master had, therefore he exactly suited him, but he possessed the talent of infinite patience; and so I offer you Hans Holbein as the best mechanical workman of his country. He is a typical German in the hardy sense, as much as his countryman, Albert Dürer, was in another and a loftier sense; for they are, like the Scotch, either sure or hard-headed materialists or else seers and dreamers: often both combined.

We turn from hard Holbein to Murillo with a sigh of relief. We have done our dry-as-dust task; now let us take our fill of solid pleasure, of which there is no let in the works which this painter has given us: 'A Spanish Peasant Boy,' 74; 'St. John and the Lamb,' 176; 'The Birth of the Virgin,' 1257; and 'Boys Drinking,' 1287. I like all his pictures, but I like his boy best of all; in fact, if you want good solid practical painting—stuff which will help you on

in life, and give you real comfort as a painter or as a looker-on—go either to the Dutchmen or the Spaniards.

Look at that kneeling figure, 'A Franciscan Monk,' 230, by Francisco Zurbaran, for chiaroscuro and bluff power; 'The Dead Christ,' 235, by Spagnoletto, for vigour and strength of touch; 'The Dead Warrior,' 741, by Velasquez. Could any man want to paint better?

For the Dutch and Flemish, turn to Gallery XII., and be satisfied that you have got real men to deal with and to copy, instead of flimsy Italian sentimentalists, like the Church-bred early masters.

Take Teniers, with his delicious silvery tones and crisp touch, the man who paid his dinner with a picture, and painted his picture first while the dinner was cooking: compare David Wilkie with him, and see how David Wilkie shrivels up with heat before the cool tones of David Teniers the younger. Consider Cuyp, with his precise touch; Van Eyck, the father of oils, with his quaint mediævalism and patient symbolism; Weyden, as in 653, with his rigid adherence to facts; Quintin Matsys, with his hard high finish; Rubens, the lavish and exuberant; Vandyke, the refined; Gerard Dow, with his exquisite delicacy; Frans Hals, with his vigorous handling and open colouring; and lastly, the greatest master of all, the immortal Rembrandt, whom, for his portraits, chiaroscuro, colour, and vigour, I cannot find words to praise enough.

No one has a right to speak as an art critic about pictures unless he can paint a picture himself, or at least is able to copy faithfully the picture which he criticises.

I trust that I may say, by way of apology for my present free criticism, without being carped at as a vain boaster, that I have painted original pictures in landscape, seascape, and composition. I can also say that I have copied some of the masters whom I recommend, and can copy any picture ever painted, provided I have the leisure; and also I can tell you, after I have copied a picture carefully, exactly how the master painted his picture, the number of times he worked over it, and sometimes also not only the time he took to do it, but also his moments of hesitation and inspiration, depression and artistic exultation. But before I can tell you all these secrets about the mystic dead, I must first study his work by copying it; it would be only guesswork were I to content myself with looking at his canvas or panel; and

what I am unable to do with my long and extensive training as a painter, I defy any non-painting art-critical dilettante to be able to do. John Ruskin qualified himself as an art critic by learning to draw and paint, and when bigotry or bilious bad temper does not interfere with his critical vision, he stands, and must for ever stand, pre-eminent amongst art critics. No human being, however gifted he may be, is able to see colours or any other merit in either a picture or a book when he has a fit of indigestion or dyspepsia. The blue appears green, the clouds heavy, the firm lines shaky, the composition vile, the chiaroscuro gloomy, and the general colours dirty and unsatisfactory. A proper pill taken in time by the critic has often saved the reputation of the painter, poet, or novelist. As one patent medicine advertisement has announced, with a wisdom which should go far with sensible thinkers to recommend the drug: 'Dyspepsia leads more often to the divorce court than vice.'

To return, however, from these reflections to Rembrandt, the master whom I am at present examining. We have fourteen examples of this art-Shakespeare in our Gallery at present, and I only wish that we had an apartment devoted entirely to him, as we have to Turner. I should have been well content, and should never have uttered a word about the indigent poor, had the 70,000*l.* been spent on Rembrandts, and the 'Ansidei Madonna' still remained in the Marlborough or some other private gallery, because I think that the British public would then have had better value for its money.

I will grant at once that his drawing is abominable in his larger compositions and his figures taken *individually* are undignified and often even ludicrous, or rather they would be all this in any other painter who had not his scheme of chiaroscuro and colour-intentions, but with him I would not have them altered. As they are, they all go to complete the harmony; indeed, I believe that he gave them this grotesque appearance intentionally, because his portraits prove that no man could draw more perfectly, as no other man could use the brushes as he could.

No. 51, 'Portrait of a Jew Merchant,' three-quarter length; 166, 'A Capuchin Friar;' 190, 'A Jewish Rabbi;' 221, 'His own Portrait;' 237, 'A Woman's Portrait;' 243, 'An Old Man;' 672, 'His own Portrait' (1640); 775, 'An Old Woman' (1634); 850, 'A Man's Portrait:' all these portraits are so splendid in their qualities, and appeal at once so strongly to the sympathies of artists and ordinary sightseers, that I must leave them to speak for themselves. You look into the frames as through a window into a shady room, and see the

living characters sitting before you; the texture of their clothing is reality rather than realism; there is no attempt on the part of the painter to assert himself; he has buried himself in his subject.

As for the skill involved in all this unaffected simplicity, begin to copy one of these portraits, and you will find out a portion of it, and as you finish off with your glazings then you will look vainly into your colour-box for browns and siennas and lakes to get at that translucent depth, and at your colour lists with dissatisfaction. This master will be too much for you to penetrate through all his films, yet rest content if you are able to dive a little way below the surface without stirring up the mud. James McNeill Whistler alone has been able to approach Rembrandt in his etching qualities; no one *yet* has been able to come near him in his wonderful shadows, except George Paul Chalmers.

Yet we must not forget that Time has to be taken into consideration with much of the depth and richness of the old masters. With paint we may, after a measure, imitate a painter as he left his picture when finished; but Time, the constant worker, has put on subtle gradations of glazings which no madder or brown can imitate, and this must be your consolation.

Before leaving the portraits I must call your attention to Vandyke's masterpiece in this walk—52, 'Portrait of a Gentleman,' a head only, therefore we are not aggravated by the display of any of those unnaturally refined hands which disfigure so many of his full-lengths; this portrait may take its place with any other likeness in the world.

We have nothing of Michael Angelo Buonarroti in the form of painting worth looking twice at in the Gallery; he did not like oils and he did not succeed with that vehicle.

Leonardo da Vinci is represented by one specimen, 1093, 'Our Lady of the Rocks.' It is a heavy but fine piece of work, and well composed—all excepting the rocks, which are not good.

698, 'The Death of Procris,' is a masterly study of a satyr; the other portions of this picture are also fine, particularly the landscape behind.

There are two specimens of Tiepolo, Nos. 1192 and 1193, sketches for altar-pieces, than which no works in the Gallery are more useful to the young

painter. His scheme of colour is low-toned and restrained, yet delightfully good and pure, while his handling is masterly and free.

Tintoretto and Titian come next; the latter is the most lavishly represented, and the former not seen at his best, even in the three specimens we have, yet they are worth looking at. Titian of course is always masterly, both in his landscape and in his figures. Tintoretto unfortunately was forced by necessity to paint too many pot-boilers, and his fame suffers accordingly.

Amongst the many masterpieces in the Gallery, for majestic composition or fine colouring, I place Fra Filippo Lippi's 'Vision of St. Bernard,' 248; 'The Circumcision of Christ,' 1128, by Luca Signorelli; 'Venus and Adonis,' 34, by Titian; 'The Crucifixion,' 1107, by Niccolo of Fuligno; 'The Marriage of St. Catherine,' by Lorenzo da San Severino; 'The Virgin and Child, with Saints and Angels,' 1103, by Fiorenzo di Lorenzo (I name this early painting for its exquisite decorative qualities and its harmonious combination of carving, gold and paint, as well as for the general design); 'Bacchus and Ariadne,' No. 35, by Titian; 'Mercury, Venus, and Cupid,' No. 10, by Correggio, for its fine drawing and colour; 'San Arnolfina and his Wife,' No. 186, by Jan van Eyck, for its minute detail and realism; 'The Virgin and Child,' 274, by Mantegna; 'Madonna and Child, with Saints,' 1119, by Ercole de Giulio Grandi, another rich and decorative combination of gold leaf, colour, and carving; 'Christ at the Column,' 1148, by Velasquez; 'The Nursing of Hercules,' 1313, by Tintoretto; and 'The Raising of Lazarus,' by Sebastiano del Piombo and Michael Angelo, No. 1. This last picture is one of the most vigorous in design and execution in the whole Gallery.

About the landscape-work of the old masters there is not very much to be said, as they are mostly conventional, and were painted in the studio from studies; therefore, nature was always falsified and improved (?) upon.

Hobbema ranks first amongst the old landscape painters for fresh, pure colour, and close adherence to nature. 'The Avenue, Middelharnis,' 830, is as fine a piece of work as any modern work; it is true and rigid to facts, with a fine command of drawing, perspective and colour—one of the few landscapes really worth copying in the Gallery.

Salvator Rosa is perhaps one of the most spontaneous amongst these early landscapists, and the most reckless. He painted a picture at the one working, and composed a poem afterwards by way of relaxation, and although almost

as exaggerated and theatrical in his effects as Gustave Doré, yet his works have an appearance of nature about them, even if it is nature convulsed, which is often lacking about the manufactured efforts of his contemporaries, Claude Lorraine and Gaspard Poussin. 'Mercury and the Woodman,' 84; 'Tobias and the Angel,' 811; and 'A River Scene,' 935, are fair examples of this vigorous artist and versifier. That of 'Mercury and the Woodman' I like the best. Gaspard Poussin ranks between Salvator Rosa and Claude, not because he was not so good a workman, but because he was not so original in his style as either. His two best examples in the Gallery are 'The Sacrifice of Isaac,' 31, and 'A Land Storm,' 36. 'Dido and Æneas taking shelter from the Storm,' 95, is also a fine work.

Everyone who admires Turner must certainly honour Claude Lorraine; and as I am one of those admirers, I look upon the earlier painter of sunsets, classical temples, and artistically arranged trees with much interest. He does not, of course, paint atmosphere; only one master did this properly, and that was Turner, but he presents to us a placid and smiling world which promotes comforting thoughts of rest and joy, and so I give him all due honour as a pretty landscape painter and also an original master. What he did came from his own invention, and if Turner painted better, that was only because he commenced where Claude, his first master, had left off.

The 'Landscape with Figures,' 12, and 'Seaport with the Embarkation of the Queen of Sheba,' 14, are two of Claude's best examples. Turner was a daring man to risk the test of Time with the four pictures; at present his two look the best, but in another hundred years, while Claude's will still appear almost as fresh, Turner's will have vanished, as all his pictures must, and leave only a few stains and cracks behind. So much for the modern masters when they try to compete with their manufactured tube colours against the wise men of old, who ground their own paints, studied the chemistry of colours, and knew how to prepare their own canvases. A century after this, readers of old books will wonder what John Ruskin meant by praising Turner so extravagantly, when they go down to the vaults where the Trustees are vainly trying to keep the remains of those fugitive masterpieces, by secluding them from the light, while Claude Lorraine will still hang on in his old places, calm, fresh, sunny and metallic. So much for atmosphere against artifice.

CHAPTER XI. THE SACRED AND THE COMIC SIDES OF ART.

PART I. THE SACRED SIDE OF ART.

YOU have doubtless all seen a photograph of that fine head of our Saviour by Gabriel Max, illustrative of the legend of St Veronica. The story tells us that Veronica wiped the face of Christ with her napkin as He passed along cross-laden, blood-stained, mud-stained, and sweating to Calvary, and in token of her kindness the Lord left the impression of that world-wasted face upon the napkin.

It is a beautiful legend, and Gabriel Max has illustrated it as, without exception, no man before him ever did.

The dimness and uncertainty have aided the painter's conception. It is not so much a face as the shadow of a face which is presented to us—the shadow of a lamb-like face, full of infinite meekness and patience, dirty and wounded, with masses of hair draggled and stuck with the blood which has trickled down the brow and cheeks to that indefinite beard.

This, to me, constitutes the great charm of this masterly work; that the painter has left to the spectator the task of embodying this divine shade.

The trick about the eyes is the weak and common portion of an otherwise matchless work of subtlety. It may please the people, and make a multitude of inartistic minds marvel at the cleverness of the illusion, but it is only a small trick at the best, and unworthy the mind which could conceive and execute all the rest.

Sacred art, from the specimens I have seen, has not yet fulfilled its aim or intention. Those Madonnas of Raphael are only pretty women nursing their babies; that is, if you can tear down the mystery and veneration which time has thrown about those dead masters and darkened masterpieces; so perhaps it is as well not to dwell at length upon olden art, which represented sacred art, but to come to my present purpose, which is art sacred, or the sacredness of art as a life calling.

I have often wondered whether there are many young men or women showing pictures in exhibitions who think seriously upon the calling they are devoting themselves to; do they think upon the duties before them, and the obligations they are binding themselves to fulfil?

To be a painter means a great deal more than to have learned the blending of a few harmonies, the proportions of a model, or some years of outline practice; more than sitting down before an object and reproducing it faithfully, as far as the outward eye sees. It means the subduing of self, and the taking up of a daily cross; the following of an ideal in spite of all obstacles, jeers, laughter, or pity.

It does not mean to be able to sell well to the public or to dealers, as any clever mechanic can learn to paint to sell: you have only to acquire the fashion and the trickery of the trade, which, with a little practice, will make you popular.

Sacred art means patience—not that patience which is composed of pitiful detail or painstaking, but the patience which will make you follow out your ideal, regardless of all consequences.

This is where young artists err in taking to the brush. A little dexterity is acquired, and they imagine that they are done, and able to criticise all and sundry.

I generally know a novice from an earnest seeker after the truth. The beginner laughs outright at first sight, and the learned student looks and probes; the intention being gravely weighed in the balance with the execution, and the worker getting all the benefit of the doubt.

When an artist first begins to tread his journey (after he has left school, I mean), it has mostly a very pleasant and sunny appearance. Of course he can draw and copy casts nearly as well as the master, a great deal more neatly than most artists who are half-way down the road; all the maxims are fresh in his memory, with the colour blendings, which he has learnt by rule.

Hope sits lightly in his heart, because he has one or two commissions, or perceives the distant promise of a few. So the morning sky above him arches without a cloud, and the early rays are falling slantingly upon countless diamonds at his feet.

There is a valley in front of him (but that is far off), a place of darkness, where high rocks are cleft to meet again overhead so that the sunlight cannot pierce through the gloom; a place of skulls—the Golgotha of the painter—where the armour of conceit is broken into pieces and left amongst the wreckage with which the place is strewn.

Those who come out of this valley of humiliation live on for ever afterwards grave men, who look more after their own imperfections than the faults of their neighbours.

Countless hordes rush into the darkness and are never seen again; the bones of some whiten there, pits on the roadside swallow up others, while others again get into false tracks and are never able to retrace their steps.

A number shirk it and go by this side backwards, as happy in their ignorance and foolish laughter as when they began so hopefully.

And the world is so blind that it consents to honour and pay those shirkers, oftentimes better than it does those grave survivors of the black valley.

When the artist first begins his pursuit he ought to begin with the high sense that his profession is a calling, and that he is the eye-preacher of beauty as the pastor is the ear-preacher of religion; he must go out with the intention always to do his very best in his own natural way, for no other man's habit of walking will do for him.

To be a painter is a great pleasure and a great pain; pleasure in the summer, when the sun is ripening the pale golden ears of corn, and the painter walks out amongst the lights and shadows, the fresh air and the singing of birds, and, fixing upon something beautiful, sits down to listen to the divine concert and sketch it all in—the *music* and the magic changes of Mother Earth; pleasure when he gets up in the night-time, thralled with his great idea, yet unborn, and labours to bring it out—those gracious hours of ecstasy when the charcoal smudges over the paper, and the brain is reeling with the intoxication of the Creator.

IMAGINATION

Gift of God to erring mortal, promise of a life divine,
When the creature is admitted to that awful inner shrine;
There is naught of earth remaining, kings and princes hedged about
With divinity the circle, leaving lesser beings out.
Gifted with the Maker's magic, out of nothing they create
Crowded earths which rise before them, void, until they animate.
They are passed in scorn or pity, beggars in their fellows' eyes.
What are rags and empty purses when to heights like these they rise?

For alas! with this gift comes too often *tactlessness*, a glorious capacity to build castles in the air, with a most deplorable incapacity of being able to reduce those splendid edifices to any marketable value.

When the artist has laboured at his idea until it takes a form, not quite the matchless creation he dreamt, but as nearly approaching to it as his skill or paints can come, a glow of unearthly passion and wonderment at his own work comes over him; he has caught something more than he dreamt about, even although it be not quite so fair; for the vague indefinite is always more perfect than the embodied reality. He looks at his work with awe and wonderment.

SOUL

Yes! the image is completed, every feature there is caught,
Death is conquered, and immortal we have made it out of naught;
And from that strange spark within us, that strange spark of inner fire,
It is like ourselves, immortal, it can grovel or aspire.
What is that which we have given it? something that we cannot tell,
Something of a life beyond us, for we feel it oft rebel;
Something thrilling, something noble, something leading to a goal,
Ours—and yet beyond explaining, call it Heart or call it Soul.

The artist wonders at himself, and, with the excitement, sees past the form to the ideal. It is like a draught of nectar to him, that Olympian wine which made the gods mad in the pleasant court of old Jove.

ADORATION

I have made it. Have I made it? It is noble, it is good.
It seems perfect, can I wonder that it is not understood?
There were pangs in its out-coming, efforts of the clouded Will,
But it forced its way to being, all my frame is trembling still.
I have made it. Have I made it? Can the *wish* engender power?
I am humble, yet adore it; it was in me scarce an hour.
I but yielded up volition, not one effort did it cost,
Only pangs of indecision when I feared the thought was lost.

He is exhausted with the effort and goes to bed, sleeping a dreamless sleep, while the dormant mind sobers down; and now comes the hour of reaction and icy pain, when he rises changed and cool to review the fevered work of yesterday. Reflection sets in, and he tastes of the cup of doubt and despair.

REFLECTION

From the clouds we have descended, time hath cooled our fevered brains,
Reason pounces on her victim, rivets round him iron chains,
Pointing out each imperfection with a finger tipped in ice,
Jeering tells him his creation cannot bear the looking twice,
Sets him up, his harshest critic; now the labour has begun,
Hours of thinking, watching, working, when the spirit part is done,
Timid touches, happy chances, beatings of the fearful heart;
First creation, second motion, then the patient tricks of art.

Last state, repose. When he has done his very utmost, listened to the opinions of doubtful friends, with friendly and hostile critics; when he has altered and re-altered as far as *he* possibly dare go, he lays down his brush with a defiant gasp, dogged in his resolve to spoil it no further, deaf to any further suggestions; he is as contented as his sacred but exacting art will permit him to be.

REPOSE

It is finished, all imperfect, but it is our very best,
We can come no nearer Nature, here are all our sins confess'd.
If we spent another hair-stroke something precious would be lost,
Ye that see it but a second cannot reckon up the cost.
'Twas an altar of the passions, burning hopes were offered up,
Prayers and fastings followed after, we drank deep from sorrow's cup.
Through dark hours of cold affliction, from sharp thorns we pulled the rose;
Marvel you at our assurance, at the pride of our repose?

Unfriendly critics are not much trouble to a true painter; he hears them talk with the consciousness that he will benefit from their jeers when they jeer with discretion, and be able to trip them up when they display their ignorance. The public, not appreciative, does not move him much either, further than he has the gaunt wolf to keep back, and must study their wishes so that they may help him to kill this monster. What is his great grief and

tribulation?—the inner voice which tells him every step of the way that he is so far behind, that he has so much to learn and so little time to learn it in. Every picture he sees by another artist seems so much better than his last picture, that his life would be a constant misery if it were not for those poetic visions and sunny hours of open-air exercise.

To be able to paint a tree or a street or a face does not fulfil all the mission of sacred art. It demands more. Nature, which for ever changes, demands from her votaries constant change of subject and constant change of treatment, and the hour which finds the painter contented with what he has learnt, and satisfied to go on reproducing his effects, finds him a hopeless invalid as far as art-progress is concerned. Like the poet, he must go on, go upwards for ever; for nothing can remain stationary either in this or the next world; if we do not climb upwards we are bound to descend. As Buddha tells us:

'The devils in the under worlds wear out deeds that were wicked in an age gone by. Nothing endures.'

We must go on, or *go out*, go on searching after purity and elevation and beauty in its highest sense; not the beauty of an inane face or fashion-plate figure, not even the ideal beauty of the Greeks, but the beauty to which we are most adapted in each stage of progression as we mount toward the infinite.

BEAUTY

What is Beauty? the perfection of the type it represents,
And the true fulfilment of the picture that the mind contents.
It is in the babbling streamlet, with its birch and fern-lined strands,
It is in the factory chimney which against the cloud gaunt stands,
In the blasted trunk that fork-like rears its bleached bare arms on high,
Framing sedgy moors and uplands past soft tones that melt in sky.
Nestling in the yellow short-gown, couched in costly wreaths of lace,
In the heart, voice, walk, and gesture, more than in the form or face.

The painter must work out his own redemption in this pursuit of the beautiful. No imitation of the beauty of another will help him; his sense must be innate and out-coming; from him the well must spring which has to quench the thirst of nations—living water and quenchless fire—to flow on

and light on, long after his own creative powers have ended. As Buddha again tells us:

'Ask not from the silence, for it cannot speak; vex not your mournful minds with pious pains. Ah! brothers, sisters, seek naught from the helpless gods by gift or hymn, nor bribe with blood, nor feed with fruit and cakes. Within yourselves deliverance must be sought. Each man his prison makes.'

As I have said, the beginning of painting is very easy. A straight line done fairly well, drawn with the full comprehension of the mind, and a flowing hand which can pause and run on at will, the knowledge of the rainbow colours and blendings, are the alphabet of the artist. Afterwards, as he grows in stature, his wants and wishes grow in proportion; and the nearer we seem (to the eyes of those behind us) to be approaching the goal, Perfection, the farther away it is from us.

To the public, for whose instruction and pleasure the artists paint, I would fain close this by saying just a few words. Beware how you are satisfied with a picture; misjudge your own eyes when they are gratified only. Is the painted cornfield exactly like the cornfields you have seen? Is it a *dead* or a *living* portrait of the corn-ears? Has the painter, in letting go the exact facsimile, not given you something beyond and better—the motion and soul of that cornfield?

Are those eyes exactly like the eyes of the one you love or mourn for? They may be the exact shape and size and shade, but are they the eyes you used to look into and let out your soul after? Or has the painter been careless about the shape or shade or size, and yet given you a gleam of the heart-longings that cling to your heart-longings with unseen angel-claspings?

Weigh it all carefully, whether you want the shape and number of the houses in the home of your childhood, or the indefinite thrill which shall wake into the active music of long ago. Do you want the cold clay that is lying under the senseless stones, or the spirit which is hovering about you still?

This is the mission of sacred art—to teach us to be better and not to go back; to bring us from the fierce chasing after the world, and make us forget the golden links we are striving to forge for the sinking of our manhood or womanhood; to tell us how the nations long ago lived and loved and laboured, and now lie dead in spite of all their pomp, as we shall be in spite of all our hankerings after what is ours no longer than a day of Time.

To give us gleams of sunshine and green fields and cooling streams, when we are parched by the dust of the streets.

To give us glimpses into the wisdom of innocence, when we are blinded by guilt and shame and crusted selfishness.

To give us glowings of chivalry and patriotism, when we are forgetting all these inspirations in the ignorance of this book philosophy.

To make us more merciful to the poor and unfortunate, the maimed in mind as well as body; to make us love all as our brothers and sisters, no matter what their faults may be.

'Living pure, reverent, patient, pitiful, loving all things that live, even as themselves, letting unkindness die, and greed and wrath.'—Buddha.

This is the mission of our sacred art—to educate each soul, painters and people; to subdue the self that is now dominant, and plant the other on its throne; to make men and women of us all, in the highest, truest, grandest sense.

PART II. THE COMIC SIDE OF ART.

ART is many-sided, but with the exception of one, or perhaps two, of the sides, all the rest are comic.

Viewed from the outside, that is, the standpoint of the buyer and the critic, the ludicrousness of it is almost appalling. It would be tragic in the intensity of its farcical characters, even as a very hearty laugh sometimes will cause sudden death by choking, were it not for the shades of the pitiful or contemptible which relieve it of the load of laughter, and change the downward curve of the broad grin into a decided upward smiling termination.

I dare say you will think my subject should be composed of illustrations from Cruikshank, Gillray, Leech, and other masters of the comic muse, and so it ought to be, perhaps, and for that very reason I do not feel inclined to treat it so. I do not like to see ladies dress all by the month's fashion-plates, whether it suits them or not, nor men do exactly the things expected of them. Where would be those delightful throbs of surprise if it were not for the tangent starts of the unconfined lunatics who pass for men and women of talent on this very superficial, thin-crusted globe of ours?

One of the most amusing sides of art is the method people have of judging a picture.

Say an old gentleman with his wife and two or three daughters come by mistake into an exhibition with the catalogue of some other exhibition in their possession. They glance at a picture, and fall into raptures over it: 'Beautiful, the *feeling* is delightful. What force of touch, strength of character! Who is it by? Number So-and-So. Ah! I knew it.' (The number in the wrong catalogue points to a well-known name.) 'I felt that I could not be mistaken.' (The old gentleman adjusts his glasses and looks at the title with triumphant conviction.) 'Odd title, though, for the subject; eccentricity of genius, I suppose. No matter, it is splendid. Quite Dutch-like in its subtlety; quite Israely in its character; delicate, refined, realistic, bold, masterly!'

One of the daughters, blessed with keener vision, has here discovered another signature on the corner of this masterpiece, a name not in the fashion, in fact one despised. 'Papa, it isn't by Mr. Smudge, R.A.; it is by Ernest Tyro.'

'Eh! what? Nonsense! why, the catalogue says Smudge.' The mistake is discovered, and at once the tune changes. 'Ah! vulgar, coarse, commonplace. Let us go out before we are contaminated.'

Now, this is the comic part of it, with a dash of the pitiful. What difference did that signature make in the merit of the picture? If it was delicate, refined, bold, masterly before, how could it be vulgar, coarse, or commonplace afterwards?

A man with piles of money to spend and a moderate modicum of brains gets hauled into the artistic stream, and goes gasping and spluttering around, spending his money on what he knows nothing about, and never will while God blesses him with cash, and his tongue can patter cant. Somebody takes him kindly in hand and educates him, as Buchanan did James VI.; he raves about the painter he has been taught to consider the master.

'Look at it! what colour, what masterly brush-marks. Did you ever see the like of that?'

Never, except in a white-washer with his broad brush, or a scavenger sweeping a crossing.

In his natural state he may get a picture which he can comprehend, because the houses are like the houses he sees every day, and the trees have branches and leaves definitely painted on them; that picture represented Nature as he saw her, therefore he considered it good. But under training he is taught to despise this sort of thing, and obediently despises it; the old love is turned out or with its face to the wall, and the splashes which have neither form nor finish are doted upon. Would this man care to have a wife without a nose or with indefinite features? Would he be charmed with the colour of a mashed-up bit of flesh? It is all right enough for musicians to rave over the sweetness of a piece of catgut, but the world wants to hear the whole tune, and what we as artists know to be good quality is comical affectation on their part.

Artists are no exception in this curious alteration of opinion. I have heard artists shouting with contemptuous laughter over a picture, calling it rubbish, and crying that the man who painted it ought to get six months for doing such deeds; taking it to pieces, running down the drawing, the composition, and the colour, until some authority said it was good, and then they saw as by a miracle beauties in the very faults. What was bad drawing before this became a splendid piece of handling; what before had no composition now

teemed with poetry, and from bad it became beautiful colouring; and I have wondered how it all came to pass, seeing that *they* ought to know what is good.

There is a story told of Tintoretto, who was kept down and scoffed at nearly all his life by the school of Titian; for even in those far-off balmy days fashion ruled the roost, and the great masters acted about as contemptibly as do the little masters now.

Poor Tintoretto could not paint to please anyone, and when he did sell, it was only for canvas and stuff, if he got a patron generous enough to give him so much, brains and labour being flung in by way of apology. It was the price of a spoilt bit of cloth he generally managed to get from his patrons.

Sometimes, when the people were surprised out of their habitual doubt and suspicion by some brilliant flash of fancy, and the wealthy controllers of men's destinies were inclined to pitch the poor wretch a sop, it was passed over his head to the hangers-on of the school then in repute; what the decorated old Titian could not swallow himself he handed over to some of his satellites, and left Tintoretto outside.

Tintoretto, although an amiable sort of fellow, was not altogether an angel, and, therefore, naturally resented this sort of starving process, and kicking out, as some of us still do, got laughed at for his pains, as I dare say is as much the habit still as it was in those golden days of old in Italy. Jerusalem is not the only city where donkeys thrive by braying.

Notwithstanding the constant snubbing to which he was subjected, Tintoretto was generous enough to be able to see and appreciate the good qualities of Titian a great deal better than the prosperous painter could see his beauties in return. If I had to express an opinion on the two men, I should say, 'Tintoretto was the prince of painters, and the lucky man was Titian.'

Amongst Tintoretto's few possessions was a picture by his tyrant, and Tintoretto had the meekness to copy it so carefully that he was pretty well pleased with it himself; so he hung them up together, with 'original' on the one and 'copy' on the other. The critics came in, as usual, to laugh or encourage the mighty but stricken heart with words like this: 'Ah, if you could only paint like Titian!' or, 'Not the least degree like the original.'

Now, Tintoretto had his own opinion about his abilities, as we all have, I dare say, about ours, and he thought at nights, when he looked over his creations, that they were as good as Titian's, and some of them better, if not nearly so well paid for; and after all these years a great number of sensible people have come to see and believe the same as the poor old man did of himself. Of course it wasn't much consolation to him, this conviction, seeing it didn't change the sour wine and black bread of his table into the Cyprus and cake of his rivals. No matter; the old man determined to have his joke, if he could have nothing else out of the gold-laden quadrupeds; so he wrote on the original 'copy,' and on the copy 'original,' and waited for the kindly-disposed visitors to come and comfort him, as usual.

'Ah, a very far way behind, old man! it won't do; you haven't the go of the master in you. It wants strength and purity; the chiaroscuro is shallow as a summer stream. Why can't you do it like this, now?' pointing contemptuously from the original to the copy.

That was the method of judging pictures long ago, as it is now. If a man paints something that becomes the fashion, then he may do what he likes with his paper or canvas. A drunken smudge or a meaningless splash of the brush will be raved over as if the man had wrought a miracle.

And how a man gets into fashion is often as great an astonishment to himself as it is to the people coming after him.

One artist tried everything, from still life to a vision of the infernal regions, and still he could neither please the public nor pay for a respectable suit. One day, in a moment of frolic, he put a priest's robe upon a brother artist, and painted him in that fashion, sending it into Paris, as usual, to stand in the windows for an indefinite time. A distinguished English art patron passed, looked at it, praised it, and gave the dealer the price asked for it.

Presto! the painter was famous, and found his vocation marked out for him for ever after; and I suppose now drinks absinthe and smokes cigarettes during the intervals of priest-making without a single care for to-morrow.

A man may paint and paint until he is white-headed, or has worn the hair off his scalp altogether, and all to no purpose. He may rack his brains until the cords crack to invent a new subject, and propitiate fickle fortune, and not be able to earn salt for his broth. He may produce picture after picture, with all the conceptive power of a Michael Angelo and the colouring of a Titian, and

still be no nearer his aim. And, in a fit of desperation, he may dash off a piece of brainless rubbish, and for that hasty bit of caprice become the lion of the day.

And when he does succeed, has he not justice on his side if he curses the goddess Fame, and laughs to derision the senseless crowd of worshippers who have raised him up on high?

When he thinks on the guineas he is making now, and the coppers he was not able to earn before; when he thinks upon the pictures which he created before, and the worthless daubs which he is flinging off now; when he thinks upon what might have been, or upon the woman he might have married, or, if married, on the woman who might have been still alive, if his deserts had been rewarded as his folly is—the woman who pined and grew haggard with anxiety, and starved to death through the want of the paltry gold that now curses his present blasted life—this is the kind of comedy to make men stand up and blaspheme, and to make women lay down their heads and weep themselves blind. The painter who *was* a man, and has become a machine; the man who grew by his earnestness near to God, and now must work for an earth-idol!

It is a comic sight to see pictures which are the fashion; colour-blendings, the outcome of craft only; men who have had aspirations after great things content to lay down a noble purpose before an order. One trick or one accident did it, and so they must run the vein threadbare or else starve.

I remember once three young fellows who went gold-hunting; they bought a digger's claim and dug away for six months without a single sight of gold-earth colour, and at last caved in.

Two new chums came along and took the claim on chance; the ex-proprietors had pocketed the transfer-money, and squatted on the surface to take a final pipe before leaving. The new hands went down and filled the bucket; it came up bulging with a fifty-six pound nugget of pure gold in it. The old hands had worked six months without avail, and the new chums struck at first sight.

Art is like gold-digging, all a blind chance.

It isn't good work that takes, it isn't earnest thought; it is all a turn of the wheel, and the man may be a genius or a jackass. If his turn comes up he wins the hour.

Gold! Ah, when will the power of it cease? The first digger who saw the nugget appear clasped his hands in front of him and took a header down the pit, dashing his brains out in the paroxysm of his disappointment. I remember once a man who had made a fortune came on board ship with the load converted into sovereigns and sewn inside a broad belt round his waist. He tried to be calm and reasonable, but it was of no use; he went frantic with his good luck, and one day, after being three weeks out at sea, he came up on deck in a frenzied condition, took off his valuable belt, opened it, and pouring the glittering contents overboard, sprang in after them, and so settled the grand problem. There was one painter who knew the difficulties of art and the capriciousness of fortune very exactly. In early life his good pictures could hardly bring him in 30*s.* a week, and latterly, when he could sell all he put his name upon, he used to say that the British Lion would give fifty pounds for a dirty piece of paper if it only had his name on the corner.

It is this truckling to gold that makes art comic and common, this buying and selling custom which takes all the inspiration out of it and renders the pursuit of it a few degrees below the honest efforts of the mechanic, just as we know the glory of womanhood loses all its sacredness when it is made the end of a commercial bargain. If the beauty is not beyond price it is worthless; so, if the picture is not too precious to sell, it is nothing greater than the price it brings.

Artists will for ever imitate tradesmen, and want to stand on their dignity at the same time, which is an impossible combination.

It is a very curious trouble, this disease of Dignity. A man may do a thousand mean contemptible actions, and yet stand back indignant at the one over and above. He may sin his soul away, traffic his manliness for a few paltry shillings, and yet feel fearfully outraged because someone proposes one other shabby trick to him; as if it mattered much one shuffle more amongst the others, one more dirty spot amongst the many defilements with which his soul is smudged over. He may feel no shame, for instance, in taking away characters, and yet stand out very rigidly against taking a purse; as if the stealing the paltry contents of the one were one-tenth part as great a wrong as the other.

A man may feel very much ashamed of a parcel because it isn't done up in brown paper, or feel very unhappy over a collar half dirty, when he would think nothing at all about the bit of villainy that is so much uglier than the half-dirty collar.

You all know those pictures and engravings of Hogarth, who painted like the moral preacher that he always was. He is of the comic tribe who set up vice as a warning, and with a laugh give you a lesson to make you grave. That is the sort of art I should like you to study when you are too self-satisfied. David Teniers and the other Dutchmen only half did their work, for they just painted the merry outside of iniquity without giving us a single glimpse of the soul, which is Ruin. All along, art has been a mystery and a problem for the wisest to solve, and I do not know anyone yet who could point out the real good of it.

A man may exercise the brains God has given him, and make a chair or a table, and no one thinks he has any cause to feel proud; and another may take a paint-brush, and, with less of the God gift, dabble over a bit of canvas, and feel qualified thereby to strut along and feel mighty. What about? Just because he used paints and brushes and the other man used wood and glue. As if the one wasn't as much to be boasted about as the other.

Again, an artist paints away and thinks he is doing splendidly, and that all the other work in the world is rubbish compared to his; or he may be painting away splendidly, and thinking all the time that he is wasting good colour, and producing rubbish.

Or you may hear a man who has not a vestige of colour-perception in his eye or mind pooh-poohing a piece of perfect colouring as being devoid of the very quality which it possesses, if it possesses any merit at all.

We see something done and we jump to conclusions right away, or we take offence without rhyme or reason, and never give the offender the benefit of a single doubt.

What is clean colour to us, through force of habit, looks a singularly dirty combination to someone else. With a jump the artist sees what he thinks is an oversight or weak spot without giving his own mind time to investigate, or the picture time to explain its intention.

A black spot is wanted there, or a white splash, or a spark of red, or a dash of blue, to make a picture of it. How does he know that the painter has not tried all these stale old tricks, and, rejecting them, chosen something better, newer, more subtle, if not quite so apparent?

It isn't jealousy that is troubling the artist when he laughs or condemns the work of a brother; it is prejudice, that will not let him look more than one way out, that fastens upon him like a pair of blinkers, and makes of him an animal under control—drawing him along in the one direction in spite of his eyes or judgment. The thing is bad; it looks good, but it must be bad.

This is one of the comic sides to Art. A man has learnt to paint and draw, and ought to know when the work set before him is good or not, and yet, like other people, he will look at the name in the corner, and heroically strangle the knowledge which he must have, in order to chime in with the clanging bells of Fashion.

Or he will see one unfortunate picture, a poor example, crop up at a sale or hanging on someone's walls, and straightway judge all that the man does from that, knowing, as every artist must, that all have sins of the past to repent of, that there are pictures which they have painted of which they are themselves ashamed, but which some purchaser has taken willy-nilly, and necessity has forced them to part with. Knowing this of themselves, it does seem strange that they never take into consideration these probabilities when looking at the works of some other man in or out of the Art upper ten.

A painter cannot paint well when starving, neither will he paint well when replete; so the time to regard a man at his very best is just that happy moment when the big elephant Public Opinion kneels down to take him up. He is elated, but not puffed up; eager to deserve the honours which he has won, not yet arrogant with success, or content to bestow a swish of the brush for sovereigns, or think that he is composed of some finer kind of material than the house-decorator who makes his walls and woodwork beautiful, without considering the value of hog-hair as he works.

Be faithful to yourselves and your intentions, and you don't need to care much whether the people about you consider you an object to be comic over or not; hold fast to your purpose, and never truckle to a whim or a caprice, and your art will be true and grand whether you are painters or plasterers. Yield to be the toy of the hour, and whether you are making for yourselves

guineas or grins, you are only the shadow in a poor, low comedy; and your art is comic without a single point about it to raise it from the burlesque, which serves no higher end in creation than does the bashed hat of Ally Sloper.

CHAPTER XII. ON VARIOUS SUBJECTS CONNECTED WITH ART.

EX LIBRIS

IT is only when a man settles down in life that he begins to gather books around him, and to think about the outside as well as the contents of his favourite volumes. First editions, and rare, early volumes, as well as *éditions deluxe*, occupy his attention during his leisure from business cares. The young man is quite content with a yellow cover and a thrilling or racy inside, while the elder man views these abominations in the shape of binding and get-up with horror.

Artists as a rule are not great readers of books, and the more modern and realistic they are, the less they read; their eyes are occupied solely in watching and studying passing effects, while they can always depend upon some bookworm friend to give them the particulars if they want a subject from history. They take their characters from their models, the bookworm friend provides them with all the other information about costumes and historical details which they may require; therefore unless, like Alma Tadema, Walter Crane, or my old friend Sir J. Noel Paton, his art inclines towards antiquity, decoration, or history, the true painter is not much of a book authority.

I have found also, from observation, that the man who is fond of his garden does not care much for his library; indeed, although no man can reach middle age without having some hobby, he is a very unfortunate man who has more than one.

My own life has been so arranged by Providence that I have never had long enough time to get firmly rooted on any special soil, for always when I have just been settling down I have been transplanted quickly and ruthlessly, and the tender mosses about my roots have been torn ruthlessly from their premature clinging and scattered.

At one period I took to collecting delf and china, one of the most seductive, extravagant, and dangerous of all passions; in this direction my artistic instinct of colour found vent.

But having inherited a love for books, I indulged in that habit also when I could afford it—often, alas! sacrificing other interests for the gratification of

these two absorbing passions. Fortunately for my peace of mind, a clumsy joiner cured me of my hobby for china. He had lined a room with shelves from ceiling to floor, assuring me that his work was strong enough to carry the contents of the British Museum; and foolishly I believed him. At this time I had about four and a half tons weight of books, and about five hundred pounds worth of china; therefore, to make my library attractive, I placed the books above and below the centre shelf, which I devoted to my specimens of china, so as to bring them, as it were, on the line.

On the second night after I had arranged my treasures I was awoke by a fearful crash, and on going into my library, I found shelves, books, and rare china, now a confused blending of fragments on the floor, as complete a mass of wreckage as mine enemy could have desired to see.

The books were not much damaged, nor the shelves, but the fragile loveliness which I had doted on with such uxoriousness had taken wings and left me for ever. No man born of woman dare indulge in two grand passions with impunity.

That ogre joiner added the last blow to my vanished delusion when he generously offered to put up my shelves again without extra charge. I have loved china ever since, but never since that hour with the unholy desire of possession. I have been content to admire it in the cabinets of my friends.

The true collector of china does not trouble himself greatly about the artistic qualities of his wares; it is the rarity which he runs after, and this is one of the most pitiful of human follies, unless he chances to be a dealer. What fascinated me in this pursuit was the beauty of the designs or the richness of the colouring. I delighted to make my room one complete and harmonious picture, rather than divide it into different pictures; and in this, while it lasted, I had the most unalloyed pleasure that mortal man could have. And this is how I should like to recommend men, who are rich enough to afford the luxury, to decorate the rooms in which they study or think; for while pictures may tell their own story, they are apt to become assertive in time, while the stories grow stale.

But with beautiful works of china, tastefully assorted and harmoniously arranged in combination with finely bound books of favourite authors, no matter whether they are first or last editions or contemptibly modern in the estimation of the china-maniac, you will find yourself constantly surrounded

with old friends who are never prosy, and by an orchestra of ever-changing songs without words—silent harmonies and poetic suggestions without limit.

I like my shelves to be open and roomy, so as to hold any size of volume; made plain and dark coloured, with little ornament, and attached to the wall.

Yet the beau idéal of a perfect library is to have it made mediæval in its design, in old and unpolished oak, with Gothic carvings where bare spaces occur; the ceiling divided into oak panels and rich with design, the furniture in harmony, so that nothing may distract the eye from the richness of the binder's art, or the tender flower-like glowing of the vases, cups, saucers, and plates, stirring up while they at the same time soothe the jaded imagination of the wearied thinker with their vague suggestions.

BOOK PLATES

THIS is an old art or taste which is being once more revived with great activity through the timely efforts of the Ex Libris Society. It is a pursuit which is most educative to the lover of books, because it is filled with symbols and leads on to the noble art of heraldry and spiritual intellectualism, in which such men as Albert Dürer stand so pre-eminent. At first sight it may appear like the pandering to the vanity of book possessors, but it is not so in any sense; rather is it the connecting link which binds men of taste and research to each other, and which leads them on to that higher level of humanitarianism and faith for which purpose the grand laws of Heraldry and Masonry were first instituted.

ARTISTIC ASTRONOMY

I THINK that a man to be a painter, more than any other student of life-lore, ought to probe a little into every science; anatomy he must have, geology, botany, and astronomy he ought to know something about.

I do not mean the very painful and exact knowledge which is begun and ended in learning the names and probable distances of the planets, or the exact theories which books teach; that sort of lore is very well in its place, so that it does not interfere with the gracious if delusive investments of fancy. But none of us like to hear a discourse upon the exact sciences from the lips of young love; we would rather have her more ignorant and responsive to our extravagance—think that her 'eyes are stars, and would in heaven stream so bright that birds would sing and think it were not night'—than to be reminded that this Romeo nonsense is exploded, and be told the scientific composition of those sapphire or amber orbs, and the cold attractions and revulsions of those rolling earths.

The painter and the poet, like the lover, should be impassioned and impulsive, keeping his knowledge only for similes and parts of the glowing idea. He ought to know all things, but be, besides, 'Dowered with the hate of hate, the scorn of scorn, the love of love,' able to see through life and death, through good and ill, and into his own soul.

Regarding the stars, we must indulge in fancy, for science will not enlighten us much, with all the help its magnificent telescopes can give us; for, after all is said and done, the wisest of scientists are forced to admit that the truth is not quite certain, either one way or the other.

Before the Beginning, we will suppose this earth to have been a molten globe of fused material, perhaps the fragment of some other vast globe, one of many sparks flung from the great flame that had spun round for myriads of centuries with other fires in the black space. To attempt in words to produce an estimate of the magnitude of this stupendous scene would be as weak a failure as to attempt by figures to describe Eternity. The circle is our only sign in the one case; let imagination's broadest and vaguest conception grasp the other as it best can. The fearful concussion as two fires met and clashed and became a blazing shower, the weird effect as the sparks, to us monster planets and measureless suns, fell whirling into the chaos of that awful night! All are silent as the stars are in their distance, and we watch at

night the shining and the sparkling, giving them, with our intense narrow egotism, a place in our emotions and our sentiments, as if they were ministers of fate for earth, so trifling do they seem to our mite world.

Science blunders on, one generation of savants giving us theories and blinding themselves to prove them correct, which another generation of as wise men flatly contradict, and set up fresh theories to be again knocked down. I pay thirty shillings for a valuable work on astronomy to-day that next year I find not worth a sixpence. They coolly inform us that at length the distance to some star is certainly discovered—at least, with the slight margin of some tens of thousands of millions of miles, to be afterwards determined as they think best, and that is our knowledge of the stars. This is science. A man makes himself a mole, scratching up a mound of earth, boring and thinking and wasting his eyes and his brains for fifty or sixty or seventy years to try to find out what he never can while his body consumes bread, and what the most ignorant clown will discover with a single flap of the wing of Death, if our belief in a future state is fact.

The poet is the wisest astronomer. He gazes an hour on the stars, with his eye rapt and his mind fallow, and the spirits or the spirit of inspiration ploughs it up and fills him with the knowledge unconsciously, and if the withered old astronomer with his lines and earth laws is so far astray in his conclusions, seeing the poet cannot wander much farther, why may he not be the only one correct, in that he writes what he knows nothing about? We, reading it, call it deep, mystical, splendid, because we cannot understand it; while the poet, poor fellow! reading our criticism, and thinking that we understand it from our subtle explanation, rests perfectly content, feels it is all right, and that he is a very clever fellow.

To us these stars are serene, as all action is when viewed from distance. The carnage of the battle-field is but an ant-covered spot of the landscape to the spectator ten miles away; a little puff of blue smoke here and there, blotting out the insignificant black and red dots, is the whole picture of the fierce drunkenness and savage lust of blood which transform men into devils; those desolate hearths where the curse of the widow and the wail of the orphan are the most enduring, trophies of victory.

Myriads of miles away, and all the thunders and rapidity become silver pin points: yet they joined in that warfare, or watched it as we do them, saw it cooling down until it died from their range, until the white glare that it once

gave out became a crimson glow, to be swallowed in the oceans of steam that rolled about it.

And so we are told that the slow stages went on—the fire, the steam, the waters, the sediment and slime that bred the life, the life that was rank and low, the preparation for other life, the light which was forcing its passage through the mists, that came and made the life robust; the convulsions that overthrew the whole, and the work that began once more, ever growing higher, as death purified and blotted out the errors, until the first perfection stood up from the other animals, and, as man, continued the work of creation.

Sciences so blend together that it is impossible to take up one without finding tendons of another passing through it. Astronomy teaches the student that this earth is only one of a cluster; that our sun is not the sole candle of the universe, nor our moon the only Luna who touches the brains of men and poisons the flesh of fish; that on each of those countless needle and pin points, love, war, and work may be going on while our tiny star is out of the range of their glasses, and speculation sets to work filling up all the blanks, and tinkering up the broken links, while imagination gilds the repairs until we can behold worlds like our own, but larger and fairer; for man ever takes himself for his model of an angel, and his world for the image of the hereafter. Fairer, because imagination hangs up a gauze veil to soften the general effect and the blemishes.

We look at the sky; mellow grey at the horizon, going through gentle gradations towards the deepest ultramarine overhead, and science tells us that this is formed by miles of atmosphere, and behind the ether belt spreads the black vacuum. Sometimes we think we can almost trace the airwaves, one behind the other, until the last thin layer is reached, and the glance is lured on as through a crystal, and we are soaring lark-like through the azure fields, the world beneath us lost, as when the swimmer in mid-ocean turns his face from the ship that represents land, and floats away on a blue sea under a blue sky, a solemn silence over all, the heart filled with the trembling delight and awesome majesty of boundless space.

But to the poet they are angels; to the prisoned wisher they are fairy barks to wing him away from this earth, which is too small for his immortal cravings and desires.

We like the science of the child, the lover, and the savage the best, for we think it as near truth as any other, and ten myriad times more satisfactory to the feelings. Claud Melnotte is our best guide to astronomy.

'To sit at nights beneath those arching heavens, and guess what star shall be our home when love becomes immortal.'

That is the sort of astronomy for the poet, the child, and the quivering heart.

I would fain bring back the world to its belief in fairies—tear it now and then from the hard facts which are being now so constantly driven into aching brains.

Were they not happy times when Jack the Giant-Killer was the veritable history of a brave boy? Were they not sunny hours when you peered under toadstools for the little fairy who was to build you up a crystal palace, where gorgeous cakes were to be served on service of gold?

Is there no cause for regret that the time is past when out of glowing embers on winter nights sprang forth knights on their war-steeds, or funny little old men and women with high-crowned hats, who you knew were all there, because you had *been told about them*?—days when falsehood was an unknown quality, and 'yes' meant surely 'yes,' and only 'no' was possible to doubt. Now it has become the large 'no,' with many a 'yes' much more than doubtful.

What were stars to you then but golden lamps of heaven; shining ornaments on the foreheads of angels; windows of another beautiful world; or little sparks put up there all for your own special delight?

And that vast immensity, to contemplate which the horrified brain of the astronomer reels with madness, and reason is nearly dethroned: what was it to you then but a cosy curtain of the earth's bed, drawn over it at nights to keep it warm while it slept, decorated with all those pretty spangles that people might count them until they fell asleep?

What did those worlds teach you in the hours of your young romance, as you turned up your flushed face, after parting for the night, and sought out the brightest one to say your prayers to—young idolaters that you were? Did they not comfort you more then than now when you know what they really are, as you watched them grow moist with their great sympathy? It was a

flick of vapour crossing them, or a tender tear creeping up to your eye in reality, but to you it was a star watching over you both, and carrying the wishes of the one to the other.

Science tells us that those fantastic shapes flying above us are caused by the vapours absorbed from the ocean, condensed up there, and sent down again in the form of those grateful showers upon which the sun paints the prismatic rainbow, the sign of grace and hope, the index of the painter.

We see the sun rising out of the vapour in the morning, a pale disk, surrounded by wreaths of the softest grey, here of the pearly ash, there of the citron bloom, broken by the salmon and the amber, while over them gleam the golden spokes and white bars of the wheels of glory, surrounded again by the curtains of grey to the chastened fringes of azure and silver, the golden car into which the king of the morning leaps, guiding his winged horses out into the day with a lustre overpowering, flinging his glittering shafts down the mountain sides, into the streams and torrents, into the mists of the valleys, breaking up the solid masses, tearing ragged edges from them, and scattering them until they fly away round the rocks, amongst the furze, in a panic of confusion, and the marble wall of an hour ago has become but a little smoke amongst the heather.

We see the mid-day lights and shades, the clouds that trail slowly along like a flock of tired sheep with languid motion and drooping head, now like chubby infants flinging about their dimpled limbs, and casting fat depths of purple over the ivory shoulders of the children underneath; white-skinned cherubs whose antics have diverted us during a sleepy afternoon sermon, as they rolled past the diamond panes and cast their gigantic grey shadows on the whitewashed church walls opposite; or the drift of dapple and scumbly white overhead, like snow-flakes melting on a deep river, stippled all over with the ripples between.

Then comes the night, and we know that the earth is turning round, and that it will soon be dawn with our friends in Australia, but to us it is the sun which is sinking behind the waves. It was a white flame on a blue field before, then the blue passes through changes of grey to gold, and the gold deepens to orange, and the orange glows to crimson, and the sun has become a blood-red eye glaring out of a purple mask, while overhead gather armies clad in regimentals of every shade. The red coats are struggling with the black and green, and the yellow and white facings are savagely torn off and

sent flying after the tattered banners stained with the clotted gore of the slain, and the castles they were swarming about are crumbling to pieces.

Then the battle is over and the stillness of death settles down, the purple grows grey, the amber afterglow is cooling behind it, and those wonderful little spark worlds are coming out to watch. On the earth long lines of silver vapour lie like stretches of water with fen-lands between; the tree trunks are submerged in the deluge, and only the tops of brown ranges float above. A sigh comes over the land, that enters into our spirits and finds an echo there, as we turn to the east to watch the mellow moon rise out of its umber grey background, giving us thoughts of rest after the day's work is over, bringing out young lovers, imparting to rosy cheeks the spiritual pallor of tender sympathy, throwing into dark eyes, that might flash mischievously in the sunlight, the melancholy languor that rivets the pensive chains, and a host of vague forms to the dreamy student, as he leans back, while the thin wreaths created by his meerschaum pipe circle heavenward from his meditative lips.

ARTISTIC BOTANY

IT is astonishing how insensibly we are drawn on to moralise when in the mood. A stone in our path, over which we stumble, may become the text for a long sermon; a little piece of crumpled, torn newspaper may lead us along a train that seems endless—the power of the critic and the abuse of that power, the art of printing, and how people got on without the use of type to spread their gossip, the machinery used for it, and the boon steam will be to the poor horses who may yet become our friends instead of our slaves; the garment that scrap of paper once was, and the romance of the wearer, the loom where it was spun, and the weavers, the vessel that bore the little balls of cotton from the western fields where the lash of the overseer once cursed the land—and we have taken up the science of botany all in a single thought, and fly backward by flashes until we come to the period when earth was like a fair garden waiting upon its owner when the work was all but finished, and the nameless lion and lamb together grazed by the Tree of Knowledge. The great hush of fifty centuries hangs over it all, flinging before it the haze of a far distance. The date-palm waves like feathers in the silver space, the cocoanut hangs from the roof of its fan-like branches. The banana is green, or ripens without the decay of a leaf; the many bright-winged songsters are sparkling with their hundred warm tints, and the fresh first spring, for they have suddenly burst into joyous animation to hail the new life. We mingle with the morning mists, the white forms of the angels who watched that great work, and the diamond drops of dew which are lying in the mouth of the lilies get between us and the starry diadems which crown their glowing heads, until we cannot separate the flowers from the deathless host.

Shall we break it all up with our relentless science, get out our trowels and our tin cases, and scatter the angels until we classify some of the unknown specimens?

This purple flower with its drooping bells, to the half-open mouth of which the black-and-amber coated bee hangs sucking, is our own foxglove, a useful foreground ornament for the painter. Adam has yet to christen it, so I may be homely in my title and leave the Latin to the professors. An orange and scarlet toadstool rests against its grey green leaves, while the greyer boulder against which they grow absorbs the grey from the green until the leaf seems as bright as the fern-tree overhead, for after this manner ring out the chimes of colour in Nature, the high note only high until we strike the next.

Yes, it is amazing upon how slight a foundation a very plausible and fine theory may be built up. I had almost fancied, while I was watching the rich crimson juice oozing like blood from the cracks of that dragon-tree, that the finale had come, and that it was our forefather Adam who clung in that most undignified fashion between me and the sky to that high branch of the upas, until I perceived the long hair upon his arms as he reached to the cocoanut alongside of him, while his graceful tail like a black snake twined round the white stem; then I recognised with feelings of relief that it was only our familiar caricature the monkey.

How familiar it all seems as we ponder! This gnarled tree trunk is the oak of England, while yonder faint mountain-top, that we can just see between its twisted limbs, looks like the cobbler at work on the lofty Ben Lomond, giving us almost the right to claim our little island as the original site of Paradise, did not those many pillars which are shooting up and drooping down from the archways of this mighty banyan stop our ideas from going farther in that direction.

Let us pause for a moment to regard the vegetation around with the draughtsman's glance. The oak rising like a pyramid, with its rugged horizontal masses, light, raw siennaish-green leaves clustering round the spreading knotty branches at right angles to its corrugated trunk. The elm, lime, and chestnut, not unlike in general outline, yet with distinctive shapes that separate them all. The rough trunks of the elm, pine, and fir may be distinguished at once from the smooth bark of the plane, chestnut, beech, birch, bamboo, and upas. The branches of the fir and beech are straight; the weeping willow and birch droop under their light load to kiss the river. Then there are the serpentine ash, and the irregular elm, cedar, and poplar, the long tapering leaves of the ash and willow, the round flakes of the beech and cedar, the fan-like masses of the chestnut, the little needle points of the fir. All these stand out stamped with their type marks, and proclaim what they are by their form and by their colour. We see, too, the dark olive duskiness of the fir crown, with its flesh-like arms flung outwards, and the warm glow of the upper limbs dying out of its body as it nears the brown earth, reddened like the bed of the larch with the dropping spray of cast-off shreds; the fir and the larch, that never change their entire garments winter or summer, but only cast away the worn bits they have done with; the willow, that grows paler as the summer advances and the other trees flush, until she stands out white amongst the orange and the russet, and the intense purple fumes of the passing year; the fairy birch, lady of the lee, with her indefinite toned

festoons, her delicate madder-brown branches, and her silver crackle bracelets, reflecting all the colours in our paint boxes.

Under foot we trample a perfect world in miniature—the velvet moss and grey lichen, the vivid sparks of green amongst the bronze, the rose and golden hairs that shake brown balls at us, and lure us into grottoes where nymphs and lady-birds slumber together.

The ferns are making themselves studies in foreshortening as they spread over the broad-leaved docken, under which the eye may penetrate the damp shadows to find that the range is endless; furry rosaries swing on green strings, little leaved tendrils that half smother blue and pink stars with white centres, brambles and ivy shooting over knotty roots upon which cling verdigris, tinted cactuses, and perfect gardens of flowers and grasses, trailing like auburn tresses, all in the space of a square inch, and veiled with the close meshes of that great spider web on which the dewdrops swing by thousands.

That wonderful dew, flashing like the purest diamonds under foot, glowing like rare opals a little way off, glittering like powdered snow farther off still, floating over the roses like the gauze webs away in mid-distance, bringing us back again to the scene we left to burrow in details! Let us bundle up our specimens, and try not to feel any smaller than we can help while we put our trowels and tin cases out of sight, and crouch down with the hot-eyed monster cat panther within his leafy shelter, and in company with the cunning cobra watch the work that is being done out there in the broad sunlight.

Is it the heat fumes which are growing denser as the day advances? Can the sunlight filtering down between those green fringes make those shapes upon the grass and on the trunks of the trees?—trailing robes of filmy white, dove-like wings of faintest pink that sweep across the glade and crowd in circles round. The lioness does not think this strange, for she squats and blinks lazily in the light like an over-fed yellow mastiff. There is a rustling like birds rising. The locust chirps in the grass; the bee is busy, so does not hum; the red-coated soldier ants defile along in rigid order, and are allowed to pass by the active little black-coats. Those that have work to do, do it, and all the rest sleep. We have surely been dozing also, for the picture is finished, the dewdrops are almost dry, the mists are sweeping away, and the red man lies in his death-like slumber, while bending over him, with the

staring eyes of a newly-awoke baby, stands that white wonder of creation, woman.

THE SPIRIT OF BEAUTY

THERE is nothing more interesting in all the sights which bountiful nature provides for the entertainment of man than the shapes, colours, frolics, and labours of the insect world; and nothing more dastardly and contemptible than the way man has of enjoying those pleasures, trapping the spirit of liberty, mutilating the exquisite bodies, ruthlessly cutting short their transient lives and merry pranks, brushing away the subtle delicacy of that matchless colouring, leaving only stiff, tattered corpses, that may appear fair in comparison with the clumsy work of their destroyers, but bear no resemblance to the sportive specks of splendour they were before: melancholy specimens stuck upon a card or in a glass case in order to gratify a latent lust of cruelty or acquisition, which is rechristened 'the curiosity of science,' or worse still, when it is to minister to the vilest of all vain passions, the empty desire to be thought oracles.

To the sensitive mind the spectacle of a show case of these poor little insect samples, pierced through with thin pins and having their Latin titles attached to each, is almost as excruciating a sight as a vision of Calvary would be, with the mockery of that Greek, Latin, and Hebrew superscription suspended from the freighted Cross; and the utility of these crucifixions is about as great to the private collector and his narrow circle of admirers as the deliberate vivisection of a fly is to the idle mind of the vicious boy, who dismembers a being of more exquisite formation and greater usefulness than he may ever become, with those instincts, in order to see how it can wriggle along after the power of walking and flying has been torn piecemeal from its quivering sides.

What can all this wanton waste of the spirit of life teach them that they may not read in the works of others, or see in any museum where the sacrifice has already been made, that they must trample like savage senseless cattle through fields already carefully gone over by men who have devoted their lives to this branch of science?

We all know that science must at times be unsparing and merciless in its hunt after knowledge, but the discovery once with certainty gained, cruelty ought to cease for ever, and the mind rest satisfied; or if unsatisfied with the dead example, seek to learn the grace and beauty of the life, the motion that must be preserved alone by memory, for the corpse can tell us nothing of life, and it is life we are most interested in knowing. We can learn from

death only decay, and any hour's walk will show us that without our paltry aid towards its manifestation.

When education costs the student labour or even agony and self-loss, consider no exertion lost time, for experience must ever be better than theory; but if it is at the cost of a single life, or even a thrill of agony to another life, then let him pause, for no life is trivial that the spirit animates, and where the mechanism is so perfect; and the lowest form of life may be of greater value in the universal scheme than the life that destroys it.

Let him pause, for the experience is too costly, the sacrifices already made should satisfy; for what is the life of a man, except that the shell is larger and coarser and clumsier, more than the life of the tiny midge that sings about our ears in the sundown, or the silent insect that, all unconscious of its danger, crawls under our feet? I speak here with all due reverence for science, when it is science that demands the sacrifice, and not the ostentatious vanity of superficial ignorance; also with reserve, for we know how men's lives have been the price of many trivial discoveries, and while we may lament, we must yield to the relentless force of circumstances.

THE BUTTERFLY SYMBOL OF ART

THE butterfly is the symbol of the painter and the poet, and so I choose it as my present symbol.

As it must first be a caterpillar, and devour greedily leaf, fibre, and all that can be devoured by caterpillars, so the student must settle down and devour all the knowledge that he can find, and crawl slowly along unheeded, or be looked at perhaps with contempt.

As it changes its skin many times while growing, so must he change the style of his admiration.

As it carries within it the wings and the colours in the egg state, so the light wings of fancy and the pure instinct of colour must be born in the painter, or it cannot be altogether trained: a perception which, like the perception of music, will cause his nerves to quiver at a discordancy, although he never handled a brush. 'Full many a poet never penned a line,' and so with the painters who have lived and died with their dreams unchronicled, the perception being too fine for the material contact of earth, which must pollute, even while it embodies; a perception ever running before the knowledge, ever torturing the possessor with the innate consciousness of his errors before he has learnt enough to perceive them.

Form is the grammar of art—a thing of measurements, which can be tested, corrected, and satisfied by the exact laws which govern it; but colour is too fitful a possession to be tested or controlled by rule or education beyond a certain stage. We have it when we least expect it, and find it slipping from our grasp, after a life-long experience renders us confident of its control. It is a quality far too subtle to be described by words; a sensitive gift which will torture the gifted, as George Paul Chalmers, the Scottish Rembrandt, was tortured until his spirit became unnerved with the galling longing, and his brush blundered and would not finish. It is not the wings of the butterfly but the golden dust which covers them, and which is so easy to rub away; not the genius of the painter, but the precious garment of his genius, to which genius is as much indebted as her mortal sisters are to the costumes of a more terrestrial texture; too fine a fabric for earth looms to spin, too delicate to be measured or shaped by fashion; and even as the caterpillar must suffer the throes and self-efforts of Nature, and lie under the wearied languor of

spent exertion, so must the student painter torture and weary his heart out with his many struggles to do that which his instinct tells him must be.

Many caterpillars perish from their own efforts, many are destroyed by enemies, many are killed by their own kind; and how like is all this experience to that of the student painter!

And the critics, who fawn upon the rich and powerful, while they sneer in their meaningless fashion at the student who adds poverty to the crimes of daring and young impotency; who, besides being devoured by the gnawing consciousness of failure, has the gall and wormwood of witnessing greater ignorance, because talentless ignorance, in the favoured, praised up as virtues; the bitterness to see them airing all the paltry tricks which their money has brought them from the studios, while his poor attempts have to be sent forth bare and ragged, because he has had to find out all that they have had held up before them, for what is given eagerly to the rich is charged double rate to the poor!

His dreams are as great as theirs, but theirs are nursed and dressed while his are sent beggars to the icy atmosphere. The world says, What right has he to attempt art, a clown, an apprentice, an ignorant ragamuffin, while the pets have been to college and Paris life schools? and it is very well for him to read up in his garret that men have risen from his level, that Murillo was a half-naked peasant boy, Homer a poor blind beggar, Claude a cook, Angelo a mason's apprentice, Mahomet a camel-driver, and long lists of illustrious characters, originally nothings like himself—if, when he appears and presumes on these great precedents, the cold iron wedge of derision is driven into his heart. If a man, his sense of purpose will support him through it all, but precedent will not much console him.

And yet, what does it matter in the end what we have to do in order to keep up the life, if the life is devoted to the thought? What though we hold horses like Shakespeare, or blacken boots, or sweep chimneys, sell cloth or make it up, prime doors and panels for others to decorate or decorate them ourselves? If a painter he is a painter, whether he splits up or imitates rails, cuts down or copies trees, whitewashes ceilings or paints skies; it is all right and proper if he is keeping himself devoted to the end. The dexterous workman is not the artist, tricks are not talents, craft is not art, any more than the dress is the woman, although men do buy tricks and pass by talents, as

men often court and marry dresses. In both cases they are all the better for the tricks and the dressing: but keep the facts separate if you can.

It is the innate impulse and power that makes the painter in spite of his own efforts otherwise, or the advice of his friends—the impulse that forces him on in the face of all omens. As an artist he requires no peculiar cut of hair or livery to mark him so. Art is above, therefore quite careless of, keeping up her dignity. She is quite as ready to sit and hob-nob with the beggar as with the baronet.

Again, if he succeeds in a very slight degree, for no man jumps at success or perfection, he is like the little caterpillar crawling out of his shelter and shadow to be pounced upon by the large caterpillars, torn in pieces and gobbled up; for although most of us have generosity enough to pity, and perhaps help, misfortune, how few are there with sufficient philanthropy to crown success!

He will suffer all the pangs of conception to hear his infant called an abortion, he must endure all the suggestions of puffed up, purse-proud ignorance, which imagines it can comprehend, with a glance through its gold glasses, what has taken months to plan. He must make the alterations the patron may desire, although his whole being shudders at the sight of a spoilt idea, or else starve; while the favoured caterpillar can laugh them to scorn in his plenty, condemn the treason of the poor, and deride the weakness of his necessity. If he remains firm to himself he will be a martyr without the small consolation of the martyr's niche; he will see his original failures ignored for pretty imitations, and so he may struggle on to the bitter end, to be forgotten, a dead chrysalis to be blown about by the world's winds, or drifted under the wheels and crushed.

But what of all that? Whether he lives despised, or dies unknown, this would be a grief to the glory worshipper, but not to the true painter, because the consolation of the painter rests in a higher pleasure than the trickster's craving after renown. The painter labours to satisfy his ideal: he knows that fame is not the reward of merit, that it has nothing to do with merit, although merit is sometimes crowned by mistake. If he gains the laurel he knows that it is the accident of chance, or the degradation of influence, and he wears it with the indifference which it deserves, or blushes at the shame of it; for if by influence it has been bought at too great a price, the cost of self-respect, he must wear it with deceit, while he struggles for ever after, not to please

his own consciousness, but to prove to unbiassed posterity that it was his by right of worth.

This is the image of fame to the true painter, a pillar whereon he is set by blind admirers, who crowd about its base and shout at the image they cannot see, while the strangers who look on at a distance behold its imperfections bare and ghastly in the sunshine.

But still, for all the frost and the evil influences brought to bear against the chrysalis, if it is to be, its time comes, and we see the butterfly breaking from its gloomy death, and fluttering away gaily through the summer air, happy, careless, beautiful, every hour an effortless success, its sole mission pleasure, working good unconsciously, rocking in the breast of the rose, rising to light up some shady nook like a fleck of sunshine, hovering over the lemon-coloured grain fields like animated scarlet poppy flowers, settling down like winged pansies in our gardens, hovering overhead like the spirit of the lovely things it sports with a golden gleam upon the violet, a sapphire on the buttercup, a velvet page amongst the lilies, a giddy flirt with all, blending, harmonising, contrasting wherever it lights upon to kiss and beautify; thus it passes on, doing the duty of its creation, aspiration, and fitful fancy. And so with the painter. He may take up the traces of custom, chain himself with laws and methods, go out with his buckler of tinsel, and his bindings of green withes, to watch the sun setting, to reckon up its strength and classify its dyes, gauge all the glories with his measuring tapes, and bring his weak knowledge to the mighty test, when, even as he seeks for precedents, he is caught up by the spirit, as Philip was of old, and borne, not to the chariot of a great eunuch, but unto a chariot all his own, made of pure beaten gold, lined with purple and crimson, and studded over with the richest of gems, and thus rolled like a conqueror through the glowing gateways of the eternal space, his frame quivering with the intoxicating joy of that fleeting hour, his tinsel buckler and green withes shrivelled up and cast behind, and his unshackled mind sent bounding through the endless vistas of dreamland.

CHAPTER XIII. NATURE WORSHIP.

LABOUR being done, we naturally look for reward, which is the legitimate termination of work. This reward may be rest, or wealth, or fame; it is the spur of our exertion, the caviare of our ambition; upon it we exist through the famishings and the anxieties, the hard roads and long miles; it is the destination which fills our imagination from the very first step of our journey, else would we have fainted twenty times over. It is the day's wage or week's wages which supports the toiler or the workman through all the hours between him and the hour of pay.

And this is not wrong. Buddha bids us seek truth and morality without hope. The sentimentalist would say, 'Work for the love of labour;' but we hold that this is not inducement enough. Walk hard, because fatigue ought to be a pleasure? No! walk to produce the fatigue, that you may be able to know to the full extent the delightful flavour of rest. Work, be it at painting or writing, that you may see the idea embodied and perpetuated; if it be at bricklaying, that you may see the wall rise up, layer by layer; help the needy and afflicted, that you may comfort them; raise the fallen, that you may see them rise.

Be pure and charitable and as sinless as you can with the help of God, that you may stand holy in that holy Light. Use your influence to make those purer around you, that you may have only the incense of purity surrounding you now and hereafter. Thus, to be virtuous after the creed of Gautama is work such as Hercules worked at the stables of Augeas; to be virtuous, as Jesus Christ taught, is to be inspired with the presence of God all through earth's life and stand unsubdued at its close.

When Hannibal, and after him Napoleon, crossed the Alps, Italy lay to their hand; the certain prospect of Italy, fertile and rich, aided them in the removal of fearsome barriers, imparted to them the daring to brave toppling crags, slipping ice-ridged streams, appalling heights, quivering avalanches, swaying to and fro as they passed, swinging over in their rear with that muffled soul-sickening thud which they knew meant a snowy grave to those behind. Italy, the grape-hung, the sun-laved, was before them on the other side, with its wealth and power—nay, it was with them, in their hunger and bitter cold, as the presence of God is with the devout every hour of his earth-life.

But when Bonaparte came within sight of Moscow, the vision of which had supported him and his famished army all through those awful icy leagues, and beheld in the light of those blazing domes the destruction of his hopes, then, and only then, the full bitterness of that winter march began.

So with the warrior prince-leader of Israel, when he stood up face to face with God and cried out in the passionate strength of his man-thirst, 'Let me go over and see the good land'—the land he had worked and walked so long to see, for which he had given up all the pomp of the Egyptian court, and, still greater sacrifice, the erudite society of the sumptuous priesthood, to consort with a nation of spiritless, ignorant, and discontented slaves.

I like to embody this great leader of Israel, not as his countrymen knew him when he led them out of the land of bondage, the snowy-bearded grave statesman and law-giver, but as the Prince Rameses, the mighty Egyptian Lord of Lords, the favoured son of the Queen Amense, always the companion of philosophers and sages, hearing the petitions of his people in the outer courts, driving his gold-embossed chariot between long avenues of sphinxes, reviewing his countless hosts in the open plain outside the great royal city of On, crowned victor as he swept home from battle, over garlands of roses and lilies, with armies of white-vestured priests of Ptah, dancing girls, singing maidens, and the sacred women of Bast (the lady of Auchta), all surrounding with fumes of incense and hymns of praise Egypt's pride Rameses the Mighty.

I think of him in the palace of his adopted mother; on the terrace, decorated with chaste designs of lapis lazuli, malachite, and precious stones; sitting upon ebony-carved byssus-draped couches, Rameses, with the royal lady, gazing over their good land. Away in the distance the red-tinged hills lifted above the tawny sands; between the palace and the Libyan hills are hordes of slaves brickmaking and temple-raising, with a white-grey sky above them and choking dust all round; slaves toiling on foot, mostly female; strong young women whom labour will not tame; dark-skinned matrons who find a joy in that they have once more sons to suckle, even in that hour of quenchless thirst; wrinkled-skinned old women who have grown passive to rebuke, and deadened to the lash; old men sweating and dropping dead or afaint, some digging trenches for the fancy lakes, some dragging the stones that have come down the Nile. The girls and boys are the brickmakers, and the strong men are the drivers, copper-tinted Egyptians who sit on chairs which the strong women bear, while others hold up the great sun-shades, or

fan with ostrich fans the heat which the lashing exercise brings upon them. It is a good land. Nile spreads along in sight of all, prince and slave, with its sweet treasures and its clouds of bird-life, and by its banks rise those columned buildings. Colour is over all, rich tints in yellow, blue, red, and black, grounded with white, symbolic in design, each tint a law unchanging. Over red and white walls the fruit trees hang, and the spreading Nile bears upon its breast the echoings of fertile gardens, and the barges ever passing from the city of the dead to the city of the living, pleasure boats with golden-wigged ladies and jewelled men, and the sounds of instruments joining and jarring upon the groans of the afflicted.

I think more of Moses as Rameses, discussing with his queen-mother that vexing conundrum of the day, increasing Israel, than of Moses solving the question later on. I seem to see his aged father and unknown mother amongst that seething mass, hiding their secret between their hearts, shouting with the crowd, Hosanna to the king of kings, their God-like son. And then my vision shifts, and I see him taking leave of his people, none there now who knew him in his royal pomp and splendid manhood.

What a life of abnegation! Bred for a king, laying down his crown, happy in his desert freedom, giving up his rest, daring in his faith, becoming the chief of a horde of ignorant serfs and advocating their rights in the throne-room— once his own—leading them out from the tyrant power, yielding but a little when sorely tried, creating reason in brains all reasonless, wandering through a land of doom, with his God ever beside him, helping that mighty work. Think on the task of raising the serfs of Russia to reason out their own condition and so help themselves! Hundreds of earnest souls have been hard at the work for hundreds of years, and yet they are still hundreds of years from the promised land.

Imagine a lower state, viler than any race you can bring up as an example on earth's face, more hopelessly sunk in the satisfaction of apathy and degradation, and you have not reached the moral level of Israel when Rameses put forth his hand to lift them out of their slough: slaves of centuries to be educated in forty years; slaves with all the whip-checked vices of slavery let loose by an acquired power. The first instinct of liberty was the beast instinct of destruction running and tingling like mixed wines through every vein. Moses and Aaron, with the Lord about and before them, led out of Egypt a congregation of mind-crusted, unreasoning serfs.

But now his task is done and he can go to his well-earned repose; the slaves and slave-binders are dead who came out of Egypt, and are buried by the way; the rest are free men now, and under control. They have their laws and obligations, which makes them a people; they have their leaders appointed, which makes them a state. Pharaoh is a thing of the past, Egypt a myth-land, Canaan the good country towards which their wishes tend. Already have their souls crossed the Jordan; and though they wear sack-cloth for thirty days on the plains of Moab for the old man who has gone from them up the hill of Nebo, though their tears flow apace, yet the strong men are grinding their steel, with their hearts soaked in triumph and conquest.

Up the mountain the great old seer passed. I think Joshua supported him up so far, to the foot of Pisgah, and then they parted. A thin mist was creeping from the brow of the hill, and even as the warrior gazed it caught the statesman, and drew him from the sight of all.

No man saw within that veil of mist, for God was there. Yes, once it parted, when he reached the top. That mist was made of angels' wings. They drew aside, and for a time permitted him to view the promised land, and the Lord was with him, pointing it all out.

A voice from the mist of the angels' wings told him of the presence of God, so he stood up, clutching to the rock beyond which he gazed, the shadow of the mountain over the plains of Moab and the last fiery ray of evening laving the land in front.

He saw all Gilead unto Dan, to the utmost sea, where the line of unbroken amethyst crossed the scarlet clouds; Naphtali, Ephraim, Manasseh, the valley of Jericho, and the city of palm-trees.

His back was to the sun, and for a moment it fell upon him, casting his shadow over the hill-edge, a statuesque, white-clad, unbent figure, with rolling tresses of grey and streaming beard, looking out.

Then the legions closed upon him and the sun went down.

To the poet the death of Moses is filled with glorious imagery. Nature is here absorbing a grand portion of her own spirit to give it out again to other souls. God is the mighty mover of all, but He is indefinite—in the wind bearing melancholy sounds and bodes, in the waters lapping the shingle or rushing over the great rocks, in the vague dreams which possess him as he gazes out

upon the countless planets, in the wild yearning to be solved by that overpowering impregnation of silence.

To the painter it all comes in a vision of colour; it is a blending of spirit harmonies, rainbow shades, a sense of the eye that embodies the spirit into a definite pleasure. By faith he sees revelations, the golden streets and crystal rivers, and, above all, the great prismatic light.

To the utilitarian Nature represents a scheme of economy and utility. We are one of a countless cluster of planets. The sun which shines over us is but one of a vast chain of reflections and magnetic communications, the moon is but one of many discs; the world swims in chaos; all partake of the bountiful provision of an unchangeable law; not one world is to be considered more than another, not one accident to be deplored, from the combustion of a globe to the crushing of a worm, while it only affects its *own destiny*. It was good that the Son of Man should die for men, good for the minority to suffer, if by their pangs the harmony of the majority is secured. Virtue is only according to circumstances; morality is a thing of adjustment; there are no fixed laws of conduct. If vice conduce to the happiness of men, then it has become a virtue; if the removal of a man lead to the restoration of peace, then to kill him is not murder. The end justifies the means: a Jesuitical policy, which has been flung in their teeth as a sign of distrust; the policy of England's Commonwealth, when Oliver Cromwell, with the other members of Parliament, signed away the life of their king. To the utilitarian the earth is a garden for the use of mankind; it is the religion, since men began to herd together; it recognises only the Gods or God of the day. It is the keynote to the sacred bond of Freemasonry. Love is good for the community; set up love and friendship, and rear an altar to them. Unity is well for man, so lay down all private likes and dislikes, annihilate all personal speculations which may breed discord; for the spirit of Truth as she hovers in mid-heaven has the hues of the chameleon, and changes in shape to each eye. What I see, you cannot. Therefore the fact must be carried by vote if you would be perfectly utilitarian in your aims. The reformer is a disturber of concord always. Cassandra disturbed Troy, Jesus Christ disturbed Jew and Gentile; so for the sake of utilitarian peace Pilate washed his hands, and the crucifiers had it all their own way.

Henry George is a utilitarian in principle, but as he speaks as yet in the minority, albeit advocating the welfare of the majority, until men are convinced as to his line of argument he is a disturber of the peace of present

society. Whether his scheme for the regulation of mankind would be successful is as yet doubtful in the extreme, seeing that he ignores all other means except his pet theory. As we find man at present, poverty is in many cases a protection rather than a curse. With passions paramount by ages of contamination, and habits confirmed, opportunity would only sink them deeper in the mire. Drink reformers, food reformers, crime reformers, have before them superhuman labour ere the Henry George jubilee will be of utility to the lower strata. Sanitation, knowledge, morality must be universally taught first, and what is good will follow as a consequence. To us it seems that poverty is of greater utility for the redemption of mankind than wealth. We would see all men poor and sacrificing. It is better for the rich to become poor than for the poor to become rich.

To the utilitarian Nature has a spirit, but it is a spirit of convenience. Floods rush, not to destroy houses, but to water districts. Hurricanes come, not to strew strands with wrecks and wasted lives, but to carry off infections, clear the poisons from the atmosphere. Nature is a great manufactory, where benefits are created for the use of man; and the Spirit is the worker who is busily coining good for the greater number. Trees are admired, not for the waving of the foliage, not for the serpentine curvature of the branches, the half tones about the boles, or glad tints on the leaves, but for the uses of that tree when it is cut down. A true utilitarian is the direct antithesis of the poet or painter.

To the agnostic Nature is a solemn image set up before the eye; the veiled Isis, soulless, or endowed with a spirit unseen and therefore unknown.

'Before I go whence I shall not return, even to the land of darkness.'—Job x. 21.

The agnostic does not deny God or the possibility of eternity; Genesis is not a legend to be laughed at; soul is not to be disputed. Agnostics only stand upon the platform of their senses; they know by geological research that earth was not created in six days; they know by astronomical observation that the sun and moon could not stand still, that if the earth paused one second of time in its velocity it would be destroyed—blotted out utterly from the clusters of stars; by naturalistic knowledge they have proved that the fauna of the earth could not be gathered together or carried inside the Ark; souls have not returned to them from that dark land beyond the grave; if

there be secrets, death has locked them up, and they cannot get past it and return to tell their tale.

They doubt not, because they know not, neither do they believe. Faith is a sentiment, as love is, or fear, only built up on a more slender foundation; what they can see and touch they testify to, all beyond that is beyond them.

Some say that agnostic means atheist; it does not. There are no atheists, nor could any human mind capable of reason be atheistic, because to be one it must be convinced beyond dispute and declared definitely that there is no futurity and no God, and the most that incredulous science can assert is that there is no evidence palpable of the existence of a God. The atheist would be a fool unredeemed and unredeemable, like to the man who, shutting his eyes, shouts out insanely that it is dark to everyone, whether it is or not. The agnostic by research has proved that he knows nothing, and there he stops; there may or may not be. If bold he takes his risk of that 'to be'; from the evidences of the beneficent order of Nature, he trusts his case in the unknown hands: if it is Providence, that Providence is too all-wise to revenge ignorance; if it is chance, he counts upon the hour.

Youth and strength and beauty and health are the aims of life to strive after, the golden hours of summer, when sunshine lights up the heart of all creation, and man, with the plants, feels the divine instinct of life surging in him. He pauses irresolute at the first stratum of earth's crust; beneath that metal plate seethes the fire; that represents to him the beginning. Yet he knows that it was not. The world revolves the portion of a circle; yet why that circle of a sun-centre, or that wider circle within which both suns and earths revolve, or what the centre which controls the entire system of immensity may be, he dares not affirm. Our lives are miracles, yet we are habituated to them, and name them chance. That the earth revolves is no greater wonder than that it should stop and roll again; yet that it revolves constantly and only stopped once, is the point that they will not approve. They learn that era after era the earth was destroyed, and species created without connecting links. Theorists as mad in their dogmatism and desire to prove evolution, as they consider the devotionalist to be in his supernatural credences, try to hang facts upon threads and dovetail corner-pieces and centres, but science gives no encouragement to theory. The agnostic, to be consistent, must hold aloof from Darwinism as he holds back from faith doctrines; he must be content to use his eyes, ears, nostrils, fingers, and mouth. Instinct or surmise with him cannot be sense.

It is a fair day and a blue sky. The mountains are piles of softest velvet, grey, mauve, olive green, and bistre; a soft air that inebriates the brain and shakes the petals of the flush-rose; a day amongst fine days to be hereafter long remembered, for the woman of his choice has listened to his words Eros-shafted, and yielded up her will to his discretion; is she not a type of more than earth-life as she stands before him in the clear lustre of her maidenhood love-glorified? It is not flesh-worship which sways him now, for her beauty has about it to him the sanctity of the religion he cannot receive; in the humbleness of his awe-freighted triumph he could forget his naturalism and cry out, 'Be thou my God!'

Around them wafts the odour of gardens and fields, the spirit of the flowers is floating around, the soul of the sunbeam is kissing them both, the union of outer beauty and inner life wraps them in the all-pervading, everlasting folds; for who dare say that the soul of a perfume can fade? His spirit clasps with her spirit, and both soar away, with the multitudinous souls of things gone by, and things drifting on, up those ladders of light into the presence of God. In this moment the agnostic is an agnostic no longer, for he has seen heaven, whether he believes it hereafter or not.

So love has opened to him the vision of St. John. It is woman who has become the typified divinity, love which embraces faith and hope, casting out self, yet surrounded by barricades of fears; it is an instinct of humanity, as pity, grief, or that innate combination which modern philosophy terms superstition, an elevated instinct of humanity, for it is not the woman-flesh which inspires him with this rapturous awe; it is the magnetic influence of the woman-soul over the man-soul, and this the agnostic feels, in spite of all his former scientific rant about body and brain.

At the present hour we stand on the threshold of mysteries, with the rusted key in our hands which will open the closed door. Four thousand years ago man halted here, with the key in his hand, only it was new and glittering then, and used to that easily turned lock. Behind that door waited legions of souls, upon the opening by man, when they would come and tell him all that lay beyond the good land, his by right of gift, theirs by right of heritage, and they brought with their knowledge great power. That was the hour when myriads of agencies—each agency strong enough to stop a planet—waited on the voice of the man who held the key of the portals between their worlds and his; that was the hour when Abraham and Lot spake with angels, when Pharaoh bent his scientific neck before the miracles of calamity; that was the

hour when the pillar of fire passed through the sea, and unseen forces swept back the water till they reared up great protecting walls—wondrous walls of sea-shells and conglomerate, like some rare kind of polished marble, the specimens alive but struck death-still with amazement, the roaring hushed as they passed under the arching crests, a gleam of starry space far above, and a glare along the watersides from that crimson pillar in front.

That was the hour when familiarity made remonstrance possible, and man gauged the strength of his science against Almighty prescience, as he does still, only then prescience replied directly to reason, and power refuted by immediate evidence of cause and effect, for then reason did not wilfully close its eyes upon possibility, and man owned the superiority of his Creator.

It was a good land when the angels of God visited man upon the plains, when the voice of God was heard within the mountains, when Enoch, by preparation, body and soul, became spiritual enough to dispense with the services of death; when Moses went up, with clear eye and upright head, to make the last peace-offering—himself, on Mount Nebo: Moses who by philosophy had rendered his mind fit to consort with the inner circle around the throne, who by abnegation had rendered his body fit to offer up the last great sacrifice for his people in the land of darkness, with soul ready to be redeemed.

Ah! what an audience waited upon that solemn change, upon the dimming of that eagle eye, the relaxing of that upright figure! No man can find his grave—no man knows his end; yet we may conjecture that as he looked and longed, with his body chained to Mount Nebo and his spirit flying over the land, held to the mortal portion but by a thread, as the falcon is held to wrist, an elastic cord that elongated as he flew, waxing thinner as it farther stretched, until it was almost unseen; then death came from that white-draped crowd, draped in the red robe of man's passionate desire, flitting over, like a gleam of sunset, from the midst of cherubim and seraphim, angel and archangel, flitting over his 'abeiyeh' with gleaming fingers, lighting up his 'kefiyeh' as it sought for the source of that unseen cord—the shears of death—red, golden shears have clipped the link, and Moses is in Canaan, the heaven of his present desires, and the supine clay is being attended to.

Nearly two thousand years ago the climax came to all that mystic intercourse: from the supernatural unseen Teacher, God became the natural sure friend and teacher of man, and so He has continued ever since—

amongst men when they like to have Him, imparting the knowledge of the supernatural to those who choose to learn, holding out a key all unrusted, in exchange for the key which we have ourselves left to lie and become thickly clotted with rust.

There are angels passing still, for men have used that key; when the lives are pure and the habits simple, when charity extends to wider circles than humanity, and mercy embraces all creation; at times and in obscure places, where God can speak, the Son of God instruct, and the angels work miracles, as they did of old, where faith is paramount and science can only gibber and scoff outside.

It is a good land to all; even to the agnostic, as he waits for darkness, or annihilation, the sun shines hope, the west wind breathes peace, the dew speaks promise when he walks abroad. Science is like the mole, it must bore; it has no affinity with moving creation, it has no interest with life or hope, it lives and battens with the ghouls amongst the dead; yet the deepest borer in philosophy is but a man, and the man part of him must enjoy light as long as science keeps from blinding him entirely.

But to the devotionalist, the Christian, the God-worshipper, what a land of bounty it is! I do not mean those narrow souls who dwell in a vale of tears, those dyspeptic souls who can no more enjoy this world than they will the next, but the man who honours God sufficiently to know that all He created must be perfect—this world for man, the other worlds for those who inhabit them, heaven only fair to the spirit to whom this earth is good. Are not the summer clouds as they float through the atmospheric belt the emblems of the angel forms which are ever passing to and fro in the state beyond—the hills, and rivers, and valleys, the ever-changing landscapes and aerial effects, all created for the pleasure of man by the good Father, all symbolic and typical of the pleasures of the future? It matters little what are the individual or sect ideals of that Creator or futurity toward which they are wending, whether they sit down in ecstatic contemplation, in the midst of Nature's splendour, with the moment of final merging into the great light before them, or look forward to that future when individuality is retained and time alone is merged into eternity. To the man who believes in immortality this earth smiles her sweetest, because there are no melancholy surmises mingling with the present enjoyments. Virtue appeals alike to believers and unbelievers as the wisest guide to follow, the consequences of departure from her laws being immediate and independent of the fear of future

punishment. It is not hell which appals the intellectual sinner and deters him from crime, but earth; manhood, not morality; the pride of honour rather than the hope of everlasting reward. But to the hopeless, or spirits who cannot rest upon a hope, what are the pleasures of time but days spent in a condemned cell to the doomed? Every sunset which glorifies the world is a day stolen from precious existence. They glance backwards upon the past with yearning pathos, to the hour when boyhood bounded along the track of life, and religion was the pabulum of custom and Sunday-school the turning point of the week. How foolish it all appears in their intellectual advance, yet how joyous; with what hopeless envy they hear of the ambition of young men and women, who rest their fame upon a class-prize or the applause attending a choir-concert! Ah! those were days when the Son of Man came near enough almost to be seen with the earthly eyes, and the divine messages were palpable.

To the Christian poet and painter nature appears animated by the spirit of a deathless Creator; the body dies, the seasons fade, but another body as real comes forth, and nature spiritualised is revived as the spring drapes the limbs of winter.

To the poet and painter to whom this earth means all, to whom the spirit of nature is but the Greek soul that goes out with the change, never more to be revived unless in the soul left behind, it is all beautiful, but filled with woe; a soul of spring dying before the breath of summer, summer shrinking before the chill of autumn, autumn crouching under the iron heel of winter; death over all—death and despair; and this is the creed of the agnostic.

But to believers, what is it but a continuation of everlasting joy? In pain they see the blessed surcease; in sorrow the golden alleviation; in death, the balmy sleep, and afterwards the glorious waking up; earth, the garden of the Lord, where æsthetic tastes are gratified, where love is generated and friendships are formed to be continued and cemented in eternity, where soul-philosophy, and not pitiful brain-logic, is begun to be followed out without an end, where problems are given to be hereafter solved.

Is it not a good land to poet, painter, utilitarian, agnostic, and devotionalist? When the sun rears from the ocean-bed and rides over the fleecy clouds of morning, while all the ground is teeming with the silver evaporation of pearly night dews; to the poet and painter as they watch the tender colour-shafts, the subtle play of light and delicate blue-grey shadows on the

meadows where the cattle graze, over the furrows that the plough is turning up, amongst the dancing ripples adown the waste of heaving waters.

A good land, despite the evils which erring man has brought upon it—the drink-devil who riots in palace and den and wanders even to the verge of pellucid springs, the demon who is sapping the manhood from the human race, who is making bare and bleak the fairest spots, the most consecrated things on earth, whose lank talons spread beyond the grave and rob Paradise of its rarest flowers; despite the smoke-fiend who is aiding and abetting his brother drink to enervate the brain of workers; the devils called luxury and indulgence in all their thousand disguises, whether it be in eating, or drinking, or dressing; despite the vampire called poverty, who squats hand in hand with crime, attended by despair and utter misery.

A good land, where we can cast aside the trammels of cities and get out to see it; where we can forget our brothers in iniquity, our brothers in sorrow and starvation, depths which charity cannot cure, or investigation eradicate, which rise up like black waves against our stemming and threaten in the future to engulf us all.

A good land, where we can abnegate desire, learn to be poor as Christ was poor in order to correct poverty; where we can conquer ourselves, lay down the most clinging habit, for the sake of mankind, and by example teach others at the lower level to be content with God's air, and God's light, and go out to get them; where we can live with less comfort, fewer tastes, and greater simplicity.

A good land, where the great social problem is solved and self-abolished for cause, and men, proud of being poor, as now they grow arrogant in wealth, join hands as little children, forgetting that bat-ghoul philosophy, taking the gifts which God has given to them as the foretaste of better things in store.

A good land here; but what is there to come, where Art begins?

Milton Keynes UK
Ingram Content Group UK Ltd.
UKHW050711220124
436466UK00017B/758